ENTWINED

Entwined

Sisters and Secrets
in the Silent World
of Artist Judith Scott

Joyce Wallace Scott

BEACON PRESS
BOSTON

Beacon Press
Boston, Massachusetts
www.beacon.org

Beacon Press books
are published under the auspices of
the Unitarian Universalist Association of Congregations.

19 18 17 16 8 7 6 5 4 3 2 1

This book is printed on acid-free paper that meets the uncoated paper
ANSI/NISO specifications for permanence as revised in 1992.

Text design by Nancy Koerner at Wilsted & Taylor Publishing Services

Many names and other identifying characteristics of people mentioned
in this work have been changed to protect their identities.

Library of Congress Cataloging-in-Publication Data

Names: Scott, Joyce (Joyce Wallace)
Title: Entwined : sisters and secrets in the silent world of artist Judith Scott / Joyce Scott.
Description: Boston : Beacon Press, [2016]
Identifiers: LCCN 2015039221| ISBN 978-0-8070-5140-5 (hardcover : alk. paper) |
ISBN 978-0-8070-5141-2 (ebook)
Subjects: LCSH: Scott, Judith, 1943–2005. | Down syndrome—Patients—Biography. |
Down syndrome patients as artists—United States. | Scott, Joyce (Joyce Wallace) |
Women caregivers. | Twins—Biography.
Classification: LCC RJ506.D68 S36 2016 | DDC 618.92/8588420922—dc23 LC record
available at http://lccn.loc.gov/2015039221

For my Judy,
and all those whose talents
and gifts are not yet realized.

For Creative Growth,
where Judy discovered hers.
May such places spring up everywhere around the world
and all of us be blessed.

Contents

Preface

The sheet is cold—cold all the way to the edge. I stir, instinctively moving myself deeper into the bed, seeking the warmth of my sister, my twin. It may be the sound of the leafless branches of the old maple tree beside the house scraping against the shingles that has wakened me. I open my eyes to the dull gray light of a November morning filtering through the curtained window. Outside I can just make out the protective silhouette of the giant blue spruce that stands guard over our room, the center of our universe, our sanctuary from the greater world beyond.

Judy and I were joined in the womb—in body, in soul—and yet we were different. Even at birth, the unforeseen differences between us were received by others as part mystery, part gift, part curse. Together we shared a rich, sensate landscape filled with ripe berries and moist mud pies. It was an unspoiled world where everything in the universe was alive and filled with meaning. Judy's lack of language forced us to live in a realm of experience unmediated by words. Most people leave

this state of preverbal communion with stones, trees, and birds by the age of two. Our first two years, remembered only as passing images from a dreamtime, are spent in a soft world of sensations, sensations without words. I remember the speckled light that moves with the curtain that hangs near our crib, our hands playing with the shadows and light coming through the bars, the softness of Judy's skin. I remember her warmth, the warmth of her breath mingling with mine, the heat of her body beside me. In discovering my own body, I'm discovering Judy's; the presence of the two of us forms a collage of sense impressions all merging into one. When I roll over, I touch her arm and she moves closer to me. There is little difference between movement and response. My body, her body, already fused in our sense memories.

I recall most of our early life as being lived in a sandbox. It is a small yard all its own, surrounded by chicken wire, with an old broken wooden gate latched with a twig. To us, it feels like home, as much our home as our room and our bed. In our sand-and-earth world, Judy and I scratch and dig; we play with sticks and leaves, and with stones brought up from the creek. We make plates and cups from the green catalpa leaves. We scrape designs in the sand, make stone soup, and pour water into holes. In handling our stones, we discover a kind of counting, but mainly we discover the joy of sharing. The feel of sand and grit in our toes and teeth is deeply satisfying. I can peel a stick, taste a stone. Together, we collect the mulberries that fall from the giant tree just beyond our gate. We smash them, eat them, paint our faces with their juice. We put the wandering box turtles in with us and paint their shells to be like us. We collect tadpoles from the pond, keep fireflies in jars, our small hands reaching toward their blinking, ever-moving lights, so often just out of reach. For years, this was our world.

In the cool night, we sleep curled together under our blankets; in the warm night, our skins are damp together, the smell of our bodies mingling, becoming one. Judy and I, always cocooned together. We sleep like spoons, small curved spoons, soft twin spoons, keeping each

other close and warm. But now I feel cold—very cold. I reach out my hand across the bed to pull her close—reach further—and further still. She is not there beside me.

I slip quickly out of bed, my bare feet hardly touching the floor, and tiptoe to the bathroom, wondering if she might be there. The towels from our last night's bath are still lying damp on the floor and our yellow duck that we pushed back and forth in the tub lies on its side, abandoned. But she is not here.

PART I

Bound

I

Eden

⌒

For seven years, Judy and I are blessed to wander in our own private Eden, a land of endless wonder and discovery, rich in sensation and the currency of love, always in a world without words. Outdoors or indoors, Judy wants to sit beside me and do what I am doing. For a long time, we do the same things—play with mud and mulberries, dirt and dandelions. Later, as my play grows more complicated, I can only pretend our games are the same and imagine rules without knowing quite what each of us means. Later, we may mean different things, but still it feels the same. There are no words, but we need none. What we love is the comfort of sitting with our bodies near enough to touch.

Where we live, with our three big brothers, Wally, Dicky, and Jimmy, it is almost countryside, and the confusion of downtown Cincinnati is far away.

Behind our house are sheep pastures with woods nearby, a little creek, and a pond—so many worlds to explore. In the field behind us, we find bunnies in the spring, their nests disturbed by cats. We try each

year to save them, but they always die, and I feel sadder each time. We have an animal graveyard with a section just for bunnies. They fit in little shoeboxes with a layer of grass for a bed, and sometimes we make them a cushion for their long sleep. We make tiny crosses out of twigs, and my best friend, Kathy, sometimes says a little prayer.

We live surrounded by a continuous mingling of friends and neighbors and, above all, neighborhood kids, who come and go, constantly circling in and out of each other's homes and yards. We feel bound and safe. Where we live, we are never afraid, even though sad things, sometimes bad things, happen. Like Aunt Helen falling on her sagging porch next door and breaking her hip. Or Gramma losing her mind and thinking my name is Teddy—that was the name of her dog that died a long time ago. I don't mind. I love her and love how she loves me as Teddy. Teddy was her best dog, her very best dog. And I love how she peels apples for us with just one long, swirling peel, which she promises she'll teach me one day.

Long before she welcomes us into her world, it seems Aunt Helen has always been old. Tall and thin, never talkative, she is formidable, but always kind. When we are not in our sand yard or our room, we like to be at Aunt Helen's, that is, until she falls and goes to the hospital. Beside Aunt Helen's dilapidated back porch, but not as far as the barn, there are rows and rows of purple violets every spring. More violets than my plump, sweaty hand can hold. I pick them with the sun beating down on my dark head. I pick them with purpose and intent. Judy helps me sometimes, but mostly she pulls them too short, with no stems. But it's okay. We pick and pick, with small beads of sweat dripping down our faces, turning bright red in the Ohio sun.

Later in the evening, we go with Daddy to the hospital. Judy and I are not allowed to see Aunt Helen, but we ride across town with Daddy and wait in the parking lot. All it does is rain. We wait in the car with the drops sliding down the window pane beside us. Judy wants to be on my side, next to me. We both kneel on the seat and put our fingers

on the inside, up against a drop and follow its downward course. It isn't a race really, not with us. If anything, I want Judy's drop to win, and I'm not sure she cares. We're snug side by side. It's dark inside, dark outside. Sometimes a car comes by, lighting up Judy's face, the drops, and our fingers pointing on the pane. With the light, Judy sometimes forgets the drop and looks at me instead, poking at my face and giving me a little shove. We giggle and get silly. We know Daddy is coming back soon.

Daddy has carried the violets in to Aunt Helen, so now she will think of her little white house with its rickety steps and the long winding porch that clings to its sides. She will remember her yard with its flowers and want to get better soon and come home to us. She'll make cookies for us again and sit with us after supper. We'll play checkers, passing Judy the extra ones. She will make me another butterfly net, and one just a bit bigger for Jimmy. We will show her every beautiful butterfly we find. On cool nights, we will sit by her little coal stove and work on a puzzle together. We may not even talk; sometimes, we don't talk for a very long time. We listen while the locusts go quiet; then we hear the crickets start up.

Uncle Clarence, known as "Toady," is Gramma's change-of-life baby, as Mommy calls him. He never left home and never grew up. But when he turned forty, he announced to everybody, "That's it; nobody is going to call me 'Toady' any more. I'm 'Uncle Clarence' or I'm 'Clarence.' That's what my name is."

None of us, not friends, not even family, had ever given much thought to his name; "Toady" was his name long before we were born. It's always been his name, but now we squirm inside with the shame of calling him that for all those years, a name so painfully appropriate to his looks. He might well have hopped out of some fairy tale. We can tell he's different, but Judy and I love him in his differentness. We love everything about him that Mommy can't stand—that he's a little slow, he moves slow, he plays slow, he thinks slow, but that means he's never

in a hurry. Not like other grown-ups. We love that he tells the same jokes every time we see him and makes us laugh over and over.

Summer in Ohio holds the hint of water, often more than a hint. There are sudden torrential downpours where the street gutters fill and overflow and all the sticks we drop go racing each other crazily, ending up on lawns and caught on forsythia bushes. There are thunderstorms when the sky cracks open with such force that the animals look for open cellars in which to hide, cats and dogs finding themselves comrades huddling together in dark dryness, the terrifying sky sounds muffled by earth and stone.

Our Midwestern nights mean moist air and bodies drenched in sweat. In sleep, sticking to damp sheets; in waking, moving through air so heavy it wraps us like an invisible cloth. Smells seem richer, clinging to us, lingering in the air. Tomatoes and onions frying spread their delicious invitation for miles. Voices calling are stronger, carry further, say more, and travel through the night air and around Aunt Helen's tumbled-down porch into the catalpa tree to find us.

Whatever we're eating at suppertime, Judy loves it all and so do I. Potato soup, chili, meat loaf, lots of tomatoes and green beans from the garden, Grampa's pickled beets all year long, Campbell's canned soups. Most everything cooked the same way—green beans with a little bacon, tomatoes sliced or eaten straight from the garden between meals. Desserts, hardly ever, but for a special treat, graham crackers with icing. Lunches are liverwurst sandwiches and tomatoes or grilled cheese with pickle relish. But Sunday dinners, now there's something special. That means Gramma's house with Uncle Toady and everyone. Fried chicken, mashed potatoes and gravy, homemade biscuits and gravy, and in the blue dish with the crack up one side, more of Grampa's pickled beets.

After dinner, Gramma, strict Methodist that she is, stays in her kitchen and busies herself washing dishes, choosing not to think about what is happening in the next room. Judy and I sit at our own little

table with our own set of cards and chips. Sometimes, we slip off and crawl under the big table where we live among the feet and shoes. Near us are the legs of the big people who at times share our world. Toady slips us some of his chips, and Mommy yells at him—she always yells at Toady. Above us, laughter and cigarette smoke, cards and chips. Below, our own cards, our own game, and a laughter all our own. Here Judy and I share the same make-believe world—or I think we do—but not the words. I begin to dream of words, the ones that will connect all of Judy's world with mine.

Summertime in our backyard, the neighbors, all the mothers and daughters, sit together watching the night-blooming cereus open, our chairs carefully placed in two rows, the excitement as intense as any Broadway opening. As we wait, the mothers talk across our heads to each other, using their codes for those stories our ears are too young to hear. Our legs swing in excitement. Judy slides off her chair and is playing in the grass next to the grown-ups. "Wait, look, here comes one. Look, look, it's opening." Kathy spots it first, and those of us who can move very quickly rush over to see this first beauty revealing itself to the night air and our admiring eyes. Soon, more open, soon more amazement, and then we hurry off to play our nightly game of Kick the Can with the boys. Judy stays back with the mothers for now, and after a while, as darkness swallows us, I slide back into her presence, where I am most safe and most alive.

All around us are the trees. They, too, are our friends, just as known and loved as any person. I knew their names by the time I knew my own. We treasure the gifts they give us—shade, beauty, grace, a home for birds and squirrels, a place for us to play—and other, deeper gifts, the ones without names. One day, the giant oak tree near the drive has to be cut down, its life shortened by disease. All our family stands silent, straight and tall, tall like it was, silent out of respect. We weep openly, my daddy, my brothers, and us—a family of few tears. The blue

spruce by our window remains. The bright-green color on the tip of each branch in the spring makes me think of everything fresh and new.

At night, Judy and I share one big bed. Beside is a table for our dolls and our two small chairs. Two small chairs, two small dolls, with two little bowls, and two tiny spoons. The table is big enough for us and small enough for our dolls. I don't know if everything comes in twos, but it seems to me it may. Early in the morning, while the rest of us sleep, Judy sometimes climbs onto a chair and unlatches the screen door. She slips over to see our next-door neighbors, especially the babies that we both love so much. There've been times I've found her sitting at the table with the family next door, and they're giving her ice cream for breakfast. I can hardly believe it. But the day will come when there are no ice cream breakfasts and no babies for Judy. Our neighbors move away, taking our babies with them. Later, the Schmidt family moves in with five girls and, then, a baby of their own, one we aren't allowed to see except through the window, one we're never allowed to touch.

I don't remember when I first realize that Judy is different or when I understand that it's dangerous to be different, dangerous to be thought of as "less than." I think I didn't realize the dangerous part until after she was gone.

When we are six years old, Judy is still very small. One afternoon, there is an accident on the Schmidts' porch. Mrs. Schmidt thinks that Judy pushed little Marilyn, although Mrs. Schmidt wasn't even there to see. There are lots of us on the porch besides Marilyn and Judy— me, Kathy, Nancy, Martha, Kitchie, and maybe Toni. Kitchie, whose father's job is to fill candy machines, has brought some jelly beans. Everybody is shoving a bit to get some. Marilyn just fell. Judy would never push anybody. I know that for sure and so does Kathy. But some people must have believed she'd pushed her. Mommy says the neighbors have begun to talk. Now I wish I'd said something right then. I wish I'd said right off that it was my fault, my mistake, that I bumped her.

I think, after that, it's Mrs. Schmidt who brings us trouble. Before they moved in, there was no fence between our yards, just a long row of bushes—forsythia, redbud, and lilac—each with hideouts and crawling paths in between. It was here that Jan Oliver and I pricked our fingers and mingled our blood to become blood sisters, where we smoked straw cigarettes to celebrate. But then Mr. Schmidt built a big fence—on Mrs. Schmidt's orders, I bet.

After the Schmidts fence their yard, they don't let Judy in. They act as if they're afraid of her just because she's a little different. On summer evenings, their three big girls sometimes eat giant dill pickles on their porch, with Judy and me watching from the side yard. They eat them slowly and seem to like to watch our mouths water. I develop a craving and scratch our brothers' backs for nickels so I can save my money for a jar of dill pickles from Hunchmyer's down the road. I hike down alone to buy them, and then Judy and I sit and eat a whole jar by ourselves. We sit on the breezeway with no one around, just us and those pickles.

Although Judy and I share everything, we don't share Big Doll. She's too important to me. She was given to me when I was three, and I have made it my mission that Big Doll will become a real baby girl. I give her something from our dinner every night while we're eating in the kitchen—green beans, strawberries.

Big Doll means everything to me, but I'm also sad about having Big Doll, because there is only one of her and there are two of us. It feels wrong to have her for myself; Judy hates Big Doll like anything. She wants to hold her the same way I do, but I worry that she'll break her and then how could she ever become a real baby? So I only let Judy hold Big Doll when I am beside her.

Big Doll lives in a mess. We live in a mess. Torn magazines and broken toys litter our floor. A disemboweled teddy bear, Jimmy's soldiers, and scattered wooden blocks lie beside the rumpled bed. This is our room. Here we can do as we want. We both like to look at books, but

Judy likes magazines best because she gets to tear the pages. She loves playing with small, soft things, loves putting them into baskets and into our dollhouse. But sometimes, when company comes, Judy and I are shut away, and our room becomes our twin cage, our shared prison.

When the ladies gather to laugh, play bridge, and trade cuttings of plants from their gardens, we stay here with the door locked, hidden away. We hear their laughter moving around the corner of the house, coming past the window, adding to our sense of isolation. I know that later the door will swing wide again, allowing us our freedom for a time. I know that next time company comes, it will again swing shut, and the key turn in the lock. We will be hidden along with the laundry, which is shoved quickly into the bathroom closet. We are to be as quiet as dirty clothes.

Tonight, Mommy has made us popcorn, and we sit in our room on the floor, passing the blue bowl between us. Sometimes, Judy picks out the puffed-up kernels. Sometimes, she puts them on the floor beside her and squashes them flat with her hand. Mommy won't like it, but I don't care and Judy doesn't care. We spill them, we step on them; we laugh and then we sit on them some more and laugh again.

Judy wants to pretend that our dolls are eating popcorn and stands up, walking with legs wide. Nearing the doll table, her foot catches and she falls, quietly at first, until her mouth hits the table edge. She cries out in pain and fright as blood gushes, spills onto the floor, onto the popcorn, onto Big Doll's dress. Blood is suddenly everywhere. I grab her and hold her, banging on the door for help, while Judy's cries grow louder and more desperate. I hear all the ladies running, and the key turned in the lock. Grabbing Judy, Mommy tries to shut the door again, but it's too late. Everybody crowds through the doorway and into the room. Florence Peeper, all the while scanning the torn pages and smashed popcorn, looks at me and says, "What did you do to your sister?" Horrified by what has happened and astounded by the question, I do not speak. How could I hurt Judy? I cannot imagine what

Mrs. Peeper means. I can't even imagine the thought. But for weeks afterward, Judy has a heavy black thread hanging from her mouth, a reminder to me of her stitches and of how I must have failed her, though I am not sure how.

One day, after I start kindergarten, I forget and leave Big Doll on her little chair in our room. I come home to find that Judy has ripped off Big Doll's arm. I am shocked and hurt. Yet I am also resigned. It has always seemed wrong and unfair that I have Big Doll and she doesn't. Worse still, I set off for school in the mornings, leaving her alone in our room for hours. So I take the dismembered arm and the rest of Big Doll with her stuffing falling out, and shove them both into the bottom of the bathroom closet. I put the old covers and dirty sheets over her and leave her, without saying good-bye. Big Doll is dead. I think it's the only time that I feel Judy has hurt me, but I forgive her, knowing she has reason, knowing it is I who am betraying her over and over by leaving her and going to school.

In Kathy's backyard behind the walnut tree is an old, faded couch in earth tones of brown and gray, with springs and horsehair stuffing hanging out, smelling of damp from its outdoor life. At night, with our upside-down-selves lying close together, it becomes our ship. We have the sea below and a million stars above to guide us. Explorers of the universe, face up, feet up, ourselves upended, searching the skies for answers to questions we can only sense, ones we could never name. We're time travelers like others, millions of years before, sharing the mystery of the stars. Judy's eyes are wide with wonder as she snuggles in closer and squeezes my arm with both her hands.

Our parents' voices float from the faraway kitchen through the warm night air, each distinctive in the darkness. But we are beyond their words. Past the kitchen table, through the screen door with its corner torn, their voices drift, but can never reach us. Our ears are with our eyes, beyond the earth—we belong to no one. We are part of a greater universe beyond the table where our parents slap down their

cards, beyond the neighborhood with the kind and the unkind, beyond the dirt, the puddles, the bent grass.

We are wild girls, we are explorers always, and in the long hot days, we live simply, richly, discovering new worlds around us. Our world, Judy's, Kathy's, mine.

2

The Colors of Gone

Where is she? I can't find her anywhere. She's not in the next room, waking our sleeping brothers. Not next door. Not in the kitchen. And where's Daddy? There's no sign of him either.

I see Mommy standing alone. She is smoking a cigarette, holding her coffee. Her hands are shaking. The kitchen is warm, but she leans huddled against the stove, the kettle hissing away, unnoticed. Steam fogs the windows; even the crack left open for fresh air is shut. The white eyelet curtains hang limp and still. The radio is silent. On the chair by the stove, Jimmy's ragged gray cat does not stir. I touch his warm, untidy fur as he sleeps. No smells of bacon or toast today, no pancakes. It's way too quiet; something is wrong.

"Where's Judy?" I ask. "I can't find her anywhere." Her eyes red and distant, Mommy looks away, toward the window and the sound of rain in the backyard. She is speaking to an empty space in the room, and I can't tell if she even sees me. "Judy's gone away. Daddy took her early

this morning to a special school. She's going to stay there now. They'll help her learn to talk. That'll be good, won't it?"

I don't understand her words. What is she saying? Judy gone . . . gone away? That's impossible. I cannot imagine Judy gone. How can she be gone?

Years later, when time had begun to unfreeze her lips, Mother will tell me about that morning, how sweet Judy looked, how she'd chosen for her a bright-yellow dress with tiny white flowers. How her heart was breaking as she tied Judy's bow for one last time. But she didn't see Judy go, didn't draw back the curtains to look out of the window and see her climb into the car. In the end, Mommy turned away.

I didn't see Judy go either. In my mind, I imagined her sitting beside Daddy in the car, babbling quietly, happily unaware that he was taking her away. But I know that Judy must have sensed something. She must have. Although she never knew the words, Judy always knew when someone was upset. She understood. Daddy would have been clearing his throat and pulling on his neck, not saying anything. He would have tapped his fingers on the steering wheel, and she would have sensed that something bad was about to happen. Judy would have patted his shoulder as she did mine when I was upset.

That night when Daddy returns, I hide in the hall and hear him talking to Mommy. "It was awful, Lil. She was scared and clung to me in the elevator. She was terrified when it started up, and she had a little accident. You know she hasn't done that for a long time. Then, when the sheriff's deputy took her from me and carried her through the swinging doors, she reached for me and cried. I heard her crying down the hall, all the way—crying. It was terrible, just terrible."

Daddy's voice grows quiet, and there is no reply. I feel sick. I know how frightened Judy must have been, because I am frightened, too, and aren't we the same? That night, I reach for Judy in my sleep and find only emptiness.

The next day, and day after day, Mommy sits in the kitchen while

the rest of us get dressed for school. At the yellow Formica table, on her padded chair with the cracked plastic cover, she smokes and sips her coffee, clutching it in both hands as though she is afraid she might lose it. She sips with that funny slurpy noise she makes when she draws her breath in at the same time. After her sip, she sighs.

. . .

Our room is the same as before, magazines all over the floor and old popcorn still in the corners. And I can feel Judy's presence everywhere. My dolls-of-the-world collection is still high up on the shelf. I look at it with hatred. Why hadn't I let Judy play with those dolls whenever she wanted? Most of the plastic zoo animals Daddy got us on one of his trips are in a small bowl. I bet Judy put them there. I pick up the other scattered ones and put them all together. I touch our Joanie dolls and their blankets, tuck them in together, pick up Judy's spools, the ones she got from Aunt Helen; then I go outside. I don't tell the other kids anything, not even Kathy. No one will believe Judy is gone, especially not Kathy. Jimmy's cat is on the steps; I pick him up, rubbing his fur backward.

After lunch, while she piles dishes in the sink, Mommy tells me she's going to our room to get some of Judy's things. "I'll save some in a box for her; we can bring them to her later," she says. Somehow I know that isn't true. Anyway, Judy's coming back soon, and her little things are all that's left of her right now. Taking them away will only make her more gone. I run ahead of Mommy to our room, calling behind, "Don't take any of her things! This is all stuff I still play with."

"For heaven's sake, Joyce, I know you don't play with those old magazines." She reaches down to grab some.

"Yes, I do. I do." I gather a bunch in my arms. "I like these, and I look at them sometimes at night."

"You do not. You read. I know you. Most of them Judy already tore up anyway." She picks up some blocks near the doorway. "Well, I'll take these blocks of hers."

"No . . . wait! I like those blocks. And, don't take our bouncy horse. It's still fun for me sometimes." The horsey rocks on springs, its seat worn smooth, one spring dragging. I've loved it forever, and Judy learned to ride not long ago. I sure don't want that being thrown out.

She sighs and turns around and goes out to the kitchen, probably for a cigarette. I take our little dishes, and Judy's blocks and a few magazines, the little plastic animals and the spools, and put them in the bottom of my drawer underneath my T-shirts.

That night, as on other nights, I pile everything beside me on the bed and feel each one in the dark, thinking about Judy's hands holding them. I can almost smell her on them. I will hold them now for her and I will wait. The air is cold around me, but the little things feel almost warm.

Before bed one night, Daddy sits beside me and asks, "How would you like to go see Judy at her new school tomorrow?" I throw my arms around him in response and both of us laugh. But it takes a long time for morning to come. I get up in the night and fill my ballet class case full of things I've hidden and saved for her, especially her Joanie doll, the one just like mine.

We pack the trunk full of extra clothes and a warm coat for Judy. It takes ages to get to Columbus, where they say Judy lives at her special school, and it feels ages since we've seen her. I am counting cows, and then cars, trying to remember their colors—how many reds, how many blues—and making wishes like anything as we go along, wishing that Judy would be somehow okay, wishing that she could come home with us, wishing that once we get there, Mommy and Daddy will change their minds about everything and realize they made a big mistake. I pick at the plastic on the backseat, feeling for the rough edges with my fingers. I throw little bits out the crack in the window as we go along, and catch a piece of the wind with my hand.

The drive feels forever, passing through endless flat cornfields and

farms. Mommy and Daddy are up front, not saying much. Mommy passes me an Oreo cookie, but she forgets to smile.

I'm wearing my dress with the smocking that's like Judy's blue one that Daddy got for us at the job he goes to in West Virginia. I am hoping she'll be wearing hers and everybody will know that we're twins. I'm mostly hoping her school will be a nice place with lots of toys, and kids and grown-ups who aren't mean to her. We stop at a little place for lunch in a small town called Washington Courthouse. Our table is right in the corner, with lots of windows. There are pretty plastic flowers and a white tablecloth, and we can watch everything going on outside. All of us get chicken steaks with gravy and biscuits, but I just poke at my food. I don't feel like eating, but I pretend to, moving it with my fork into one neat pile to make it look smaller. I save my biscuits for Judy and put lots of jelly on them, then wrap them in my napkin. She'll love them. I can just see her eating with sticky fingers and the corners of her mouth turning all purple.

The special school doesn't say "School" where we drive in. It says "Columbus State Insti . . . something." It has a long driveway and lots of big, old buildings with trees around so that no sun can reach inside. Everything looks dark and a little scary. Getting out of the car, I can feel the cold, and there are a few snowflakes coming down. We have all these clothes and a few toys for Judy, so it's a big mess trying to get everything out of the trunk and carry it all inside.

Before we get to see Judy, we have to go to a different building, one with giant hallways where Daddy leans through an inside window to look at stacks of papers and sign his name all over the place. It's so hard to wait. I have a magazine we brought for Judy, and I look at it about a hundred times. It has a page with some pictures of bunnies on it. I bet she'll love that. They are just like our Uncle Toady's bunnies, and everybody knows how much she likes to hold them and pet them.

When we finally go to her school building, it doesn't seem like a

school at all. I don't see any blackboards, posters, or books, not even any toys or blocks. Everything is way too big for little kids, with a giant staircase and a huge wide hallway. It's all empty except for a few people sitting along the sides. Some of the people are rocking, some sit still with their heads drooping. It smells like old cigarettes, sweat, and damp floor mops.

We are told to wait in a little room with chairs and an old green couch, where we sit together. A radiator just behind us is making loud hissing noises, and the room feels hot and stuffy. There is only one other lady. She's in a plastic chair across from us, but she doesn't say anything. I try to smile at her, but she looks away. Then a big woman with a red blotch on her face walks in. Wearing a white coat and clutching a bunch of keys, she holds Judy by the hand. Judy looks so little beside her, smaller than I remember.

Judy comes to me first, and we give each other big hugs. She hugs Mommy and Daddy and starts talking to us in the way she likes to talk, with sounds that are almost like words. She sits right down on the floor, pulling me down with her. She wants us to look at the magazine I have brought. I find the bunny page for her right away. She does like it a lot; I knew she would. Mommy wipes her eyes on her sleeve. She's not noticing that Judy is trying to tell her something. Judy always has more to say than anyone. We just can't tell what it is. I look at Judy real close and say, "Hi," in a loud voice. I had decided that would be a good start for talking. She replies, "Ho, ho, bah," and pats my face.

I have to use the bathroom, so the lady with the red blotch takes me through some doors and hallways and leaves me in a room with a whole lot more doors and toilets. She tells me to come back when I'm finished; I try to get back, but I can't find my way. I have no idea which way we've come.

I find myself in a dark hallway with doors that all look the same. I look both ways. I don't know which door to take, so I open one door after another. I keep opening them, looking in, trying to find the right

one. Instead, I find rooms full of children, children with no shoes, sometimes with no clothes. Some of them are on chairs and benches, but mostly they are lying on mats on the floor, some with their eyes rolling, their bodies twisted and twitching. They are moaning and reaching into the air when there is no one there to reach back. Only the hot heavy air. And there are terrible smells, sweaty smells, bathroom smells where there is no bathroom.

Finally, I find the right door, and there they are, just as I left them, except Mommy is trying to make two little ponytails out of Judy's little bit of hair. Everyone seems the same, but I don't feel the same at all. I feel scared and my stomach hurts.

When we leave, Mommy takes me to the car first and Daddy comes later. Inside the car, all is quiet. In the silence, my mind fills with nameless images and words that can never be spoken. The awfulness I've seen will never find a way out through words. It stays locked inside me.

In my mind, I will return again and again to that time, that place. At night in my dreams, and sometimes even during the day, I am lost in that long hallway, endlessly opening door after door. The colors have vanished, enveloping me in a soundless gray. Other times, I am Judy. I am there instead of her, and always I am lost. I am the little girl in the institution. Sometimes, I am there with her, both of us lost, but at least we're together. Always I can smell the smells, sense the heat, and feel a heavy, damp sadness, the air thick with it.

• • •

Everything has changed since Judy left, but no one says a thing about her being gone. I think it's easier to pretend our family is still the same. We pretend bad and sad things don't happen. We turn away. It's not a good idea to talk about feeling sad, and if you cry, you only make the people around you feel sad, too. No one cries. No one even cries about Judy. After a while, no one talks about her any more, hardly ever, and we never talk about where she is. Never.

Now I eat at the table with my big brothers. We have given the little table that my oldest brother Wally made for me and Judy to our neighbors down the street and their little kids. Jimmy picks at his food and complains about the seeds in his tomatoes. Wally and Dicky talk about cars and football games. With their words, I can feel a fog rolling into my brain. I want to eat and get back outside. We all do. With so many places to play, we don't want to be home much, except to eat something at supper time.

Soon after Judy goes away—it might have been almost at once—Mommy seems to give up taking care of us. She keeps forgetting everything, even to pay the milkman so we can have milk. She still tries to put dinners on the table: meat loaf, baked potatoes, Grampa's canned green beans and pickled beets; baked chicken, potatoes, and green beans; hamburgers, potatoes, and green beans. Soon she stops that, too. Sometimes she leaves a box of cereal on the table for us in the morning. For a while, she washes our dirty clothes, but then she doesn't anymore. They pile up in the bathroom closet until the door won't close.

She stops paying attention to us, her eyes always somewhere far away. Mostly, she leans against the stove with the oven on, saying the house is so cold, but it isn't. Her body shakes and her teeth are always rattling. I can hear them rattle as I read the cereal box.

Then one day, Mommy is gone, an attack of "nerves" they call it. With Mommy gone, Daddy has to take care of us when he's home from work. Every day after I walk back from second grade, I watch the clock in the kitchen, waiting for him to come home from his office in the tall building downtown, the one where the pigeons live and make a mess on the window sills. When it's almost time, I hide in the forsythia bushes by the corner where the bus stops. Then I jump out and surprise him when he gets off the bus. It's always about five-thirty. I'm always there, but I surprise him every time. He never catches on.

At night, he lets me read to him, sitting in the big red chair in the

corner. *Horton Hatches the Egg* is our favorite, and we say together, "I meant what I said and said what I meant, an elephant's faithful one hundred percent." It's then that I know I feel the same as Horton does, but about Judy. Daddy tucks me into bed. Well, he doesn't tuck me in exactly. He says, "It's time for bed now," and I shout, "No!" Then he says, "Hmmm, it looks like someone needs a spanking," and takes off his slipper and shakes it at me. I shriek and run in circles around and around the hallway while he chases me, until I race into bed and dive all the way down under the covers. Then he comes in saying, "Where's Joyce? Where's Joyce? Where did she go?" feeling all the lumps in the covers, tickling the lump that's me. I wish one of the lumps was Judy; I bet he does too.

After a long time, I don't know exactly how long, Mommy comes home. At first, she stays in her room and sleeps a lot. She's changed, and soon the house changes, too. An unnatural feeling of order takes over—order and a deep chill. There is an emptiness, a feeling of everything frosted over. We become snowmen; I am a snow girl, living in an igloo wrapped in red bricks that, on the outside, still looks like home. I keep quiet and listen for the sound of snow. I can feel it falling softly, inside my room, on our dolls, on my covers, and on the place where Judy had slept beside me. Snow falling softly everywhere.

Mommy cares a lot about tidiness now. But even more than tidiness, Mommy cares about bridge. In time, she will become a champion player. I see her frowning in concentration as she fills her mind with classic plays and skillful maneuvers, memorizing the cards and remembering the little ways of each player. She and Daddy replay and discuss endlessly the games from the night before, cards spread out all over the living room floor after he comes home from work. I want them to talk to me, to notice me, and I lean up against the chair, waiting. "Shhh," Mommy says. "Go outside and play or something. Can't you see we're busy now?"

• • •

With the softness gone out of her, there are no more loving hugs against Mommy's warm, soft tummy. Instead, she now keeps everything ordered and held together with rubber bands: pencils, pieces of paper, egg cartons, the cat-food bag. Rubber bands are everywhere. I start wanting her to put a rubber band around me, wanting to find some way for her to hold me tight and not let go.

At night, I am restless. Tiptoeing down the hall, I hear Mommy and Daddy talking in quiet voices in the kitchen. The loudest sound is of ice hitting the glass as they drink their highballs. I lean forward, edging closer by inches. On Tuesday, while I was in school, Mommy had gone with her friend Rene to see Judy without us. I long for news of her, imagining that, at last, they've decided to bring Judy home.

I hear her say to Daddy, "Scotty, I wish you had been there with me. It was so strange. This skinny little girl came up and sat with me and Judy on that bench in front of Judy's building. I don't know where in the world she came from. Somebody should have been watching her. You know that bench, the old wooden one that looks like a million people have sat there with nothing to do ever. You know the one I mean? Just out of the blue, this kid says, 'Sing me something.' For a second, I tried to bring my voice to make a song, but then all I could think was, if only Judy could ask us that, just once. But, of course, I know she can't and never will and, besides, you know me and my singing. No point in embarrassing myself."

She pokes at the ice in her drink, little clinking sounds. I can't see her, but I imagine she's staring through the back window, same as she always does. I never know what she looks at. I peep past the corner as she says, "Remember how I used to sing 'I'm Looking Over a Four-Leaf Clover' with the girls in the tub? I guess those were the happy days, weren't they? I wish I'd known it then. Judy used to sing in a way, those little sounds she made. You could call that a sort of singing, don't you think?" Daddy kind of nods and glances sideways at the dishes that he'd piled up at the sink. They like things neat and tidy.

I hear Mommy say, "Fill up my drink, will you? Aren't you having yours? I don't know. I wish you'd come with me. I didn't know what to do with that scrawny, raggedy thing right up next to us. Wonder what's wrong with her, funny little thing. Anyway, I scooted Judy away and took her down the sidewalk. It seemed like she recognized our car, but I don't know. Maybe she would have gone to the closest car, whatever it was. You know how retarded they said she is. We drove her around the grounds and then took her back inside. Thank goodness Rene was waiting for me. There wasn't much to do. I hate that drive back, especially without you."

She paused and then added, "Oh, I remember something else we did. We sat on the grass for a while, and I started looking for four-leaf clovers like we used to do. You know, just to pass the time. She wouldn't know a four-leaf clover from a stick of gum, so pretty soon I thought, 'What's the point?' She seemed to like the feel of the grass, though, and her fingers sorted through it, looking for something, just like we used to do. Who knows what somebody like her would remember, would be looking for?"

But then their talk changes to bridge. My eyes heavy, I creep back to bed, barely able to hear the faraway murmur of their voices.

• • •

"God blesses you. He gives you what you ask for, but only if you pray. You have to pray a lot!" Kathy says this with fervor, wiggling the toes on her twisted foot. I often wonder about her foot, about her polio, and I'm curious about her prayers. Kathy, like Nancy, Nita, and Martha next door, is Catholic, and they all worry about what might become of our non-Catholic souls.

We often gather at Kathy's house and lean her against the sagging garage door. Then, closing our eyes, we each say one more extra-special prayer before popping our eyes open to proclaim, "You can walk now. You can throw away your crutches. You have faith. We have faith.

Believe, believe, you can do it. Come on, come on!" We know she believes and we believe. Lining up, just beyond her reach, we begin to cheer her on, staring at her full of hope and expectation.

Her blue eyes look at us with purpose and intent, with absolute readiness. She leans forward, then steps forward, stumbles, then falls to the ground. Again, we pick her up, lean her closer to the corner, kick a broken board and rock out of the way, and try again. And again. Something's not working. It might be that our prayers aren't strong enough, or maybe we haven't prayed often enough.

But Kathy and her friends are certain that if you pray for something often enough, long enough, and hard enough—and believe, really, really believe—then God will give you what you pray for. They just know he'll give it to you if you pray right.

So I begin to pray and begin searching for ways to pray better, to focus and concentrate my prayers. My intention is to pray continually. I feel there is a good chance it might help. I pray when I jump rope, when I play hopscotch, when I wish on a star or pull on a wishbone. I pray when I walk past the corner of the house with the dented garbage cans and bent lids, pray under the giant mulberry with the boys' tree forts overhead. Wishes, prayers, and incantations fall everywhere, in winter as snowflakes, in spring as raindrops. In summer, the gullies rush with torrents of warm-water prayers. I can make the prayer fall between my words as I speak. Sometimes, the prayer might come as a song and be sung. It can have numbers and be counted. It can be my heart beating. However it goes, there is always a rhythm to my prayer. I pray when I go to sleep, pray when I wake up. "Let Judy be well, let Judy talk, let Judy come home."

Sometimes in my prayers, I pray that Judy speaks to me in real words. I often wonder why Judy never says any words that I know. Her mouth sometimes opens and closes without a sound. Her eyes large and tender, Judy is like a goldfish that way. At other times, her voice can be heard speaking, not words, but soft strings of watery, dovelike coos.

These come from some almost forgotten time, long ago. The babbles, the sounds, are like a song she sings without knowing the words, a song with rhythm, with high and low notes, a conversation with the cadence of animated speech, hinting at intense topics of mutual concern.

But there are times when I forget. Times when I find it hard to pray, like during a Monopoly or canasta game on the breezeway with the other kids. On summer nights, when all the neighborhood plays Kick the Can, I lose myself in the game as we hide. Eventually, someone shouts, "Olly, olly, in come free," and that means "It's okay to come back home now," and that, too, is something like my prayer.

Kathy takes me to the little cement grotto with plastic flowers near the Guardian Angels School and teaches me to say Hail Marys. Lots of miracles, she says, have happened here. I don't know exactly how miracles happen or even what one might look like. I only know that I need one. I want Judy back home, and that will count as a miracle because I can't make it happen on my own, and so I pray.

In my dreams, where my prayers have been answered, Judy's sounds do turn into words that I can understand. In my dreams, we whisper and share our dolls' secrets. I'm sure it's just a matter of time now. Soon, with our quiet voices, we will tell each other stories in the dark, our heads under the covers, our hair and our breath tangled, entwined.

Another spring comes and, with it, a baby kitty named Smokey, who holds in her small body some of the tenderness I lost when Judy disappeared a couple of years ago. I lie on our bed with my new kitten and feel her soft baby fur. The sound of my name being called far off in the distance breaks through my thoughts. It is Carolyn, my new friend from school. She's tall and skinny, with sunny bits in her hair. We quickly become best friends, cutting through the woods together, making honeysuckle forts along the way.

The first day we meet, she sits next to me in Miss Mahony's fourth-grade class. When school is out, we walk back together along the cinder

path. For a while, we just walk. Then she turns to me and says, "I have a little brother who talks funny." I'm startled when she adds, "You have a sister who talks funny too, don't you?" At first, I say nothing. I don't know what to say or how to say it. I never talk about Judy, and no one ever asks. There's a long silence. Finally, I mumble a short, vague reply.

"So what happened to her?" We keep walking, the cinders making crunching sounds under our feet. I glance at her with my head half-turned and wonder if it is safe to say something. I tell her that Judy goes to a special school in another city, and that's all I say, except, "Yes, she does, she talks funny," and we nod together. We have that in common, something shared, and it connects us. But I never tell Carolyn about the dark rooms and the high ceilings in the institution, about looking for Judy and losing my way, or about the soft, warm place in the bed where I used to sleep with my sister night after night.

One day, during dinner, I hear Mommy and Daddy talk about Judy coming back home and having a vacation with us. I know what a vacation means. A vacation is a holiday. But what will it mean for Judy to be home? I imagine her return, especially just before I fall asleep, when I think about what it used to be like when we were together. How easy and good it will be for us to have our family back again. Mommy and Daddy are bound to realize it was wrong to send Judy away. She was fine at home. She won't be any trouble. Everything will be possible again. She can play with my dolls, our dishes, the marble game, anything she wants. I've saved everything for her. She could look at magazines and tear them if she wants to. That would be okay. No one cares about that.

My mind begins to race with excitement as I plan our life back together again. I can leave for school at the very last minute and run up the cinder path and be home for lunch with Judy and Jimmy and Mommy. Judy and I will play out in our sand yard, just like before. I'll take care of her, and she can be with me and Kathy, all the time. We'll

push her in the tire swing. If it's raining, we'll go together to Aunt Helen's to get a cookie, and Judy can play with her empty spools and yarn, just like always. When Judy comes home, we can pull a string with a ball and Smokey will chase it. Judy will laugh. I can show Judy the cicadas coming out of their shells at night as they hang on the tree trunks, and catch lightning bugs for her to hold. I'll remind her how to make a gentle cup with her hands for catching them. She still might squash one, but she wouldn't mean to.

I live for the day that my sister and my kitty will meet. Somehow, the moment of their connection and the sharing of our love all three ways will bring my sister's love into my kitty's body, and the love between kitty and me will pass into Judy's. Soft, lighter even than sunlight.

Judy does come home, the vacation that Mommy promised. She meets Smokey, and for a little while, the summer feels almost the same as summers in the past. Heat and greenness, cicadas humming all through the day and into the long, hot nights. We play games she can and cannot play. On the breezeway, Judy can still wrap her legs around her neck and do tricks none of the rest of us can do. Just as before, the kids come over to see her and how she still does her special tricks. We eat Wheaties at the kitchen table, legs swinging, patting each other's arms.

My heart is singing from Judy's return when they knock at the screen door, five of them, small, skinny, and somber, with dusty shorts and scraped knees. No one says a word. Judy is still eating her Wheaties while I open the screen door and stare at their troubled faces, their eyes full of a worried sadness. They turn and I follow, down the cement stairs, across the stone walkway, past the garbage cans on the corner to our side yard.

There on the ground, stretched out dead, lies Smokey. While Judy and I slept, holding each other unaware, his body grew stiff and cold, all his softness disappearing into the night air. I look and look. Then, I turn and run through the house, back up the stairs, across my long

attic room until I fall onto our bed. Only Judy follows me, slipping into our bed to hold me as I sob. She rocks me, with her small arms reaching around mine.

The summer is over. The visit is over. Our kitty is dead. And Judy's gone and, although I don't realize it, never to be back.

3

Epitaphs

It was all Jimmy Mergler's fault. Skinny, grubby, he and I used to be friends and liked to climb into the storm drains together. We would go on and on until we came to an open manhole cover, and then we'd have to find our way back home. Jimmy's mother, Millie, is Mom's best friend. A bit chubby, she wears high heels, layers of jewelry, and bright red lipstick, looking something like a movie star, except for the plumpness. Every day, as my mom talks on the phone with Millie, I can see her leaning against the stove, the receiver in one hand and a cigarette in the other.

This morning, after my father went to the hospital because of a stomachache, they talk for a long time. Mom is using her hard-to-hear whisper voice, and I strain to listen. I've had had stomachaches, too; I know they go away. Not for a minute am I worried. That is, until I meet Jimmy on the cinder path to our fourth-grade class.

"I'm sorry about your dad's heart attack," he says right off, kicking a rock down the path.

"What? What are you talking about? He didn't have any heart attack. My dad's just got a bad stomachache, that's all."

Jimmy pauses, looking at me sideways. "Oh, that's not what my mom said. But, maybe . . ." He kept on kicking that stupid rock.

"Maybe is right. Don't you tell me. There's no way he had a heart attack."

That's when I knew I hated Jimmy. That I'd always hated him.

But it was true. My father had had a heart attack and was gone for weeks.

I am waiting when he returns, as I had waited for him to come home from his office on so many other days, watching the clock on the kitchen wall, flipping through an old Nancy Drew mystery I'd already read a bunch of times. Finally, he comes up the walk, past the dogwood tree he'd found in the woods two years before and had planted for me. He calls it our "Joycie tree." Bootsy, our dog, whom he loves almost as much as I do, runs to greet him, jumping high, her tail wagging into her whole body. He barely notices her. And as for me, well, he gives me a very small hug and heads for his bed. I see him climbing in as Mom closes the door.

Who has come back to us from the hospital is not my father, but his shell, fragile and empty, like a locust husk left on our oak tree in the summer. Mostly he just lies on his bed or the couch, following doctor's orders. Mom tells us he needs to rest and not do anything. And so, he just lies there, his arm covering his eyes.

That is when everything changes for me, and it changes for Judy, too. When she first left for the institution, we did not wholly abandon her. Every month, following country roads, we would drive to Columbus to see her. All the while, I would watch out of the back window as farms with cows and alfalfa fields passed by and disappeared in the distance, each new field bringing me closer to Judy. Mommy and Daddy would talk softly, their voices mingling with the radio as we drove along. I'd

think about how soon Judy and I would be together and happy again, at least for a little while. But that was before Daddy's heart attack. After that, he stops driving, not even to see Judy. He stops cooking, even his special chili dish that we all long for. He even lets the giant garden he loves so much just grow weeds and die.

After Daddy's heart attack, Judy is moved to Gallipolis, a place even further from Cincinnati, along the Ohio River all the way next to West Virginia, and we see her less and less. I overhear Mom on the phone with Millie, telling her that Judy's school has said they can't handle Judy anymore, that she bites other kids. I can't believe it. Judy biting other kids? It seems impossible. I think to myself, "Well, I'd just like to hear her side of the story." I ask Mom if we can at least telephone her in her new place, and she says, "Don't be ridiculous."

It's harder now because Mom doesn't like driving far without Daddy, and she always worries when she leaves him alone. So the first time I finally go to Gallipolis to see Judy, Mom stays home with Daddy, while my brother Wally, nine years older than Judy and I, drives me there. His girlfriend, Carol, comes with us. Carol reaches around and braids my hair, fastening it on top of my head so I can look special and surprise Judy. The drive takes hours, but it is fun. We play games and tell silly jokes. The next thing we know, we are beside the river, then we can see some big gates, and we are there. I thought this time it might be a smaller place, a nicer place for Judy, with some fun things for kids. When we get there, it's true, it is smaller, but it still seems too big, too dark and scary, and not all that different from the school she left in Columbus.

We find some swings two buildings down from Judy's, and we play there for a long time. Judy laughs while I push her knees, grab her feet, and push her backward, run under, and turn up on the other side. Then the two of us get on the swing, Judy sitting on me, legs over mine. Wally pushes us higher and higher as we squeal with delight.

On the way home, I think about the lady who had brought Judy to us as we waited in the hall. She held Judy's hand, helped her with her little blue sweater, and hugged her when she left. It seems to me she cared about Judy, just from the way she held her hand when they walked toward us. I noticed that when we walked outside, she was still watching Judy from the doorway and waved and then waved again. She never turned away.

I imagine that this lady lives there in that same building; maybe she sleeps downstairs behind the door next to our waiting room or there might even be a bed just outside where Judy sleeps. I give her a name, Cora. Cora is a nice name, a nice person's name. I imagine Cora has made Judy her special little girl, that she knows that Judy is funny and silly and kind, knows that Judy likes to save worms on the sidewalk when it rains, just like I do. She understands that Judy is smart, even if she can't talk yet, that she always knows if someone is sad, before any-one else does, and hugs them and pats their face. She might even push their nose in, just to make them laugh. I picture Cora tucking Judy in at night, as Kathy's mom does with me when I stay over. I can see her kiss Judy's cheek and hug her and I know Judy isn't so alone.

After that, every time we visit, Judy and I go to that same swing. It becomes our ritual. Even when it is a little rainy, it doesn't matter. It is something certain we can count on. At home, in the bed we had shared, waiting to fall asleep, I picture Judy on that swing. Except, in my mind, it is always Daddy pushing us the way he used to. We're laughing—Daddy, Judy, and me.

Later, when we come again to see Judy, just me and Mom this time, I squirm with excitement on the couch and fiddle with the books we've brought, waiting for Cora to bring Judy to us. I know Judy's hair will be brushed and pretty, with a little clip on one side. Judy bounces into the room, expecting us, but instead of Cora, there is an older, different lady—thin, pinched, and crabby looking—in a hurry to pass Judy on to us.

Somehow, after that, whenever I think of Judy at Gallipolis, I learn to erase the big rooms with the heavy, hot air, the bodies breathing in each other's sadness. I erase the hallway, dark and full of cold drafts, even when the doors are closed. I erase the rows of metal beds upstairs, all in a line, all tidy and empty, each with a typed name tag at the foot, placed near one neatly folded blanket.

Lonely without Judy, I find comfort in reading. I learn in fairy tales that no matter how horrible the circumstances, something magical can happen. A girl in a timeless sleep might awaken, a wicked witch can be locked away and the children she has captured set free. I wait for our special magic to happen, for Judy to leave that terrible place. But for me and Judy, the magic I wait for never comes. And so, in time, I switch from fairy tales to epitaphs—epitaphs for dead children. I had discovered them by accident in a big book in the library. I keep them hidden, folded and refolded into tiny pages, in my bedroom under my mattress.

So small, so sweet, so soon;

An angel visited the green earth, and took a flower away;

A sunbeam lent to us too briefly

I never knew that anyone else could understand the sadness I feel, but I can tell at once that the people who wrote these epitaphs felt the same as I do.

I keep some of the epitaphs on little pieces of paper in my pocket, with certain special pebbles. In my mind, the pebbles hold stories of me and Judy, and they keep her close. I start with just one pebble, the one from our sand yard that Judy and I always used to start our stone soup. After the stone, we added mulberries and grass and water, and then we stirred. I like to remember our soup. I add more pebbles and more memories, and I feel them in my pocket as I walk, one hand in my pocket, while my free hand runs along all the bushes the way Judy and I used to do. We knew how every bush felt, the prickly ones, the smooth.

I am almost ten now and in fifth grade. Judy has been gone for almost three years. I belong to a family, to a class, to a school, and yet I belong nowhere. My place of belonging remains with Judy and Judy is gone. We see her even less than before. Mom works, worries, and is always tired. Daddy looks sad, with a different kind of tiredness, and it seems as if he worries mostly about himself. I see him on the couch, checking his pulse over and over again.

I worry that Judy might be forgotten completely if I don't remember her. It doesn't seem as if my brothers think about her much. They don't say anything. Nobody does. More and more, it's as if she never was, except for me and the remembering I keep with the pebbles in my pocket that I can touch and hold whenever I want. Now, even loving Judy has changed; loving Judy and missing Judy feel almost like the same thing.

Why was Judy sent away to that terrible place? Why not me? I think about all that confusion after we were born; how they weren't expecting twins and couldn't think what to call us for a long time and then there was some kind of mix-up about our names. I knew the big baby had been named Joyce and had gone home first, but the big baby wasn't Joyce; it was Judy. I was the small baby who had stayed in the incubator in the hospital. Our parents laughed about the confusion, but I wondered. Judy had gone home. Was Judy, Joyce? Was I Judy? What if I was meant to be Judy and Judy, me? Judy would be Joyce and should be here walking to school. I should be Judy and locked away, far from everyone.

My sadness lives its own secret life and is fed by my epitaphs. The papers, worn and folded, have nothing to do with the rest of my life— not my parents, not my brothers, not my friends, not school, not the recreation center where I play fiercely at everything—gymnastics, swimming, and every kind of ballgame. My sadness is a secret; my epitaphs are a secret. Judy is a secret and who I am is a secret, even to myself.

One day at the kitchen table, I sneak bits from the graham cracker and icing plate. Mom says, "I want you to stop that, just stop it

right now. Whatever happened to the good Joyce we used to know? Where is she?" I then ask myself the same question. Where is the good Joyce? What happened to her? Is she with the good Judy or is she Judy, the Judy who is good? Who is here? Who is gone? Who remains behind?

After a while, when I give up all hope that Judy will ever come home, I stop wanting to save everything that belonged to us, stop wanting to keep our room the same for her. I take our dolls, every one of them—our old ones, our best ones, our dolls-of-the-world collection, even the ones with the old-fashioned shoes and buckles that Aunt Ivy had left us when she died—and I give them to the polio carnival we're having at school. They can go to other kids. They can help kids who have polio. I don't need them. I don't want them without Judy.

When Mom finds out, she's furious. I see her look around the room and spot the empty shelves and the doll beds with nothing in them. I know I am in trouble and take a breath and just wait. She glares at me. "I can't believe it. It's that school polio carnival asking for donations, isn't it? You've given them all away, every one of them. Now I'm sorry we ever gave them to you. It's just too much. And what about your Christmas doll? She was brand-new. Well, that's it! You've nothing left. I don't know what to do with you." She moves into the living room, and I follow close behind her, smoothing my hair down so she might think it looks nice.

She lands heavily on the stained sofa with its loosened wings, climbed on too often by too many children, and looks away, staring vacantly out the back window. I look, too. Outside are the rich greens of another Ohio summer, the ancient mulberry tree heavy with berries and the chatter of birds. But she doesn't seem to see the mulberry tree or the lawns where Judy and I had played. Doesn't seem to see the gardens

behind, now overgrown, or the sheep pastures beyond. Her eyes seem to look at nothing; she seems somewhere else.

Barefoot, thin, and restless, I edge toward the door, watching her closely as I go. "I didn't need them. Really, Mommy. It's better someone else have them."

. . .

It's already dark one evening in May when I come home late. Everyone else has almost finished eating. "Where've you been?" Mom asks. "You've missed your supper."

I mumble something about taking a nap, but actually I have no idea where I've been. I just know I feel sleepy. She tells me I've not been home all afternoon and stares hard at me. I sit down and she gives me a bowl of potato soup. I try to eat some but throw up again and again.

Worried, Mom sets out, asking all over the neighborhood if anyone saw me or knew what happened to me. No one knows. Then, a few doors down, little Kiki Gombrich is just going to bed. She whispers to her mother, head down, that we had been riding together and I crashed the bike. She says that she had tried to wake me many times, over and over, as I lay on the path, but then decided I must be dead. Without saying a word, she had gone home, leaving me for dead at the bottom of what we call Catholic Hill.

Dr. Cronin was called to examine me. I remember being carried on a stretcher and feeling frightened. I remember an ambulance, lights rushing by and the wail of a siren. Outside my hospital window, the city lies spread out below me. During those nights in the hospital, there are red lights on the three nearby radio towers that blink on and off all night long. As I lie watching them, I mostly think about Judy and how alone she is, how she must feel as I do.

Afterward, when I leave the hospital, my mind feels muddled and confused. I can't remember any of the things that were once so simple. I had been the living, moving phone book for my family, for numbers

of any kind. Now all those numbers lie in a jumbled pile inside my head. Running fast used to be easy, but now I stumble when I walk. And hardest of all, I no longer have a sense of what those around me mean or expect from me. I am quiet and try to listen more closely on the playground until kids stare at me like I'm someone strange and move away, leaving me by myself.

After a summer of bewilderment, of feeling a fog between me and the world, the nightmare of seventh grade begins. School was always easy for me, but now when I have to stand in front of the class giving a report, I have trouble thinking on my feet. I get confused easily, and I often feel embarrassed and humiliated. My hands shake. My voice shakes. I wonder if Judy feels the same sense of uncertainty.

Sometimes, it seems to me that I have become more like her, trapped in a body that no longer works effortlessly, with parts of my mind that don't connect to the outside world, a mind that feels different from everyone around me. Who am I anyway? The thin boundary that separates me from my sister, my twin, seems more porous. Everything takes me more time; I have to rest more often, and the voices of my parents seem hazy and distant, as if they are not nearby but echoes reaching me across a wide expanse of space. I dream of Judy more now that we are joined by our shared losses, and I want her with me more than ever. She has been gone for four years, and yet lying in my bed without her, it feels like yesterday.

. . .

As his world shrinks, my father clings to us. Positioned on his couch by the front door, he checks his pulse, waiting for and fearing the end, all the while watching us. Happy with neither our coming nor our going, he's no longer with us, yet he stands in our way. My life feels smothered by his watchful eye. With this new layer of uncertainty following my accident and my dad's heavy presence on the couch, the two of us struggle through the last years of his life, alienated from each other. My

father, desperate about his survival, is disappointed and frustrated by me. Disappointed when I leave the bottles of milk out in the sun all day, dismayed when I forget my books by a tree and never find them again, cross when I leave the new skirt I had just bought on the bus. An accountant who values order in life, he now has a daughter who leaves everything behind, breaking, losing, forgetting.

In preparation for my eighth-grade graduation party, I sign up for a dance class at the recreation center, hoping the Audrey Hepburn hiding inside my thirteen-year-old, still flat body will emerge one evening like a butterfly stirring from its chrysalis, to the wonder of all the tall gangly boys and all the short stubby ones, too. My father drags himself to that horrible eighth-grade graduation dance, where he sees me sitting awkwardly and alone at the end of the row of empty folding chairs. I am sure he knows what I already know—that just like Judy, I'm not like the other kids. Just like Judy, I am different and unacceptable. For the final dance, my father, who gets out of breath just walking from the couch to his bed, comes to me and reaches out a hand to dance.

The week after the dance, he is rushed to the hospital again, this time with a second heart attack. In the afternoon, we go to see him. He is in an oxygen tent and looks very gray, folds of gray where his face should be, gray to his fingertips. After several days, the doctors tell us he is getting better. This time, when we leave, I want to kiss him, but I am afraid of the oxygen tent he's in, and I don't.

That night, Mom allows me to spend the night at Kathy's. It had rained all afternoon, and as I walk to her house, the leaves stick to each other and to my shoes, the new black ones I bought for my eighth-grade graduation. Kathy's mom, Rene, is one of my favorite people. With Kathy and her brothers, we play cards late into the night, and in the morning, Rene tells me I need to go home for church. It seems strange. Why church? Why this Sunday? We hardly ever go to church. Rene seems to be staring at her keys on the corner of the old dining table that has the torn upholstery chair, instead of looking at me. It's not like her

to avoid looking at me. I find my sweater, toothbrush, and book, and start for home through the backyard, past the Schmidts' fence, past the bushes, past the mulberry tree, past the stone fireplace Daddy had built years before, and up the cement steps to the back door. As I pull the screen wide to enter, Dicky opens the door. Without looking at me, he announces in a flat, still voice, "Daddy's dead."

I hear someone screaming, but don't realize that it's me. I am running up the stairs to my room, when a dizzy darkness moves into my head. I am asleep, I am dreaming, dreaming that my father has died. Feeling sick and thinking to myself, "What a horrible dream," I open my eyes. I am lying at the bottom of the stairs, surrounded by faces full of sad eyes. My dream is real.

After Daddy dies, the neighbors come by with casseroles and cakes. As the house fills with food, it seems to me that eating would mean that his death doesn't really matter so much, that life will go on as usual, and I don't want that. I don't want to let go of him. So for days, I eat nothing.

At his funeral, I can't stop staring at his casket. He's gone, but to me, he seems only a bit more missing now, here in his casket, than he was during those four years of waiting on the couch, already living in a crumbling shell. In some ways, the casket doesn't seem all that different from his couch. I secretly study his face, how not him he seems to be. There are circles of pink makeup on his checks. His hair, still mostly dark, is combed back too straight from this mask he's wearing.

Carolyn stands with me, off to one side, both of us unnoticed. I hear someone whisper, "How will Lil manage?" Someone else says, "Such a shame, he was still such a young man." I am thinking, "Are they crazy? Fifty-two years old, a young man?"

Back home, I stay alone in my room; so does Jimmy. We keep our doors closed. Then one afternoon, I slip downstairs when everyone is gone and gaze for a long time at the kitchen table. All that food is still arriving, days later. I look at the chocolate cake covered with thick white icing, and finally, I take a bite. Just a bit, just a bite.

• • •

Not long after Daddy's death, Mom and I go to see Judy. I worry even more about Judy. Will she understand? What can she remember of him? What will she miss, now that he's gone? Does she save her memories like I do? Memories of when he held us, spun us about, one in each arm, or when he brought us those baby kittens when we were small. Maybe she has bigger memories, more memories, better ones. Has anyone told the people at the institution that her father died? How will they explain it to her? How can they?

As we drive hour after hour, saying nothing, I glance sideways and see Mom with tears sliding down her cheeks. Without looking toward me, she says, "How can I be left alone like this, and on top of that, I've still got your brother and you to raise, and you've got all these years in high school?" She seemed to be asking not me, but the sky, as the car bumped along the Ohio back roads. I'm thinking, "You're alone? What about me? Aren't I here? And what about Daddy? How alone is he?" I barely look at her, feeling a new layer of hatred growing, hatred as only a thirteen-year-old can hate.

Our visit with Judy is short. We stay less than an hour and only sit with Judy on the bench in front of her building. Judy and I take a short walk and pick up acorns, which we stuff in her pockets. Mom looks through her purse and finds a cookie to give Judy, one we had packed for the ride, then we walk her back inside and someone takes her by the arm to lead her away. Mom turns toward the door and motions to me to hurry.

• • •

High school begins badly and never gets much better. I start a week late because of my father's funeral. I'm not thinking straight, not even walking straight. I become the silent girl, dressed mostly in black, riding in the back of the bus. I feel like a shadow as I sit alone and blankly stare out the window. With Carolyn now gone to a private school and

Kathy to a Catholic one, I have no one who feels like a friend. Wearing glasses that I hate, thin, but never thin enough, I'm convinced I'm taking up too much space in the world. In the morning, I slowly eat a sliver of toast, then hurry to the bus stop. I carry my new books and binder clutched close. But closer still, I carry a grief for my father, a sense of belonging to him and to those who are gone. With his gone-ness surrounding me, I wrap myself in what remains of him, a ragged cloak of memories, wanting to warm myself, to keep every color and thread of him. But all I can remember are tiny fragments, torn threads; all I have left is a cloth full of holes.

I remember how when I was little, he carried a matching blue pen and pencil in his shirt pocket. When he picked me up, I could pull them out and taste them, then put them back. Next, Judy would do the same. And then we all laughed. I remember how he'd count the mosquitoes he'd swatted and lined up on the mantle, Judy pointing with him as he counted. But I want to stop remembering. I see other people's lives, which seem to me full of a lightness mine can never have. I would give anything to be one of them, almost any one of them, to have somebody else's life. It doesn't matter whose life, only not to be me, not to have mine.

Jimmy and I are both at Withrow High School, but he's a senior. I see him in the hall and pretend not to know him, and he does the same with me. I study the graffiti on the wall as he gets closer. Then, as we pass each other, neither of us speaks. He embarrasses me, and I'm sure I embarrass him. He is a James Dean type, hair slicked back, slouching through the halls. As soon as he can, he gets himself a motorcycle and looks even more like the tough guy he's not.

A year goes by, and I find myself longing to belong. I want to find a place for myself to fit in. I write for the yearbook, become a reporter for the newspaper, join every club, am elected vice president of the French Club—then never go back. I belong to the Dolphin Club, combining synchronized swimming and dance; I become secretary of GAA, our

girls' athletic club, an important position, but I hate it. Then I am proud and surprised to be chosen as a drum majorette for the football team, but almost immediately, I want to quit. I want to be somebody, to be recognized, but every time I am, I feel the embarrassment of being recognized as me. Better to be invisible.

Weeks go by. Months go by. There never seems to be a weekend that will work so Mom and I can visit Judy. Finally, a Sunday is chosen, but in the morning, Mom again decides we can't go as planned. I think of all the times our visits to Judy have been canceled, the endless reasons— bad weather or even the possibility of bad weather, trouble with the car or even the possibility of trouble, Mom not feeling well or about to feel not well. I decide that I can't not go.

I still don't think Judy even knows about Daddy or realizes he won't ever be coming to see her again. We never tried to tell her anything last time. But maybe she does know, in that special way she understands things. I want her to know. I want her not to know. But either way, I need to see Judy, need to feel her beside me, need to know that she's okay. Determined not to miss another visit, I call my brother Wally and Carol, now married. They understand my anxiety and sense the desperation in my voice. They change their Sunday schedule and suggest that all of us go together to see Judy in the morning.

While I sleep on their couch, waiting for morning to come, I can see the clock in the kitchen and I check it over and over. Then I hear Carol at the sink and the sound of the coffee maker. We bolt down our coffee, our corn flakes, and some jellied toast and set out. By the door is a little stack of things for Judy. Before going to bed, we found some magazines and a warm, brightly colored hat that had been Carol's.

The ride seems not so endless this time. We are cozy together in the car and talk without the usual long, miserable silences Mom and I share. From the back, I lean forward between the seats so I can hear every word, so I can be heard. We talk about Daddy, but just a bit. It's

hard to say much. Our family's way is not to talk, but with Wally and Carol, it feels different. We even laugh a little about how Daddy let Bootsy squeeze up on the couch beside him. The tension I feel when going with Mom is not there; what I recognize later as her ambivalence and her pain is not there, only an eager anticipation.

After we drive through the little town, there is still the long lane through the grounds to Judy's building. We sign in to see her; a secretary of sorts gives us papers, but no clues to Judy's well-being. No one seems to know who Judy is; she is only a name on a list of patients in Building K. Since we last came to see her, Judy's been moved again. The new building is smaller and has recently been painted, but inside, everything looks barely used. There is nothing for young people—nothing. I wonder where she sleeps and who sleeps beside her now? I wonder if they care for her a lot or not at all? What does Judy hold onto in this life of changing places and, even worse, endlessly changing faces? Does she find me in her dreams, where I find her?

We wait and are quiet. I look down and notice how Wally has polished his shoes for the visit. Then Judy is there, dressed up especially to see us in not just a dress, but also a little matching vest. She looks taller, but still small, bigger, but still tiny. She laughs to see us, throws her arms around me, both of us squeezing each other tight.

We bundle Judy into a coat and scarf, give her Carol's hat, her new hat, which she pulls over her forehead and down over her eyes, a joke especially for us. Then she puts the hat on my head, pulls it down over my face, and we all laugh. She takes it back again quickly, deftly, and we are off.

For once, we are not hurrying to leave. We are not looking at our watches every few minutes. At Frankie's Diner on the way into town, we have our lunch, Judy eating eagerly, smearing jam on her chicken sandwich, dipping every french fry into her pile of ketchup, squirting on more. We sit close beside each other, and I imagine this time never

ending, the closeness of her arm near mine, touching my arm as she reaches up to her plate. The smell of cleanness, the smell of goodness that surrounds her, the freshness of her skin, the sticky sweet ketchup on her fingers. I memorize it all.

After lunch, we drive down to the river. It is cold, and we hold tight to each other's hands. I pull Judy's hat down a bit more over her ears and turn up her collar. She does the same for me. The rushing water brings back memories of the Poohsticks we played together as children. I imagine we can relive those times again as we watch our sticks racing beneath the bridge, but the river is swollen and rushing fast. There is no way we can follow the sudden disappearance of the sticks, no way to track their loss.

4

A Thousand Miles Away

⁓

The years of high school, which began with my father's death, were colored by my grief and guilt, a sadness that came between me and the rest of the world, but upon graduation, I am determined that my new life will be different. Helped by grants and a scholarship, I enter Wittenberg, a small liberal arts college north of Cincinnati, just two hours and yet a lifetime away from my home. Beginning that first day, in my perky culottes and my one cashmere sweater, I wear a new personality as well—warm, friendly, and fun. Soon I have two close friends, both sophisticated, both from New York City, both involved in theater. I join them in singing songs from Broadway musicals as we work together in the cafeteria, mixing dance steps with pushing carts up and down the rows, collecting dirty dishes, wiping tables. They smoke. I smoke. They are self-assured, I am self-assured. But, most important, the three of us are locked in our own tight-knit circle. At last, I belong.

After doing well academically in my freshman year, I am recommended for a live-in position with a professor of history whose home

is on the edge of campus. She is away on sabbatical in Russia, but in time we will grow close and she will become "Aunt Margaret" to me. During those first few months, in return for room and board, I care for her elderly mother, fierce Grandma, in her nineties, bedridden and a little muddled much of the time, often confusing night and day. Each night, from nine until eight the next morning, I study or sleep near her door, responding to her needs and requests when she rings her silver bell. I have left my carefree freshman dorm days behind and am now responsible for another person's life. With each ring of her bell, I grow more attached. My love for Grandma and my desire to protect her grow with time and care. I've known and lived with these protective feelings since birth and for more than seven childhood years. This time, I promise myself, I won't let her slip away.

I try to fill the hole within, the one left by Judy's loss, by my father's death, and by the chasm of unexpressed grief that isolated us within our family. That void is eventually filled, at least in part, by my new friend Janet. Janet and I are both English majors in an advanced class, and we find ourselves drawn to each other, questioning life's meaning and our own purpose and place in the world. We share a life crisis and a pool of doubts, in which together we are struggling to stay afloat. We are drawn to Rilke, to T. S. Eliot, to Millay and Hopkins. I memorize the words of others who are outsiders. I can repeat them to Janet and to myself, wherever I am—walking to class, sitting beside Grandma, wandering through the nearby cemetery. Janet, who arrived at Wittenberg the year after me, feels alienated from college dorm life, just as I do now. With her curly hair and quiet beauty, she becomes much like a sister, almost a twin. With her I share the secret of Judy. It is Janet who knows that I am missing half of myself, that much of me has already been lost.

One weekend, I ask her to drive with me from Wittenberg to see Judy in Gallipolis. Janet is the only friend I would ever invite to see Judy, the only person I'm certain would respect Judy and understand our connection and our love. As we pack our provisions for the day,

I think about how this will be my first visit without either Wally and Carol or Mom, and it feels both strange and freeing to be going without them. I realize I've felt as though I had no right to be there without Mom controlling the visit and our time together. Janet's little VW pokes along the small roads, the narrow highways, past farms and rivers, all while we talk. We take turns reading from Dostoevsky's *The Brothers Karamazov* as one of us drives.

Janet bumps my leg as she moves the gearshift, and I excitedly poke her arm in return, saying, "Janet, Janet, listen to this."

Fathers and teachers, I ponder, "What is hell?" I maintain that it is the suffering of being unable to love. Once in infinite existence, immeasurable in time and space, a spiritual creature was given on his coming to earth the power of saying, "I am and I love." Once, only once, there was given him a moment of active living love, and for that was earthly life given him, and with it times and seasons. And that happy creature rejected the priceless gift, prized it and loved it not.

She pulls off the road and we grasp the book with four hands. We both are speechless for a moment. "Mark it!" Janet says. "We can put it in our notebooks as soon as we get home."

Reaching the winding drive and the dark, ominous administration building, we discover that Judy has been moved to yet another building on the grounds. At first, I think this could be good. After calling ahead, we find Judy already there waiting for us. She is smiling, beaming. So am I. Then, suddenly I am not. Where are her teeth? In horror, I see she has absolutely none, her lips sinking into her mouth, a caricature of an old woman. How can she have no teeth? Anguished, I demand an explanation from the attendant.

"Oh," she says casually, "it's hard for people here with cavities and all that. It's not easy, either for them or for the dentist, so it's quite

common that inmates get their teeth pulled as soon as the adult ones are settled in. She'll be much better off this way, you'll see, with no trips to the dentist, no problems at all. We just blend her food, or give her very soft things like bananas. It works out fine."

Horrified, I realize that there is absolutely nothing I can do now, but how I wish I could have had the power to stop them. From Judy, who has already lost everything, they've now taken even her teeth. Is there anything else they can take from her? Powerless, I return to Wittenberg. Janet drives; both of us stunned, we barely speak. Back at Aunt Margaret's, I close the door to my room and lie staring helplessly into the darkness.

Aunt Margaret, tall, formidable, and profoundly kind, returns as winter ends. I am drawn to her as though she is my spiritual mother. I find her to be everything I admire in a human being, everything I aspire to be: wise, principled, deeply thoughtful, and deeply caring; so different from my mother.

Week after week, I remain on call outside Grandma's room each night. But in April, when she has a stroke, I begin to develop an all-consuming fear that she might die while I'm sleeping. She can no longer ring her bell for me in the hours of darkness, and however close my bed is to her doorway, I worry that sleep will separate us and I will be unable to save her. I start imagining that her electric blanket might catch fire, she might have another stroke, anything could happen. I already know how someone can be lost while I sleep, and soon I stop sleeping altogether. I hover over her, stand watching as she sleeps without waking, knowing I can't protect her, can't keep her alive, and feel a sense of imminent loss. Soon, I stop going to classes, stop eating, cry when I'm spoken to, and lose all interest in life. I think continually of Judy imprisoned, of our father's early death, and now of Grandma, who could die at any time.

Aunt Margaret comes to me late one morning when I've once again remained in bed, not eating breakfast, not going to class, my face

turned to the wall. When she tries to talk with me, I begin crying. She asks me gently, arms around me and tears in her eyes, if I would like to talk with her doctor, who might be able to help. After the doctor's visit, Aunt Margaret is advised to call my mother, who comes to gather me up and bring home the broken self I've somehow become. In her yellow Pontiac, we drive to Cincinnati, first to a downtown psychiatrist who prescribes medication for what he calls my "breakdown." Heavily drugged, I find myself stored in the newly painted bedroom above the garage of my mother's new house, which she shares with her new husband, "Good Time Charlie." Two of the other bedrooms are for Mike and Charley Boy, my stepbrothers, all of us destined for the same short life together as a family. Set on a cul-de-sac, the house is lovely, its patio just off the kitchen with its double glass doors handy for evening drinks with their neighborhood friends. I shrink from the liquor and loud laughter, from the "Kissy Face" name Charlie uses for Mom. I keep quiet as their voices grow strident and ever more loud.

"Hey, Lil, get me a drink while you're in there."

"Get yourself a drink or just wait a while. You've had too many already."

"Ha, aren't you the one to talk!"

As the weeks slowly pass and the fog from my medication begins to lift, I write, I read, I take long walks alone through the nearby countryside and press leaves into my books as I did as a child. Janet and I find ways to call each other late at night, and we continue to share poetry. We write daily. I walk to my old neighborhood and look at the mulberry tree in the yard where Judy and I played. I slip into the yard and gather a few mulberries, squeezing them between my fingers, allowing the purple juice to run over my hand. Remembering.

Still heavily medicated, by late fall, I can function only numbly, in the world I'd walked away from. So many doors have closed. The college world I knew is gone. My scholarships are gone, the grants gone, too. With college no longer an option, I take a job in a department

store, Shillito's, in downtown Cincinnati, where, after written tests, I'm placed as a supervisor in the women's clothing department. Ironically, I can barely dress myself, care nothing for clothes, and am excruciatingly shy. I leave by bus each morning before daylight; the journey from Mt. Washington to downtown is long and tedious. Each evening, I return to my room above the garage. Wally helps me open my first bank account, and I carefully save every paycheck and hold tight my dream of returning to college, someday, somewhere.

On my days off, I often stay with Wally and Carol, who've moved to a new house just an hour from Cincinnati. That they have taken me to see Judy gives us an unspoken closeness. Carol cooks our meals with love and care: we eat solid Ohio fare, my favorites—meatloaf and Jell-O with pineapple chunks. I play with their little boys; I race to the park with Brian by my side and Phillip on my back. In the evenings, we drink pots of coffee and stay up late talking about the big questions in life.

Over time, and with our closeness, my feeling of despair begins to lift. Both understand my longing to return to my classes and realize Wittenberg is now an impossible dream, a private school with unaffordable tuition. But less than a half hour from their new home is Miami University in nearby Oxford. They suggest that I live with them. With their support, I return to school full-time, feeling relieved.

• • •

I first meet Mick while climbing the long steps to Chaucer class. Mick isn't strikingly handsome, but he has an easy way about him, a kind smile, and a bounce in his walk that draws me to him. His friendliness balances my shyness, and we begin to talk, draping ourselves over the plastic seats in the cafeteria, drinking Styrofoam cup after cup of weak coffee. We talk and keep on talking. We talk while walking, the two of us squeezed close under one umbrella, rain coming in sideways, our bodies damp around the edges. We talk sloshing through the days-old

snow, barely noticing our cold, wet feet. We can't stop talking. We discover that we share the same values and a common vision of wanting to help people without opportunities, those living in extreme poverty, both of us wanting our lives to have some larger meaning. We find that volunteering with the Peace Corps is a shared dream, nurtured long before we met.

Together, we are drawn to the civil rights movement burning around us. It is 1964, and Miami University lies in a region rife with racial prejudice and yet is the national training center for the support of black voter registration in the South. As we plan to head to Mississippi, our group gathers together in a huge, cold building. Outside, angry mobs hurl rocks and bottles, shouting abuse outside, "Nigger lovers. Get out! Go home!" With windows shattering around us, we draw closer and closer still. In that closeness, the sweat of our fear and the heat of our bodies mingle.

Day by day, we grow closer. Mick's old car carries us between our families' homes and college. On the back roads, it brushes past spring flowers and grasses, wind and sun, and the smell of new life. Mary Wells sings "My Guy" on the radio while we sway to the music, sitting so tight together that the two of us occupy one space.

I'm spending the summer back at Mom's, doing full-time babysitting for neighborhood families. And Mick and I are in love. The night after my brother Jimmy's June wedding, Mick sleeps on Mom's embossed cream-colored couch in the living room. He comes to my room in the night, pulls me to him and out onto the couch, onto the raised patterns, cushions cascading around us. Shadows appear through the window curtain from the one street lamp and the street's dead end. Kisses and closeness, touching, discovering each other. We are children ourselves and hardly know what we are doing.

Weeks later, I go with Mom and Charlie to Lake Erie for a long weekend and spend much of my time running to the side of the house, throwing up beside the cover-up sounds of the water faucet. And

I'm sleepy, very sleepy, very tired. Something is going on. I begin to worry about that night on the couch and our muddled attempt at birth control.

With the summer, the heat, and the unrelenting nausea, it's not long before I realize that I'm pregnant, but still I can't believe it. I don't tell anyone and I don't let myself think about it. I feel barely grown, still a child myself. I'm not ready to become an adult and a mother so suddenly. Instead of planning for a baby, I continue my plans to remain in school. I imagine myself taking classes with no one ever noticing my growing, changing shape. For now, only Mick knows. He says that he will marry me, but I can tell he'd rather not. Besides, he's already been accepted into the Peace Corps.

When I told him I'm pregnant, his immediate reply was, "This is going to kill my parents." I hated him for saying that. Hate him. He wants to leave for the Peace Corps right away, and now none of this shared dream will be possible for me. But still I know my plans to return to school can work; I can wear loose clothes, a large baggy coat, if I need to. Then, during spring break, I can have the baby, it can be adopted, and I'll go right back to school. I won't let myself get very big. I'll stay small. No one will ever know. Most of the time, I barely know myself. After almost four months, not one single person has noticed a thing.

Mick is picking me up in less than an hour to drive me to school, and my packed bags sit by the door. We've barely seen each other in the past few weeks. My closeness to him has faded, and the thought of his touch makes me cringe. I've avoided him, but it seems important that we have this time to talk before he leaves for the Peace Corps in Peru. We need to say good-bye.

I quietly close the door to my temporary room in this temporary home. This is my mother's home and her life, not mine. I don't belong here. I walk to the kitchen, dim with only a few rays of sunlight penetrating the closed curtains. Mindlessly, I open the fridge but find

nothing there. Instead, I leave the house with *Catcher in the Rye* under my arm. These words I can taste. They feed me and speak to me in a language I understand. The heat of the day is coming on; everything is still. The cicadas are singing in the trees, the last of the summer. I decide to walk around the block until Mick comes. I'm feeling anxious, and I have to be moving. I know I need to think, but my brain feels thick and sluggish. It's hard to think at all anymore. All I know is that my return to school has got to work out.

But as I walk, I begin to realize how impossible everything is. I stare past the neighbors' houses. I'm thinking I must have lost my mind to imagine I could go back to school. Of course, people will notice the difference, notice my changing shape, and they will whisper about me. Who I am will become this pregnancy, a cheap story for all time, my baby a matter for gossip and conjecture. I think of Nancy Percival in our senior year of high school, how she disappeared for a while. Everyone knew. Everyone talked. Everyone whispered. I imagine Dean Dietrich calling me in and asking questions, then telling me to leave. No, no . . . it's impossible, but then what? There is nowhere for me to go, yet my bags are packed. What can I do?

I pull off the pyracantha berries, remembering how Judy liked to stick them up her nose. I squeeze them between my fingers and drop them one by one, giving myself a trail to find my way home. I walk slower and slower, pulling at the bush's rough edges.

It's his car I hear first; without a muffler, it's louder than it should be. Now I see the faded blue, the dent from our trip to Coney Island last spring. He waves and slowly pulls over so I can climb in, leaning across the seat to open the door. I slide over beside him, the seat sticking to my bare legs. I slide closer, but not too close, not anymore. We smile sadly. Mick reaches out his hand to mine; it's moist. I remember loving his hands, imagining the lifetime of work we would do together, but not now. I wish I could love him still . . . yet it all seems so long ago.

Mick has turned off the engine and looks at me expectantly, his

hands pushing against the steering wheel. I turn part way toward him. "I can't go back to school. It's not going to work. I know everyone will notice and they'll ask me to leave, make me leave. I can't. I can't. I can't." I feel my eyes brim and try to push the tears back inside. He moves the hair out of my face and reaches over to pull me to him. "Of course, you don't have to. We can find a way."

"No, we can't, we can't. I can't." He pulls me closer to him, one arm reaching around me. I pull away. A fly lands on my arm, and I can't brush it away. I'm paralyzed. Mick swats the fly. It could be me; it is me. So easily, my life is over in an instant. We stare at each other in sadness. Then, with hesitation, he starts the engine. We begin driving slowly to the house, no car but Mom's in the drive. From the porch, I hear the sounds of Grampa and Uncle Clarence, who both live here, with their baseball game on the radio, cranked up all the way.

"I need to go in and tell Mom. I'll call you later, okay?" I see some pyracantha berries on the seat and brush them away. "I'm sorry. I'm so sorry about everything."

I jump out of the car before he can speak, give the door a hard push, and wave good-bye as I stumble toward the front door. I barely notice the packed bags still standing just inside and force myself to go straight to Mom's room, closing the door behind me. She glances up at me, eyes slightly narrowed, and continues putting her clothes neatly in the drawer. As always, her bed is perfectly made, slippers underneath and beside each other, just the ends showing. I see Charlie's shirts, now unused since his recent cancer diagnosis but still in the closet with hers, taking up just a bit of the space. Her closet stretches the length of the room.

I throw myself on the bed. I try to speak, begin sobbing, and cannot stop, cannot tell her, cannot stop sobbing. "What is it? What is it? For heaven's sake, what is it?" She reaches nervously for her cigarettes. I clutch the pillows. I want to reach for her, want her to reach for me.

Finally, my words come out in long, desperate syllables. "I, I, I am, um, am, um, pre pre preg preg . . . nnaann . . . t."

"What? How could you? I can't believe it!" Silence. "Well, never mind, if that's the way it is, then you'll just have to marry him."

"I can't marry him."

"You have to."

"I can't. I don't love him anymore. And, besides, he's leaving to live in Peru."

Silence again, except for my leftover sobs.

She breaks the silence at last. "Okay, then, that's it. We're gonna go see Wally and Carol. They'll talk some sense into you."

We drive along back roads, barely speaking, Mom's lips drawn into a thin line, scarcely visible. Then the stoplights of the city and four-lane traffic, children standing and waiting at the light, poverty breathing through their torn shirts, dirt and dust, bare feet. Through city streets and beyond to more back roads and finally the sloping driveway in Hamilton to Wally and Carol's new house in a new development with trees just beginning to grow in the sloping front lawns. They have neighbors like themselves, growing babies with their newly planted trees, time stretching before them like the long green lawns.

Wally greets us at the door, pulls us into the warm space of their lives, a row of cereal boxes just visible through the archway to the kitchen, the sound of their little boys, my nephews, playing together beyond. Mom lights another cigarette, then puts it down and speaks.

"Do you know what she's done to me?"

Pause.

Everyone waits.

"She's pregnant. And on top of that, she says she won't marry him!" She sinks back in her chair and begins to cry into her hands. Wally rushes to kneel in front of her chair and envelops her in his strong arms. I am watching, wishing he would hold me. I tell Wally what I have

already told Mom; I don't love him now and I can't marry him. Wally deliberately clears his throat, "Well, I don't think she should have to marry him if she doesn't want to. We'll think of something, some way to deal with this."

Within a day, it is decided. I will go to Florida. I'll be sent away, a thousand miles away to Aunt Dotty's. My twice-married, now widowed Aunt Dotty works in a small dress shop in Coral Gables. Since childhood I've heard how Dotty had made a mess of her life. I know the story well and am pretty sure Mom imagines me to be next in line for the small but growing string of family losers. Believing that it's important to create and display a life rich in dignity and success, Mom is proud of her homes and her husbands—the first a CPA, the second, a banker. So Aunt Dotty does not make it onto her list of people worthy of respect. There aren't many, and she herself resolutely tops the list.

The following day, Mom prepares two egg-salad sandwiches and some pickles for my trip. She knows I like pickles. She says good-bye with an awkward kiss to the air near my face and then rushes inside to catch the phone that is ringing. A friend drops me off at the Greyhound station and I board the bus with the same bags that had sat by the door, carefully packed for school.

Two long days and nights from Cincinnati, across the cornfields, pastures, and forests, through the mountains, to the tropical heat of Miami. The bus makes twenty stops or more, mostly in anonymous little towns, each time gathering more sad bodies. To me, each rider mirrors my own outcast state, my own misery and fear.

Here, in the less-than-unpretentious south end of Miami where the hired help lives, there has been an increase in Cuban and Latin American immigrants, something that concerns Aunt Dot quite a bit. Her house of yellowing cement blocks has one giant palm tree in the front that sets it off from the other empty, mostly untended, postage-stamp yards. I have a little room of my own, and we share the small, windowless bathroom. Every night at bedtime, I see Aunt Dotty poke her head

through the edge of the curtained front windows, just enough so she can see the street in front to check that her aging Dodge Dart is still in the driveway unharmed. In the daytime, with Dotty gone to work every day, I have little to do but feed her eleven stray cats and watch the giant cane toads finish off what the cats leave in the bowl on the back stoop.

I've been working ever since I started babysitting at eleven, and I want to be working now. Looking through the Miami paper, I find exactly what I want, a job working with emotionally disturbed little boys in a residential care facility where I can live as housemother. I apply and get the position. I will be gone five days a week, then back to Aunt Dotty's for two. Of course, the job can't last forever; they are bound to notice eventually. I am already wearing long tops and baggy dresses. But, for now, I have work, and my days have meaning.

I come to love these little lost boys, and my heart aches for them. All are grade-school age with severe behavior problems. People have given up on most of them, brought them here and abandoned them; they are living their lives without family. There is Cliffy, who thinks he is a butterfly and flits from room to room; JK, who never stops talking and whose rich parents dropped him off years ago and never once returned; this little guy Edwin, too shy, too afraid to speak. Then there is Jakey, who says only, "Kin ah haaave some pahh-napple juice?" and "Git arounn meh," which means "Cuddle me" in the heaviest of South Carolina accents. I would "git arounn" Jakey, my arms holding him close and think of Judy in her place of strangers.

One day, at my prenatal visit, my doctor gently asks if I would like him to help arrange an adoption. "Yes," I say, my arms holding my full, tight belly. He refers me to an attorney in Palm Beach, who tells me he can make certain that I have a choice of who will be my baby's new parents. This idea encourages me; I sit up in my chair, lean toward him, and explain that what matters to me is that the parents give this child a good education and a life that is culturally rich with the arts, with ideas, rich with the world I have discovered and love.

A few weeks later, the attorney asks me to come to his office. He tells me he has the perfect potential parents for my child. They live in a small town in New York State, where the father is a professor of literature. I sigh deeply. I want this for my child. I am relieved, almost pleased. I easily believe what the attorney tells me. My baby deserves so much more than the life I could provide. These parents can give it everything I could never hope to give. The attorney explains to me that, without my help, they will have no child. This woman is ready. She will know how to be a mother. Me? I have no idea.

Back at Aunt Dotty's, the phone is ringing. At first, I just stare at it, for it seldom rings. It continues ringing. Finally, I pick it up with some hesitation.

"Hello?"

It's my brother Dicky, who has no idea that I'm pregnant but thinks only that I have taken time off from college to earn some money. "How are you?" Without pausing to hear my reply, he goes on, "I'm calling about Mom. She had a rupture in her intestines and she's got something called peritonitis. They're not sure she's going to live."

"I'll come home. . . . I'll come, right now."

"No, don't. She said for you to wait. She doesn't want you to come yet. She doesn't feel well enough to see you."

A pause. Of course I understand why, even if he doesn't. Here I am seven months pregnant, except for Wally, a secret even to my brothers; to Charlie, her husband now dying of cancer; to Grampa and Uncle Clarence; and, of course, to all her bridge friends, all six clubs of them. Of course, I know. She's ashamed of me.

"If she may be dying, I should come," I say.

"Joyce, she said no. She was very, very definite about it. She wants you to stay there. I'll keep in touch with you."

I imagine myself showing up, and the shame killing her on the spot.

"Okay. You will call me soon, won't you?"

A few weeks later, the director of my children's program calls me

into his office. I'm headed into my eighth month of pregnancy, and without directly mentioning it, he makes his point clear.

"Joyce," he says, slightly hesitant, searching for words. "Joyce, you're doing a great job, but . . . well." Here he stands up and turns around to readjust the blinds, then sits back down and begins shifting in his chair. "I . . . well, I don't think it's a good idea for you to stay . . . to continue working here. It might not be good for you, you know what I mean?" He clears his throat. "Well, I think you understand."

I do understand. Reluctantly, I say good-bye to my lost little boys and return to Aunt Dotty's.

While I'm sitting on the back stoop, surrounded by anxious feral cats and indifferent toads, Dicky calls. I trip over a dying geranium in my rush to reach the phone. "Good news," he says. "Mom is recovering and she's going home tomorrow. She says for you not to worry, but not to call. She doesn't feel strong enough to talk on the phone." I feel an enormous relief in my shoulders and a terrible sorrow in my chest. We have not spoken since I left months ago, and it doesn't look as if we will be speaking even now. I feel myself a motherless child, one soon to be a childless mother.

Every day as I wait, I spend long hours walking on the beach, knowing there is not much time left for the baby and me. Then, one evening, just as I'm falling asleep, it happens. I lie awake all through the night, feeling the pull, the tightening tug of the being within me. I know this must be the beginning of saying good-bye.

The door opens quietly. Then a pause. Then Aunt Dotty's prematurely bent figure shuffles in. With her usual bewildered expression, she peers into the room and sees me holding a pillow against myself and breathing quickly.

"Are you all right? I mean, what is going on? Is this it? Is it?"

"I think we should go to the hospital soon. I've had these cramps since midnight. But I'm okay. I'm fine."

In Aunt Dotty's faded green car, we move across Miami through the

early morning and still quiet streets. Aunt Dotty is driving ever more erratically, rushing the red lights, hesitating at the green. This time I barely notice. Every few minutes, my urgent voice whispers, "Please, stop the car; you've got to stop the car. Stop, right now!" She pulls into an empty parking lot. I climb out quickly. Knowing nothing of Lamaze birthing techniques, I discover within myself ten million years of instinct and experience. Walking circles through the pain, moving, moving, moving with it and through it with circles, always circles.

Five more parking lots later, I am in the hospital, wrists tied, ankles tied, locked to cold metal bars, my comforting circling abruptly ended. Next, despite my pleading, they remove and take my glasses. I am unable to move and unable to see. Instead, I close my eyes that cannot see and concentrate on my breath and the growing force of life within me. Soon, I hear strange, powerful, unearthly sounds, a new voice that is my own. I feel a force moving through me, bearing down and through, an unknown, unimaginable force coming through me.

As I feel the intense burning of my baby's head crowning, the doctor rushes in and gives me an injection. I lose consciousness. Through a thousand quickly falling, heavy curtains, I hear my baby's first cry.

Waking to brightness, I ask the nurse, "Is my baby all right? I need to know if my baby is all right."

"Yes, your baby is fine."

"Is it a boy or a girl?" It would be easier to let go of a boy, someone separate from me, but a girl . . . a girl would be like giving myself away. No, even worse, it would be like giving Judy away, abandoning her again.

Silence.

"I need to know. Please—please."

Looking again at my chart, then holding it to her chest, hesitantly she says, "It's a girl. Seven pounds, seven ounces. She's fine, completely fine." My heart soars and sinks at the same time.

They come, pick me up and move me to a gurney, and roll me down

the hall to a room full of darkness, where all the shades are drawn. Heaved up onto the bed closest to the door, a bed with rough sheets and a thick pillow roll, I struggle to find comfort in the almost darkness, and then realize I am not alone. A form stirs in the shadows of another bed near the window.

"I'm sorry. I didn't realize you were there. You're awake, aren't you?" I ask. I think I see some slight movement, a turning of the head. An utterly flat voice replies, "I think so. I think so. I can't be sure."

"Have you just had a baby, too?"

"My baby is dead."

"Dead? I'm so sorry." I shift my body toward her, feel her misery mix with mine. An ache not physical moves through me.

"My baby is gone."

No response. She says nothing, never stirs. I wait. Then I stop waiting. We both lapse back into private silence and turn away. Our two distinct tragedies leave us lying beside each other in one small room, facing separate walls, unable to reach out or even begin to connect to the other in her loss. I wake in the night drenched with tears and blood and milk just beginning to flow. My sobs wrack my body as the birth had, except more painful in their emptiness.

It's barely morning. The attorney calls and, to my surprise, announces that the new parents have already arrived from New York, have seen the baby, and love her with all their hearts. He tells me they are so grateful and so very thankful. Learning that these new parents are Jewish, in my mind I name this baby Anna, after Anne Frank, long a heroine of mine. Ever after, I carry with me a picture of Anne Frank and a pressed flower from the beach at Coral Gables where I last walked with my Anna still a part of me, the afternoon before going into labor.

In my hospital bed, as the hours go by, I become restless and determined to see my baby before saying a last good-bye. No matter how many rules must be bent, I must see the one who has lived within me for nine months before she is gone. For months, at each visit, the

doctor had told me firmly and with great authority that it is best I not ask about "the baby." It is especially important, he says, that I not see it; it is "easier to forget what you've never known." As if sharing the same flesh and blood and the same body for nine months is not a most certain knowing. He assures me I will soon forget and go on with my life. The baby will have so much more than I can ever give. I can have more children someday, and I will be making the baby's new parents so very happy. All I need do is forget and move on. Of course, no one needs to know. Better for everyone, really, he says.

For the first day, I hold my intention in silence. Then, on day two, I ask the nurse if I can see my child. The answer is, "No, sorry. Doctor's orders." I ask a different nurse. Then I call my doctor's office and leave message after message. The following morning, when at last he returns my call, I speak calmly and promise to ask for nothing more. I just need to see the baby. After a long pause, with great reluctance, he agrees.

Into the wheelchair, down the elevator to the floor below. We stop in front of a room full of tiny bassinets. I wait at the glass window as the nursery attendant turns away and comes back with a tightly wrapped bundle. The little bundle stirs and stretches, eyes still closed, then eyes opening slightly. Here is my child! Small, delicate features, dark brown hair, tiny pink fingers, perfect in every way. I lean closer, to memorize every bit of her. Then I lose my sight as my eyes so flood with tears that everything blurs. Then, inside my chest, I feel my body turn to ice, feel the ice cracking and breaking everywhere inside me. A shattering of ice and chill water floods through me, out to my fingers, down to my toes, cold water and splinters of shattered ice everywhere.

From that moment on, I remember nothing. Somehow I am back at Aunt Dotty's. Now I feel an empty place inside me, more than the baby's exact space. There are other parts of me gone as well—my arms, they're missing for sure, my eyes are blind, and maybe my heart has gone with her. Inside me is an echo, with my own voice gone, only the echo remaining. I thought I had known emptiness, but those other

emptinesses had some color and some sense of light somewhere. This black emptiness is as big as the sky.

Wally and Carol arrive with their two little boys, making the long drive from Ohio to support me. Wally goes with me to the courthouse to sign the papers. We're both numb and miserable. He looks so deeply upset that his pain merges with mine. The attorney hands me the papers, watches me sign, removes the papers from my hands, and we leave. Years later, I see that paper and the signature. It looks like a child's signature, of someone still almost a child.

I have no idea where baby Anna is. Only that she is gone.

5

Without a Past

From Florida, I first fly to Cincinnati to see Mom, who is still recovering from peritonitis and is now grieving the death of her husband, Charlie, less than two years after their wedding.

Dicky picks me up at the airport, and Mom is at the door when I arrive. She kisses the air near my cheek and turns to my brother. "You might as well put her bags in that back room," she says. I stand, look around for some kind of support, and put my hand on the buffet near the door. I feel both terrified of facing her and completely numb at the same time. "For heaven's sake, Joyce, sit down somewhere," she says from the hallway. Once Dicky—who, like Jimmy, has no idea of my pregnancy or the baby—has left, Mom and I sit together at the table. Stirring her tea, carefully watching the sugar dissolve in her cup, she says, "Are you all right?" I move my bits of toast around and reply to my deep-blue plate, "Oh, me? Oh sure, I'm fine." Neither of us ever says anything more. She never asks if the baby is a boy or girl. Nothing. Like Judy, I have now become a shame and a secret, and baby Anna has

become one of the invisible, silent threads of disgrace woven into the tapestry of our lives. We have dinner with Grampa and Uncle Clarence, play a little "Kings in the Corner," and head to bed. I feel cold.

My classes start soon, and I'm desperate to leave this house. At Ohio State in Columbus, spring break is almost over. Mary, a close friend from Wittenberg, has started teaching there, and together we have planned to share an apartment. Although Wittenberg is now financially beyond reach and Miami holds too many painful memories, I've decided that I can finish school at OSU, work to support myself, and start rebuilding my life.

In the morning, I set off on the first Greyhound bus to Columbus. Mom seems relieved to drop me off and has packed a tuna-fish sandwich for the journey. A couple of hours and a lot of highways and cornfields later, I arrive at the station where Mary picks me up and hugs me tight. I panic. My breasts are rock hard and leaking into Wally's handkerchiefs, which I've stuffed inside my bra. How can she not notice? We head to our almost empty apartment near campus, where we will be sleeping on a mattress on the floor. Every night, in the midst of sleep, I wake sobbing and crying out. Mary begs me to tell her what's wrong. "It's nothing, nothing. It must be just some kind of nightmare," I say. After weeks of these nightmare outbursts, weeks of Mary begging me to tell her what's wrong, finally I weaken and get Mary to promise on the lives of all the children in the world that she will never repeat what I'm about to tell her. And so, I tell her about Anna. She holds me close and we cry together. We say nothing more.

I start my classes, more than a full load, and begin life once again, this time anonymously. From 3 to 11 p.m., I work as a ward clerk in the newborn nursery at University Hospital. My life is too full for me to ever think or feel. Just the way I want it.

A few months later, the telephone rings early one Friday morning as I am finishing a third mug of coffee. The voice, strong and direct, is one that I instantly recognize.

"Joyce, I want you to listen to me."

Catching my breath, I feel around for my papers, searching for something missing, I'm not sure what. Then I straighten my shoulders and push my empty coffee mug across the desk. It's Aunt Margaret from Wittenberg.

Somehow news of my situation has reached her—my guardian angel, wise, caring Aunt Margaret, who loves me in spite of myself. She has learned that I am at OSU and knows about my many classes and my full-time job.

"I know what you're trying to do and it's not possible. You cannot expect to do justice to your course work if you mix a heavy load of classes with full-time work. You risk damaging both your health and your future," she goes on.

I nod my head in silent agreement, wondering where this is leading.

Aunt Margaret continues, "I have already made arrangements for you to return to Wittenberg so you can complete your degree. If you will agree, I've also arranged a grant for you. You can live with me, so you will have no worries about having to support yourself. You can focus solely on your education."

There is no way for her to see my eyes fill with tears of gratitude.

Aunt Margaret's continuing belief in me sows the seed of belief in myself. Strengthened by her friendship, guided by her example, and sustained by her support, I return to Wittenberg, determined that my life will have direction and purpose. I hope that I might one day be in a position to emulate her immense capacity for kindness.

Adding an extra semester, I switch my major from English to psychology. I imagine that by combining psychology and teaching, I might somehow obtain a key to unlock and free children who are imprisoned by the tragedies of their births, their families, or their pasts—that I will have a way to save them and set them free. The truth is, I imagine myself as a kind of girl Catcher in the Rye.

In a year's time, with my degree finished, I say good-bye to Aunt

Margaret and return to Columbus. For the first time ever, I live by myself. I am by myself, but never alone. Judy, though hidden, remains completely woven into the fabric of my being—entwined with threads both bright and invisible, connecting me to her and to all we've shared, all we've been and are to each other. I carry my past, my secrets, with me everywhere.

On the wall above my bed, a large print of Picasso's nursing mother hangs as a constant but unconscious connection to all I've so recently been given and so recently had taken away. Always in my wallet is the small picture of Anne Frank, my symbol of Anna, and the tiny pressed flower I gathered on the beach that last day.

• • •

On a humid afternoon in July, I interview with the principal at Glenwood School, housed by strange coincidence at the very same institution where Judy had been sent years before. Facing him and his immense smile across the desk of his cluttered office bursting with children's drawings, I find that my decision is an easy one. I will accept any teaching assignment, just as long as it's here.

I am to teach troubled fourth- to sixth-grade children. They are mostly boys, many institutionalized. The resident children at Glenwood occupy the same tall, dark buildings where Judy had lived. I think about how one of them may even sleep in the same bed where she once slept. Each day, I wind my way through the old institution buildings, past the casement windows and the dark red brick walls, all the way to the Glenwood School grounds. I see the massive dark doors and remember myself as a child pushing their weight and heaviness inward to reach Judy. As I drive, I can feel the ghost of Judy's childhood surrounding me. The lives of these children are not much different from what hers had been, except that I am determined that they will have a chance to open their locked doors through love and through learning.

In the early mornings, balancing a coffee cup in one hand, I pull off the freeway and enter the institution grounds, continuing on to our tucked-away world. Then, late in the day, I retrace my route, winding past the buildings and their late afternoon shadows. I gradually begin to feel stronger, not gripped and helpless as Judy had been—as I had been. New pictures begin to join with the scorched memories of waiting with my parents to see Judy's small, sweet self; with the pictures of Judy feeling the grass beside me; of us on the swings and of her tears when we would leave. The institution comes to feel like the place where I teach, where we read *The Hobbit* just before lunch. Here Matthew tries to skate in dirt, and forever-bouncing Stevie explains to us what his parents told him about sex, singing his words like a bird's song in the midst of the other boys' sneers. I can see Tyrone as he slicks back his hair, and Eddie, who broke my heart when he stole all the money from my wallet. There's much that can't be fixed: Malachi's disturbed mother phoning over and over again to tell me her son was born of Satan and is now the devil himself.

The children become my life. I never stop being with them, never want to stop. On Saturdays, I pick them up and we pile into my old powder-blue VW convertible and explore the back roads of Columbus, the parks and farms nearby. On other weekends, I bring them, one at a time, to my little row house with its narrow kitchen, where we cook, bake, and play chess together. I'm not made with boundaries.

One day, when phoning Mom, I mention to her what I'm doing and how rewarding it feels. "Why would you want to help those people?" she questions. "They're strangers. You should be helping your own mother."

As the year slips by, I begin to think less often of baby Anna and Judy, and more of the children who surround my desk and come to occupy my heart. Only in the night, as I near sleep, I feel myself pulled toward Judy and Anna, the two hidden and missing parts of myself.

Three evenings a week, I work at Children's Mental Health Clinic as

a therapist, holding one-on-one sessions with kids who have emotional or learning difficulties. This is the kind of work I've dreamed of—helping children, offering them a hand to hold and a way up. I love it. To my surprise, I soon have a private office with my nameplate on the door, and a playroom with a one-way mirror for therapy observations. Only a year out of college, I feel proud and full of possibilities. I begin to feel that Aunt Margaret's belief in me is maybe justified.

One weekend, I pack up some playing cards and a few little treats for Judy and me and make the long drive to Gallipolis. Judy and I fall into each other's arms, overjoyed to be together. It's been ages since we've seen each other. It's too cold to do much walking outside, so we head for our usual diner. The orange scarf that Judy wraps twice around her neck contrasts strongly with her pink sweater, but she is more interested in devouring a hamburger and fries, liberally covered in ketchup, than in sartorial elegance. I cut the hamburger into tiny pieces for her and watch her every bite: every bite, however small, is a worry, now that she has no teeth.

Afterward, in the car, we play with the cards on our laps, just the two of us, spilling, laughing, stealing each other's cards, laughing some more, all the while nudging one another with knowing looks. When it's time for her to go in, she hesitates and I hesitate. A sadness begins to fill the car, but I quickly collect the cards and wrap them together in a wide rubber band, place them in her eager hands, and she puts them carefully into her pink purse. We force ourselves to open the doors and walk back together hand in hand.

• • •

At Children's Mental Health Center, I meet Michael, a PhD intern, and share what is to me a marriage of best friends. We live together and share our lives, until he is sent to establish a clinic in Nevada as an alternative to service in Vietnam. I spend months weeping, but when the school year ends, I go west to find him. When I find him, nothing

has changed. The love is still there, along with the uncertainty of commitment. So I head on to California, hoping for the healing magic I imagine since the recent "Summer of Love."

Reaching California, I drive from San Francisco down to San Diego, exploring the coast, stopping in towns, visiting schools along the way, imagining myself teaching in each. After San Diego, I turn around, driving north again, searching through all that sunshine for the place that might become my home.

I find a teaching job in the Bay Area at an inner-city school in Richmond and settle in Berkeley, sharing a big, old brown-shingle house with several other young women, all of us feeling our way, as if by Braille, into adulthood. I keep myself busy and engaged. I now belong to a new, exciting world far from Cincinnati, far from Columbus, but not so far from Judy that I can't see her a couple of times a year.

Here in Berkeley, I can pretend to be someone without a past, a past punctuated with loss. Here I can pretend to be simply the person I appear to be, not the person who is also Judy, not the person who is always a part of Judy, always with Judy. Not a sister without her twin and not the person secretly a mother, a mother without a child.

One night, while the house sleeps, the phone rings. I've learned not to bother with late-night sounds—the front door banging at all hours, the trucks on Telegraph Avenue, students drinking and shouting across the street. Instead, I pull the covers over my head. But the call is for me.

It's Dicky with very bad news. I fly immediately to Cincinnati where my brother Wally is in critical condition from an error during routine surgery. But he is gone by the time I arrive.

Grieving after Wally's tragic death, I return to Berkeley. Vulnerable and desperate, I long to create a home, to be a mother and have a family. I fall into an unwise marriage with a deceptively charming, much older man with two young children in need of a mother, and I a mother in need of a child. This fantasy family soon disintegrates.

I find it impossible to ignore or to tolerate his absences and involvement with other women.

Yet, from the ashes of this ill-fated, short-lived marriage comes the gift of a beautiful daughter. In those wonderful hours together after her birth, I stare and stare, expecting to find Anna in her. But, fortunately, she is different in every possible way, sturdy where Anna was delicate, bald while Anna had a head full of dark hair. There is no room for confusion. Lilia is herself and I love her.

Flying back to Ohio to introduce Mom to her new granddaughter—her namesake—I feel the cold that has settled into the house as soon as I arrive. Since Wally's death, following so soon on that of her husband Charlie's, she plays more bridge, buys more antiques, and sets down more rules for Grampa and Uncle Clarence, who mostly keep to their rooms or, when the weather permits, listen to the ballgame on the screened porch.

With Lilia on my knee, I watch Mom closely, but I can't tell how she feels about her; her face is a mask to me. We arrange to visit Judy three days after my arrival. So many times in the past, Mom has found reasons for not going. I'm worried and I nervously busy myself passing Lilia pieces of banana and tearing up my napkin at the dinner table. We eat early, go to bed early. My sleep is restless and broken. The morning of our trip, Lilia and I are all dressed and ready. From the hallway, I can see Mom in her bathrobe and slippers in the kitchen. She is on the phone and has done nothing to get ready. She's talking to Millie, a cup of coffee in one hand and doodling with the other as she makes arrangements for a bridge game that afternoon.

I interrupt. "Wait, Mom, what's going on? What are you saying? Today's the day we see Judy."

"Just a minute, Joyce. I know you can see I'm on the phone. Darn it! Millie, I'll have to call you back."

She turns toward me, her eyes angry and distant.

"It's not going to work out for today. For heaven's sake, Joyce, just

look out the window at the weather and that sky. We can't go anywhere when it might storm. There's no way I'm driving in this bad weather."

"Mom, it's okay, I can drive. I drive all the time. I've driven across the country by myself. The drive to Judy's is nothing for me. I'll drive. Really. You don't have to worry."

"I've already made my decision, Joyce, and I don't want you arguing with me. I just won't have it. I'm not going to make myself a nervous wreck with that drive. You can see her the next time you come."

"Mom, I really, really want to go today. It's important to me. I've wanted her to meet Lilia. It's not like I can go again next week." I can feel tears inside, wanting to fall.

"I'm sorry, Joyce. I can't control the weather. There's no point in risking our lives driving on the highway in a storm. Anyway, you know she has no idea you were planning to come. She probably hardly remembers us. I doubt our visit would mean anything to her." She bangs some dishes down beside the sink. "You know how retarded she is—they've explained that to us. She's fine there with her own kind of people. It would just interrupt her life to have us barging in and then leaving." She gives me one of her dark looks. Speechless, I swoop up Lilia and leave the room just ahead of my tears.

• • •

Three single mothers, three babies, a Vietnam vet, and a go-go dancer working her way through college: we are all sharing our babies, our house, and nightly dinners. Here in Berkeley, we don't think of ourselves as a hippie commune, but I suppose some might. Leaving the disappointing past behind, Lilia and I find our new home here and a sense of safety and belonging.

Many months and many meals later, I feel myself inexorably pulled again toward Judy. This time, with our camper, Lilia and I can see Judy, whatever Mom might decide. I set off with Lilia, adventuring across the western states, camping and bicycling through national parks and

then onward until we reach Ohio and Judy. Weeks later, Lilia is almost two when we arrive at the institution. Judy is surprised to see her and finds her a bit of a mystery. Lilia seems to recognize that Judy is different from the other grown-ups she's known, and she senses that she has something they lack.

Judy takes Lilia's little face in her hands and looks deep in her eyes. Then she reaches her arms out to hold her. I want her to sit down first; Lilia's quite heavy, and Judy's very small. So they sit, Judy talking to Lilia in Judy-speak, Lilia listening and then pointing to the dog going by. "Doggie!" she squeals. Judy nods and says, "Ho, ho, bah," and nods again. Lilia squirms out of her arms and runs halfway to the big dog, turns and runs back again. Judy welcomes her, arms wide. It brings tears to my eyes to see what they have together and, also, what Judy can never have. Yet maybe her happiness in this moment is enough.

When Lilia and I return to Berkeley, we discover our friends have moved on and we no longer have the home we once shared. However, after a month of friends' couches, a teacher friend finds us a tiny cottage with an even tinier yard that backs up to the fire department in North Oakland. I can hear the firemen playing basketball when I leave the kitchen door open to catch the breeze. Their voices bring back the feeling of big brothers around me, a sense of comfort and security. At night, as I lie in bed with Lilia snuggled beside me, I think of Judy in her bed alone. I think always of the smallness of Judy's world, yet I know bitterness is not included in her repertoire of feelings. Sadness, yes, and loneliness must be woven into the rough blanket that covers her.

• • •

The year Judy and I turn thirty, we are apart once again. Friends have organized a party, and the house rocks with Gloria Gaynor and "I Will Survive," played over and over. I picture Judy at the institution and wonder if they celebrate her birthday. Or do they forget? Does someone get her balloons and a cake? I want to think so.

I think back to our birthdays in Cincinnati when we were little. There were no balloons, no party, no birthday songs. No one came to dinner. Never a birthday cake. It was just another day. Then I turn away and push my old resentment of our mother into the drawer as I pull out the silverware. I reach back through time toward Judy and find a memory waiting—graham crackers with icing as we sat at our little table. Judy gave me hers and I gave her mine. I guess we could think of that as a party, a party of our own.

When I begin working at the Infant Project, a center for mothers who have babies with disabilities, I feel that I've at last found my calling. An important part of my job is to give support to these new mothers and the path on which they have unexpectedly found themselves. I am well aware that the situation is so different from my mother's experience and what she had to face alone—the lack of support, the baseless assumption that Judy's differences were bad and the result of something my mother had done wrong. I begin to understand so much more of Mom's isolation, her sadness, her sense of guilt and fear of being judged. Her situation must have been overwhelming.

For the mothers at the Infant Project, my presence can make a difference. Besides home visits, we have twice-weekly mother-baby groups where we provide activities and developmental suggestions for the mothers and a time in which they can connect with each other.

One mother is Elizabeth, a successful professional with a handsome husband, a beautiful house in the hills, and expensive cars, who enjoys the finest clothes, restaurants, and vacations. On my first visit to her home, I meet Jennifer, her new daughter who has been born with Down syndrome. Jennifer's birth, sudden and swift, happened at home. Only later did Elizabeth learn that her child had Down syndrome. She now finds herself thrown from the well-managed, luxurious life she was living into an unexpected, more challenging one. At first, Elizabeth seems numb and unable to respond—staring at a vacant spot in the distance, not unlike my mother as I remember her.

On my first visit, Elizabeth is in high heels and perfect makeup, although it is ten in the morning and she is the mother of a two-year-old and a new baby. The baby, Jennifer, is in a cradle off to the side in the living room. At first, Elizabeth doesn't even introduce me to her baby. She seems to have forgotten why I am here.

Finally, with some encouragement, she goes with me to the cradle. I wait for her to pick up the baby, but Elizabeth holds back, wanting me to be the one to pick her up. Curious to see how she will relate to the baby in her arms, I wait some more. Jennifer is asleep on her tummy and dressed all in pink, even the little bow she wears. Elizabeth finally reaches down and holds her, but with arms straight out, far from her body. Only after many weeks of much needed support and encouragement does she begin to bring the baby close to her body. My first huge success is getting her to hold Jennifer face-to-face and make eye contact. My heart melts when Jennifer gives her mom a shy smile and Elizabeth responds. The connection has begun.

Over time, through meetings with other mothers, our weekly visits, and some inner transformation, Elizabeth comes to love Jennifer deeply. And with her love for this gorgeous, unexpected child, her heart expands. By the time Jennifer is three years old, Elizabeth becomes a leader in the local Down syndrome group. She becomes a volunteer, going to the local hospitals and spending time with new parents who have just found out that they, too, have been blessed with a child with Down syndrome. When we talk years later, she tells me that her life had been transformed, that what she cared about before Jennifer was born had fallen away, much of it had lost its value, and that she now lives on a deeper, more meaningful, and intensely satisfying level.

It is with the mothers who have children with Down syndrome that I feel the strongest connection. Almost always, I tell them the story of my sister and her institutionalization and how, because of the prejudices of the times, our family lost almost a whole lifetime together that should have been ours. With these mothers, I share both

this sadness and our happiness in the new possibilities for their babies and the educational opportunities and inclusion that are now available to them and their families. Together, we believe that these children will have a chance to realize their potential and that, as parents, they will be advocates for them and fight prejudice wherever it exists. We are full of hope.

My work with the Infant Project involves ongoing training through Children's Hospital Oakland. For two years, I and everyone else admire Dr. Richard Umansky, who heads the clinic where I receive training. We watch his heartbreaking kindness and intense blue eyes as he interacts with mothers and their babies. We hang on his words, discuss every idea he voices, and even notice how his shoes are worn around the edges. I take notes as he talks and do my best to think of something interesting to say. When he looks my way, I look down. When he looks elsewhere, I study him closely and wonder what he thinks about besides these children. When he's home and alone, what does he do? I picture him reading poetry and taking long walks.

He gives a party for Infant Project staff at his house high in the Berkeley Hills on Panoramic Way. Lilia, who is always with me, has fallen asleep on his bed, surrounded by storybooks. I go to check on her sleeping self and find him standing there in the doorway gazing at her. Lilia hasn't had a word from her own father for almost four years, and here I find Richard with tears in his eyes at the sight of Lilia's sleeping sweetness. I decide that I'm certain of what I already almost knew. I am in love with him. Later, with a sky full of stars, he walks us to our car. He calls the next evening to invite me to dinner. I grab Lilia and swing her around the room, dancing to some music I've just begun to hear.

Richard and I soon marry, and in my heart, I celebrate that it is through Judy that our worlds have become joined. When I find that I am pregnant, I am surrounded by babies with difficulties and almost expect to face challenges with our child. It seems just as likely as not.

However, our baby is well, but it will soon become clear that her father and I have disabilities and limitations in our capacity to understand, love, and support each other. Instead of having more children, I raise goats and chickens in the backyard and, with my friends, start Birth-Ways, which over time becomes a thriving Bay Area nonprofit organization supporting women during pregnancy and birth.

Richard works long hours. After we finish dinner, regardless of frustrations at work and our disintegrating relationship, every night he reads bedtime stories to Lilia and Ilana. Then he returns to his study. I'm pursuing a graduate degree in child development on weekends and continuing my lay midwifery program. Although we are both dedicated parents, we begin to live parallel but separate lives.

After more than a year, at last I take Ilana and Lilia back to Ohio so that Mom can meet Ilana and so all of us can see Judy. Judy is instantly attracted to Ilana and never wants to stop holding her and kissing her fat cheeks. Ilana laughs every time. Judy slips her onto her own lap. For this moment, this baby is hers. Then we walk around the grounds, very slowly. Lilia collects some hidden flowers and gives them to Judy. Mom looks at her watch.

Back home with Richard, our relationship continues to spiral downward. Between us, there exists no closeness. My closeness is growing elsewhere—with the girls, my work, my friends. Outside, nothing grows but our goats and chickens, nothing green and grassy anywhere. Inside and outside, separated by occasional temporary truces, only the battlefield grows.

For over a year, desperate to leave, I have been secretly searching for a sanctuary and eventually find an apartment, becoming a single mother once more. I support myself with a patchwork of jobs, including hospice work, birthing, and home visits with new mothers, especially those with children with disabilities. Recognizing that my work would be more effective if I had medical skills, I enroll in nursing school. After three concentrated years of training, I study for my nurs-

ing exams in afternoon intensives with my friends. I take early morning walks with index cards, down by the Berkeley Marina, although I find myself thinking more about Judy and about baby Anna than oncology treatments or the physiology of the kidneys.

Anxious to see Judy, I return east and am determined to see her, even if Mom protests. This time I will not accept any last-minute cancellations and contrived excuses. No longer will I silently bow to her old, crushing dinnertime mantra—"Nobody cares what you think." When the time comes, we do go. The weather is gray and drizzly, and the drive is long, but none of that matters. We're here. As we get out of the car, I see Mom already looking at her watch—the gold one Charlie gave her when they married.

As we enter the building, a wave of warm, stale air and a smell of unbrushed teeth hit us. How can a building smell of unbrushed teeth when so many people living here have none?

Then, here is Judy, looking a little smaller and a good bit thinner. They keep her on a strict diet now. She is all dressed up with a headband holding her fine, delicate hair. Mom immediately pulls out a hankie from her purse and gives Judy's mouth a fierce wipe, although it's perfectly clean, just terribly chapped and close to bleeding. Vaseline! Why didn't I think to bring Vaseline from home? I have brought her two magazines—*Better Homes & Gardens* and *Good Housekeeping*, both a couple of years old. Mom objects: "I bet someone takes them away from her. What's the point? They give her what she needs. It's not our job." I keep quiet and check for something indefinable lost inside my bag. Judy is thrilled with the magazines and after scanning them, clutches them to her chest. There's no way they will be going anywhere. She reaches out with her free hand, pats my cheek, gives my nose a small push like she used to, and then leads us to the door.

The lady in charge tells us Judy is learning to load the dishwasher and already helps wipe down the tables. One day, she says, she will learn to wash her own hair. I feel so sad that she's never had a chance to learn

anything or even been taught to talk. It seems to me they're using her as a free worker, and I'm definitely not pleased with the situation, but at least she's not just sitting, as many of the other patients are. I still hope she might learn to speak a few words, and I feel certain she would enjoy some music and art, if only she'd have a chance.

6

Among the Redwoods

On bright mornings, when a fresh breeze is sweeping in from the Pacific through the Golden Gate and across San Francisco Bay, Ilana and I head down to the shore with our kites. Here, at the Berkeley Marina, we race the wind with our yellow Lab, Dustin, loping beside us. As the wind snatches our kites, driving them skyward, I think of them as metaphors for our hopes, soaring higher and higher on the wind. On other mornings, I head to the café for my latte to enjoy the half hour of the day that is mine alone.

This morning I am lost in thought as I drive down the deserted streets of Berkeley at dawn. It's Anna's sixteenth birthday, and tonight I will light a candle, as I have done every year. I will make the same birthday wishes for her—that she be well, that she be happy—and that we might one day find each other. Passing the main post office on Allston Way, I notice a single, forlorn figure sitting alone on the great expanse of wide, white steps. She is about sixteen, with dark hair and dark eyes. She has a worn green backpack beside her and looks lost. I slow down

to get a closer look. Could it be her? With my heart racing, I circle the block and approach the post office again. Dustin scoots in closer beside me, puts her face in mine, and gives me a wet lick. I wipe my face and give her head an impatient shove. It takes me no time to decide my next move. I will park, walk up the steps, and then ask if I can sit down with her. We will begin a conversation, something very general, of course. I won't mention anything right away. I picture us having breakfast together at the Homemade Café, our discussion deepening.

As I pull up in front of the post office, I get out and look anxiously up and down the steps. There is no one there. I turn in every direction, walk to the corners of the building, scanning. She's not there. Back in the car, I begin circling in ever-widening blocks. There is no one.

• • •

Through my work with pregnant mothers at BirthWays, I learn about the Post-Adoption Center for Education and Research (PACER) and soon arrange to volunteer there as a phone counselor. While counseling others, I discover that there are groups offering support to adult adoptees and birth parents. In particular, I learn of the Adoptees' Liberty Movement Association (also known as ALMA), a national organization whose purpose is to help connect adult children and their birth parents, something enormously difficult since all records are sealed and all files are secret. I call ALMA and find that the next meeting of the local chapter will be held in a church basement in Oakland.

When I arrive at the meeting, a woman at the door welcomes me and asks me to find a seat. On one side of the room sit women whose faces look haunted; I realize that these must be the birth mothers. Those on the other side have fresh, young faces—these are the adoptees, flowers that have lost their roots. I find a chair at the end of the sad row of parents and start to imagine that I'm feeling the pain of the woman beside me. Here, next to me, sits the first woman I've ever known who

has lost her child in the same way I have. I want to ask her so many questions. Instead, I stare at my handout.

The woman who welcomed me at the door wears an attractive blue suit and stands tall and straight. She comes to the front of the room and talks about ALMA, explaining what to expect if we decide to search. It may be easy, but more likely it will be difficult, she says. None of us know what kind of reaction we will receive. Regardless, she says, it will be worth the effort. She talks to the adoptees about how they have a right to know about their medical background and their cultural heritage. She explains that a search to locate either a birth parent or a child who has been given up for adoption usually takes about six months. I'm adding up the number of months on the margins of my paper, but I already know all these months that lie like mountain ranges before me. I'm thinking that I will give myself plenty of extra time, just in case. By eighteen, Anna will be an adult and, I hope, away from her childhood home and in college. But I don't much care what she's doing. What I need to know is that she is alive, that she is well.

After the talk, we introduce ourselves by our first names and explain why we are here. For the first time ever, I hear women say that they are birth mothers, and most are not hanging their heads. They speak without shame. Suddenly it's my turn: "My name is Joyce and I'm a birth mother." I've said it! My face is flushed and I can hardly breathe, but it's out in the light. Who I am is not a secret any longer. My daughter is not a secret.

From this gathering, I learn of the monthly search education meetings, specifically for birth mothers seeking their lost children. I'm determined to go. I leave the meeting exhilarated, my mind bursting with information, all of it related to direct action. I am absolutely ready to act. At home, I've almost forgotten about dinner, rushing to write a letter to the hospital and another to the courthouse in Miami. I prepare the letters quickly but with care, including all the information I can re-

call. All of it was burned into my memory long ago, the date, the time, the exact moment of her birth, her weight, her height—everything that might be needed to find her.

Mission complete. Carefully, I place the first photocopies into my new black binder, confident that these letters will succeed.

• • •

I feel ready to tell my daughters and my closest friends about Anna. I want her to be real to them, like Judy. I want them to know about their sister, this missing part of our family. I also know that Mom is not going to be ready for me to tell the Ohio family, but that can wait.

Ilana and I are driving through traffic on Oxford Street. It's already dark outside. Inside the car, it feels cozy; it feels like the right moment. Ilana is eight years old. When I tell her about Anna, she says, her troubled brown eyes studying my face in the passing lights, "Mommy, how could you give away your own baby?"

"I don't know, honey. . . . I really don't know. I've asked myself that every day. I wish I hadn't, but things were very different back then. I felt I had no choice."

We're at the dinner table when I tell Lilia. I've made us some mint tea, and she's made chocolate chip cookies. I tell her I have a secret and a surprise to share with her. I had hoped she would be happy and excited, but she seems mostly upset. "You know I hate secrets and I hate surprises. Besides, I am the oldest girl in this family, not her, whoever she is," she says.

Slowly, I tell a few of my closest friends. Mostly they are shocked and then excited for me that I have another daughter and that my mission is to find her. I soon discover three friends who are birth mothers themselves, friends I've known for years who, like me, have told no one. All have learned, as I have, to fit in, disguised like me, their secrets held as tightly bound and wrapped as our breasts had been with the milk coming in and our babies gone.

As my black notebook gets fatter and fatter with my failed efforts, I realize that I need to seek professional help if I'm ever going to find Anna. Tapping into the extensive network of information available to me at PACER, I hire two search consultants in Florida. They, too, come up against a wall of silence. There is the same lack of information and total absence of clues.

Disappointment follows disappointment. The original attorney had told me that Anna's adoptive father was a professor at a small college in upstate New York, so next I hire a search consultant in New York. We too speak frequently on the phone, but after weeks of searching, he also comes up with nothing.

When all possibilities of finding Anna seem exhausted, Rachel, a birth-mother friend, asks me to join her for dinner. We meet at a local Thai restaurant, and over iced tea, she says earnestly, "Joyce, I need to tell you something important." Lowering her voice, she pushes her tea aside and whispers, "This information is confidential. You must promise to keep what I'm going to tell you a complete secret. I've not yet told anyone, but when I was searching for my daughter, I learned of someone who could help me." She sips her tea, then moving it away again, adds emphatically, "And I feel certain he'll be able to help you. I had problems like you're having. No one knows who he is, only that he is called 'St. Jude', the patron saint of lost people and lost causes. He has ways of finding people; no one knows how he does it. He's the only person in the country with the ability to find impossibly lost children. His identity must remain a secret. Otherwise, he will be arrested and all of us lose any hope for help."

Even before we have finished dinner, I am picturing my next step. I excuse myself, thank her, and give her a quick hug, waiting just long enough to receive the precious piece of paper on which she has written a phone number, which will eventually connect me to St. Jude and which I am convinced will unlock the secrets of Anna's life and whereabouts. I clutch it as if it were Dumbo's feather, my talisman, my amulet.

The house is in darkness when I return, and all is quiet. Forgetting about time zones, I call the mystical number with which I've been entrusted. Someone far away on the East Coast answers. As I wait in the dark, an anonymous female voice answers. I tell her my story. Eventually, word will travel across this complicated network until it reaches the ear of "St. Jude" himself. I need only wait and he will call. Only when he has found her will I need to pay him, but how I do not know.

· · ·

I go on teaching childbirth classes, attending births, and breathing with others through their birthing. I do hospice work with people in their last days of life, I breathe with them in their dying, I breathe with my girls, I breathe into my own life of waiting and hoping.

At four o'clock one morning, the phone rings loudly. Lost in a deep sleep, my flailing hand sends my glasses onto the floor and knocks over a glass of water as I grope for the receiver. A deep voice speaks through the darkness, and I know it must be him. I'm instantly alert, straining to hear every word. "Joyce," he says without identifying himself, "I'm calling about your daughter. I need you to tell me everything you can remember, absolutely everything." In response to his questioning, I repeat my now oft-told story, with each detail of Anna's birth and adoption.

"Okay then, Joyce, your only job is not to worry," he continues. "I will take care of everything. I'll get back to you in the next couple of weeks and will know the name of your daughter and where she is now; for you, it's your time to relax, to trust me and your future."

Relax? How can I relax? But he is so confident, I have to believe it's true. Besides, I know he's already found Rachel's daughter. I fairly dance through my days, but as the weeks go by with no call, I dance a little slower. Then, with only silence, I pretty much stop dancing altogether. I go on with my classes and nursing, go on with everything, but the little song I have been singing to myself has gone quiet.

At the same covert hour, the phone rings and here he is again, mysterious beep-beep-beeps sounding in the background. Again, he begins with no introduction. He explains that he hasn't called because he has no news. He has been unable to find her through any of his usual channels and says that there must have been something irregular about the adoption. However, he again promises to continue his search and will be back in touch before long.

Time passes ever more slowly. Months slip by with no phone call, but every night, I go to bed thinking that this could be the night. Darkness outside and inside, sleeping and dreaming. Then, finally the phone rings, the familiar beep-beep-beep sounds soft in the background. I know it's him. I know before he speaks that he's found her. "Joyce, I have to call you, and I hate this call. I've done everything I can, and it is impossible for me to find your daughter. I think what you thought was a private adoption must have been a gray or black market one. Your child was sold. Money paid. Records falsified. There is no trace of her, and I don't think you will ever know what happened to her. I'm very, very sorry. There is nothing more I can do. I'm so sorry. I don't know what else to say." Click. The line goes dead. Silence . . .

I begin my first nursing job after graduation at the neonatal intensive-care unit at Children's Hospital, but soon realize I am not well suited for this high-stress position. So after three months, I find a job through a nursing agency in San Francisco, a job that feels made for me.

Frail and misshapen, little Sasha is a survivor. She has spent the first three precarious months of her life in intensive care at the UCSF Medical Center, where her chances of survival are thought to be less than one in ten. Given her tiny body, with its multiple severe birth defects and serious respiratory problems, she requires twenty-four-hour nursing care.

When she is finally able to leave intensive care, her mother, Nadia, insists on taking her home. I join the team of pediatric nurses dedicated

to Sasha's survival. She requires percussing and suctioning every hour, tube feeding, and constant oxygen. This is the work that I am trained for, and with a single patient on whom to focus my care, I soon become her head nurse.

Together by Sasha's bedside, night after night for four years, Nadia and I sit, sharing secrets from our complicated pasts. Never have I seen a mother more fiercely determined and committed to her child's survival, steadfastly refusing to accept the doctors' dismal predictions. In endless discussions, as we sit guard over Sasha, we explore the meaning of life and the nature of death and dying. Inspired by the miracle of Sasha's survival, and by our own shared introspection, Nadia and I begin to attend weekend retreats in San Francisco conducted by Stephen Levine, a Buddhist teacher and writer, widely known for his work with those confronting death and profound tragedy.

During one of these weekends, I learn that Stephen and his wife, Ondrea, will be leading a retreat at Mount Madonna Center in the Santa Cruz Mountains south of San Francisco. I realize that six days of silent meditation might enable me to go deeper in confronting the inner demons that continue to haunt me.

I recognize my pattern of endlessly overcommitting and of creating a doubled-up life that is crisis driven and forever hurried and unfocused. Although I know there must be another way to live, whenever I pause and sit quietly I find myself overcome by an excruciating sense of emptiness and loss. I am conscious of remaining incomplete, of missing half of myself, like a solitary bookend that can support nothing. I need a safe place to be with these feelings, to explore them, and to see what happens when I don't lose myself in busyness. I know absolutely that I'll need support if I am to conquer the feelings that lie in wait for me and haunt my quiet moments.

Finally, on a Friday afternoon, after several weeks of apprehensive anticipation, I leave Berkeley and drive south through the redwood for-

ests lining Highway 17 as it winds through the hills to Santa Cruz and then down along the California coast. Richard, with whom I share joint custody of Ilana, and often share Lilia, has once again agreed to keep the girls with him, so their lives will continue as usual. Mine, however, will change. I can sense it.

I arrive at Mount Madonna, already in a state of heightened awareness. Even as I park the car, I've begun to move toward the space of silence. The car door closing and the crunch of gravel underfoot sound too loud, too intense. The room I am to share is a small, simple, but sustaining space with three double bunks and a little window looking out into the redwoods.

Our retreat will consist of hours of silence, with evening sharing and discussion of living and dying, of grief and loss, of love and a celebration of life. It is the coming hours of silence that frighten me.

In our room are six women, one already a dear friend, but the others all strangers to each other. None of us speak; we are seldom together in the room except for sleep. When not sitting in meditation, we are outside walking near the stream, alone in the forest, walking, slowly walking, and meditating as we walk.

Through the open window, cool forest air fills the room. My friend is in the bunk below mine. Although we never speak, her hand occasionally reaches up and grasps mine in silent communion. In the darkness, we can feel each other's presence, just as Judy and I found comfort in each other so long ago.

Our silent meditations last for hours at a time, many in one huge room, with its dark green rugs and windows open to the equally silent forest world that surrounds us. In the early morning, the room gradually fills with people, some no longer able to walk on their own, some soon to die, all looking inward to find who is there.

Those who are the most ill lie on mats in the front of the room, enveloped by the group and ringed like our distant ancestors in primitive

circles to receive the warmth of an ancient fire. The rest of us do our best to support ourselves while sitting upright for our meditations. All of us have slipped into cocoons and, like butterflies, are awaiting our new winged selves to emerge. We are almost all strangers and yet not at all strangers, feeling an immense sense of love and connection to each other as the hours and days go by. Once a day, those who wish may speak and almost always their words resonate with our individual struggles and the universal elements of being human and living our short lives here on earth.

For me, the hours of silence and meditation allow everything to fall away, thoughts carried off like the dandelion heads Judy and I blew gently toward each other. With distracting thoughts no longer filling my consciousness where they create chaos and confusion in my mind, with a sky now visible, I can see beyond myself and the hectic rush of my everyday life.

I begin to see Judy clearly, as I last saw her a year ago and as I've imagined her since. Judy running toward me weeping, Judy in her barren, antiseptic space. I see her wiping tables, loading the dishwasher, putting her clothes neatly in drawers. Now I see her sleeping in a room with sad, abandoned bodies. I feel her waiting for me. Yet is she waiting? How can she know to wait? How can she know I will come for her? Yet I see her, and I feel her unending patience in waiting for me, knowing that I will come.

It is the beginning of the fourth day. Four days of silence, silence while walking, silence while eating, silence while sitting, while breathing . . . always, always silence. In that silence, my armor gradually falls away. The incredible distractions, the busyness of a single mother working as a nurse, often both nights and days, raising two daughters alone, owning a house shared with tenants, strangers who come and go, briefly entering our lives and then disappearing—all this taken together bringing me to the far edge of sanity and yet serving as a protective shield.

I have a foolish, probably mistaken idea that my girls need every op-

portunity to explore every potential interest in order to develop in the directions that most suit them. Living in the Bay Area means there are countless possibilities—theater classes in the city, voice lessons, piano lessons, the Lawrence Hall of Science programs, volunteer work with elders and animals, art classes, after-school programs. The list grows each semester, so we drive back and forth across town and across the bridge in our overly used, quickly aging station wagon, often full of extra children, dogs, and the occasional goat or chicken. Nowhere is there ever room or time for sadness.

I begin to feel the missing and essential parts of my life—Judy and baby Anna—and then the bitter taste of two failed marriages, with divorces that have equally failed, resulting in anger and disappointment, with no softening into friendship, but only a kind of tolerance, as Richard and I share parenting. As the layers of busyness and chaos fall away, the layers of grief reveal themselves.

Another day of silence, and we gather for the fifth evening. We find our chosen places, quieted, comforted now in sitting with the stillness, feeling our minds slow and our hearts open further. As I feel a heaviness come over me, I lie down on the soft green rug. Tears begin to fall from my eyes. They flow down my cheeks and pool in my ears. More and more they come. Tears of such sorrow for all the days and nights of our lives that Judy and I have lost, tears for Judy's loneliness and pain, something I can barely stand to think of, tears for my own aloneness without her. All the sad waste of days turning into years. I feel my whole being dissolve and melt into a pool of sorrow.

Then, gradually a strange lightness begins to fill my body, a lightness and a sense of joy. In the center of my heart, I feel Judy and me, the two of us still together, still one. I know now our connection has never been broken and can never be broken or changed. I realize the absurdity of our separation and know with absolute certainty that it is no longer necessary, that it is possible for us to spend the rest of our lives together.

It is more than possible. It will happen. I now know that I possess

whatever determination and whatever strength is required. I know that our love, which has always strengthened me, will strengthen me still more now. The question is not, how can I think of bringing Judy to live with us? The question becomes, how can I not? Then, simply, how to proceed? I feel a tremendous clarity and lightness filling me, a feeling of sheer, undiluted joy.

7

A World of Silence

On Sunday night, I return home from Mount Madonna, going first to the kitchen to make a cup of tea. There are only two small lights on in the living room, and I turn one of them off. For now, I like this almost darkness, and I sit, just sit, something I never ever do. I look around our little house and see everything with new eyes. It's all changed. For now, for this first time, sitting quietly feels comfortable and right. I allow my looking to spread everywhere. This house, this one dim light, will include Judy. Where I'm sitting, she will be sitting. I want it better for her, perfect for her, but already I know that being together will be enough and, in itself, a kind of perfection.

The girls won't return until morning and I'm alone. All my life I've hated being alone, but now this aloneness feels full of Judy and a nameless calm. Now I wonder how I could ever have believed that I was alone. I stare at the dark shape that is the phone. I stare and imagine the questions I need to ask tomorrow. Who will I call first? Who at the institution? The administration? I'm not sure.

Sleep is far away as I lie in bed, my mind struggling to keep track of the thistledown thoughts floating through my head. What steps are necessary to release Judy from her institutionalized life and bring her to us? Could the state try to stop me? Could it refuse? I scribble notes to myself in the dark, only to find the next morning that my pen has left no visible record of the thoughts committed to its care.

I decide that the first step should be to call Jean Denny, Judy's sympathetic social worker. I had first spoken to her a couple of years earlier after Mom had canceled so many visits to Judy that I had begun to wonder whether Judy might have died and no one was going to tell me—like Daddy's heart attack, like Judy taken away, both of them disappearing while I slept, wrapped in ignorance. I think Jean Denny may have suggestions about the people most likely to be helpful or the pitfalls that I should avoid. I know Jean will understand how difficult this move could be for Judy, and might suggest how to make her relocation less stressful. She is caring and knows Judy well. I can trust her insights.

I close my eyes and breathe into my thoughts, allow myself to think about these next steps, but soon my mind wanders toward my daughters. Shall I tell them right away that Judy will be coming to live with us? No, it's better to wait until I've spoken with the institution and Jean Denny, wait until I've consulted someone who understands the legal issues, who can advise me on how best to proceed. I know, too, that at some point I've got to tell Mom. But not yet. I'm sure she will think it a bad idea. But this is my commitment to Judy and to myself. It's my decision for us. Present Mom with the idea and she will be dead set against it. I will wait until I know enough to explain it to her in a definitive, already resolved way. She's more likely to accept the idea once it's in place. I must handle her carefully. I can tell her all about the wonderful programs here in California that will have opportunities for Judy. This has been my professional area, one way or another, for a long time. I can remind her that I know it's getting harder for her to

see Judy as she herself ages, even if I can't say the truth—that it's always been hard for Mom to see Judy.

In the morning, the girls return, and then I drop them off at their respective schools. With Dustin beside me in our corner of the couch, I call Jean Denny. "Judy Scott, yes, she's fine," Jean says. "I was with her just yesterday. I took her into town to buy some underwear and socks." Then she adds, "Of course, riding into town with Judy can be slow going. The car's so quiet when it's just Judy and me. My radio doesn't even work."

"I'm not sure what you mean."

I've moved the plate from last night's pasta to the kitchen and stand in the doorway, the phone pressed hard to my ear.

"Well, you know, her being deaf and all."

"Deaf? Deaf, what do you mean, deaf? Since when is Judy deaf?" I feel a stab of ice running through my body.

"Since when? Well, I guess I don't know since when, but ever since I've been here, which is about seven years, I've always known about it. My understanding has been that she may always have been deaf."

I am silent in shock and disbelief. Deaf? How can that be? How could she be deaf and we not have known? How could we not have realized? It is beyond belief. I can hear the clock ticking, hear seeds scattering in the one-legged canary's corner. Outside, a car is reversing out of the drive, and in the parking lot next door, some kids are playing ball. All of these sounds Judy can never hear. And, worse yet, never could hear. It's impossible.

The pieces of our life spin wildly around inside my head and fall back into a completely new and painfully clear pattern. I see Judy running down the road with all of us shouting at her while she keeps on going; then how surprised she would seem when we grabbed her arm to turn her around, hold her hand, and head back home. I see her playing in the grass and needing my touch to stop and bring her indoors. Her need for my hand, my touch with every change in what we would do. It

all suddenly becomes understandable. I feel a terrible pain in my heart. Judy living in a world without sound. And now I understand: our connection, how important it was, how together we felt each piece of our world, how she tasted her world and seemed to breathe in its colors and shapes, how we carefully observed and delicately touched everything as we felt our way through each day.

I suddenly think of Helen Keller and how she had become deaf after an attack of scarlet fever. I remember hearing that Judy, too, had scarlet fever when very small. Might it be that Judy's learning to speak stopped when she could no longer hear, so her speech sounds like an infant's babbling? It makes sense.

Jean suggests I call the administration at the institution to find out what will be required legally for me to become Judy's guardian, although I am barely able to hear her words through my shock. In spite of my nervousness, the person I speak with in administration is perfectly polite and understanding, promising a reply in the mail by next week. I begin to wait, one day after another, sorting impatiently through phone bills, utility notices, and advertisements.

Meanwhile, I set about doing some serious, completely nonessential organizing in preparation for Judy's arrival. I empty the silverware drawer, sort it piece by piece. I make a list of what we need. Four more teaspoons and a sharper knife. Next it's the spice jars. And the sheets. We need some nice ones for Judy. I add that to my list.

A week later, the letter is there on the red cement floor of the porch. I tear open the envelope even before sitting down. "Dear Ms. Scott," the letter begins. I scan ahead to the important parts. "As you know, your sister is a ward of the state of Ohio. It is impossible for us to begin to consider your request without you first becoming your sister's legal guardian. You would need to do this through both the State of Ohio and State of California courts. We will be able to help you arrange the move when you have acquired legal guardianship. In the meantime,

your sister will remain in Cottage C as a ward of this state, a patient at Gallipolis State Institution."

I begin to realize I know nothing about the legalities of obtaining guardianship, particularly of someone already a ward of the state—a different state—but I want to move forward quickly. Judy is already over forty and has lived far longer than anyone thought possible. At birth, her life expectancy had been just thirteen years. I want our last years to be spent together, and I feel a tremendous sense of urgency. The wasted years, the empty years, her years of suffering weigh heavily on my heart. Now, realizing at last that I have the power to shift our separate lives to a shared one leaves me holding the letter with a feeling close to despair.

It becomes clear that this procedure will not involve just a few letters. I try to find some information at the library. I contact some families I know with an adult with a disability. I phone the courthouse. There will be court hearings involved. This is not something I can do on my own. My mind makes some small anxious circles and settles on my friend, Berkeley attorney Peggy Hill. I feel certain she can help us. With all her years of legal experience, she must have handled guardianships. She'll know the procedure and can hold my hand as we go. She's already held my hand through the fallout of two miserable divorces. I dial her number, but get no response. Impatient, I drive straight to her office, sitting with my coffee and notebook, waiting. She arrives with the usual stack of files and an even greater overload of kindness.

"Peggy, I'm sorry to just show up like this, but I badly need your advice, and no one answered your phone," I say, jumping up to grab some of her papers. "You know I've told you about my twin sister . . ."

Of course she remembers, and while shuffling through my notes, I proceed to tell her about my plan, my confusion over how to become Judy's guardian, my uncertainty over what must be done, and the advice I badly need. I explain that I want Judy out of the institution and

with us in California as soon as possible. That first she can live with us at home, and then later she can move to a board-and-care home nearby, where I can see her every day. It will be impossible for me to stop working to care for her.

Peggy closes the door and takes the stack of papers from my arms. "Okay, Joyce, well, I can see that you're already clear in your mind about this decision, so let me first contact the court in Ohio to see what's required on that end," she says. "I will help you with the petition to the court both here and in Ohio. But what about your mother? How does she feel about this?"

"Ah . . . well, I've only hinted at it. I'm waiting until everything is in place, as I know she'll be dead set against the idea. She's convinced herself that Judy's in a very nice place. I think it's essential for her to see it that way, and besides, she feels that to move her would be too disturbing. Actually, I think it's hard for her to think about Judy at all, and even talking about all of this must open up old wounds, but that's no reason to leave Judy in a state institution," I answer.

Peggy gives a supportive sort of sigh and looks up, saying, "I suppose she could make it difficult for you, but the legal decision will rest with the institution and the state, and I doubt they are going to fight you on this. We'll have to see. Why don't you call me in a few days and I should have some more information for you. Of course, I know how it's done here in California and I can check on Ohio. While I'm checking, we can at least begin preparing the California legal guardianship papers for you."

I send for Judy's records. I want something tangible, something to hold onto while we wait. I need to understand everything I can about Judy's life and her needs, although I dread finding out more about what her life has been like at the institution. But, most importantly, I need to know about her health and any special medical needs she may have. If we get to share our lives again soon, I want to know everything I can to make her transition smooth.

Peggy helps me create the letter I need and stops me from sending the completely inappropriate, early morning, maudlin letters I've written, letters painfully personal about my love for Judy. She notarizes the correct letters. I mail them, and again I wait, both for Judy's records and for information from the institution.

Weeks pass. It is Thursday, and when I come home, there are just two hours before starting my hospice work, two hours to prepare dinner and spend a little time with Lilia and Ilana, who will be home from school any minute. I throw my books and papers on the already cluttered table, turning to reach the mail that lies scattered on the floor behind the front door. Dustin, tail wagging, gives me one of her big wet kisses as I bend over. It's not there. Anxiously, I open the door and check the porch.

There is a large envelope bearing the imprint "Gallipolis State Institution." My heart races. This is what I've been waiting for. What will I discover about Judy? Can I stand it? Are there more surprises? The envelope is not as thick as I imagined it might be. I wedge my finger in one corner to tear the top end open.

Dustin obligingly follows me inside as I sink into a corner of the couch. I flip quickly through the first few pages, my anger rising as I read:

"Not appropriate for any educational programs."

"Mongoloid idiot—Profoundly retarded—IQ 30."

Ridiculous! My cheeks burn in mounting indignation. I hate them, whoever they are. How dare they label my sister like this and use it to justify depriving her of any opportunity to learn, no chance for a life, no chance to realize her potential.

The notes skip ahead, listing only records of immunizations, but further on, I read that Judy is a "behavior problem," is "unmanageable," has begun attacking other children. What year was that? Looking back, I see it was 1955, the year before Daddy died.

How is it possible that Judy became aggressive and unmanage-

able? Judy, who loved me and our family, who loved to save the worms drowning in puddles on the sidewalk, who loved the bunnies with their soft fur, loved even the grass between her fingers. But it begins to make some sense. It was when we had almost stopped visiting her. We couldn't tell her about Daddy's heart attack and how it had changed everything. How could she not feel abandoned and afraid? I touch on her despair and begin to feel sick again. My heart aches. Dustin scoots in closer to me and puts her head in my lap. I rub her ear absently and turn to the next page.

Now I understand why she was moved to Gallipolis. Later, it will seem to me that, in being unmanageable, in getting sent away from Columbus and those huge dark rooms, her frustration and rage may have saved her life. Gallipolis was an institution, but the awfulness was smaller and less dangerous, and the possibility of survival greater. Judy had at least a chance of being noticed and cared for.

Then, the records suddenly stop. Twenty years of her life are missing, never mentioned, unaccounted for. Nothing . . . nothing at all? I flip back through the papers. What appears next comes when she is in her thirties, with a series of reports on behavior-modification programs. By the time I've come to the last page, I'm filled with rage and left with more questions than answers.

I drop the records off at Peggy's office, mostly so she can share my outrage. Then I wait. Eventually, Peggy calls, telling me to bring in documents related to my work, my income, and my living circumstances. Soon after, I come in to sign all the documents. She has been working with the institution and the courts in Ohio and California. After the probate court hearings, Judy should be freed, and our lives joined and shared again at last.

PART II

Unbound

8

Reunion

Another year has passed, and my joy in knowing Judy is coming home to us is mixed with a growing despair over my failed search for Anna. I am restless as always, punching the pillow; it is four o'clock in the morning when the phone rings. Without any greetings or formalities, the mysterious voice of "St. Jude" directly asks, "Joyce, would you like to know what your daughter's been doing this summer?"

"You've got to be kidding? YES, yes, yes, tell me, please!"

"She's been working as a camp counselor for children with disabilities and she's in New York, as you thought."

Unbelievable. My daughter. Working with children with disabilities. Of course. She's my daughter.

"How did you find her?"

His answer is no answer at all. He's not going to say. But he does say that this case is the hardest he's ever had, something about documents being altered. He then tells me she's at a university majoring in aerospace engineering. She is?

My euphoria on learning that Anna has been found is soon layered with new worry and doubt. As I drive across the Bay Bridge and into San Francisco, heading for Nadia's house and another eight-hour shift with Sasha, I'm desperate. The mysterious "St. Jude" never asks for payment unless he gets results, as Rachel had explained. Now, to receive my daughter's new name, her address, and telephone number, I must send him two thousand dollars in cash through his network of anonymous intermediaries. The years in nursing school have taken a heavy financial toll, and my job has yet to generate any savings. Two thousand dollars might as well be two million.

Yet, just three days after hearing from St. Jude, I receive a phone call. "Ms. Scott?" It is a man's voice, but not one I recognize.

"Yes," I reply hesitantly and, with more than a hint of suspicion, thinking of all the unpaid bills.

"This is . . ." The name is unfamiliar, and I feel my defenses rising.

"Who is this calling?" I ask again in my most distant professional voice. "I'm sorry; I didn't catch your name."

The caller identifies himself again. I suddenly realize that he is the attorney I had hired more than two years earlier after an accident in which my car had been rear-ended and my neck injured, an event long forgotten. "Ms. Scott," he says, "I have a check here for you. It's for two thousand dollars. You can come down and pick it up whenever you like."

Truly a miracle! And one for which I had not yet begun to pray.

"I'm leaving right now. I'll be there in a few minutes," I say, putting the phone down and grabbing my purse at the same time.

I am breathless as I collect the check from the attorney's office. I go straight to the bank to convert it to cash, carefully slip the twenty one-hundred-dollar bills into a brown manila envelope, and mail it with a prayer of gratitude on the first leg of a circuitous journey to the mysterious St. Jude. Now, at last, I will learn Anna's new name, where she lives, and eventually, maybe even meet her again one day.

• • •

The complex multilayered process of becoming Judy's legal guardian has been delayed by crowded court schedules. Nevertheless, over the past twelve months, I have made all the arrangements for her arrival. Only the date remains uncertain. Mom has become resigned and now only occasionally laments, "I just hope you know what you're doing." In just a few more months, Judy will arrive in California, making her first-ever flight accompanied by a caregiver from the institution in Ohio.

While we're waiting, I begin to think about what to say to Lilia and Ilana about her arrival. I want them to feel comfortable with Judy living with us. We're sitting out on our front steps, the poplar leaves fluttering beside us. I begin our conversation with, "You remember when we went to see Judy back in Ohio, I explained how Judy has Down syndrome and looks a little different?"

"Yeah, we remember," both say at once.

"Well, now that she's coming to live with us, I thought you ought to know a bit more, in case you have questions or your friends ask about her. In a way . . ."

"Wait," nine-year-old Ilana interrupts. "Why does she look different?"

"Because Judy has, well, with her Down syndrome, Judy has something extra—an extra chromosome. That's what makes her different and makes some things harder for her."

"Well, yeah," Ilana interrupts again, "but what's a chromosome anyway? What does it mean that she has an extra one?"

"Chromosomes are in every cell of our bodies and carry the genes, the little bits of information that make us who we are. I guess an extra chromosome means different things for different people, but usually people with Down syndrome take longer to learn things."

"You mean she's retarded," Ilana says, satisfied that she knows what I'm talking about.

"You know, 'retarded' is not a nice word and it's not even an accu-

rate one. It's not a good word for any of us to use. Judy is very smart in lots of ways, and slower in others, but because no one realized she was deaf, they thought she couldn't learn anything. It was her deafness that made it so she didn't know what people were saying and never learned to talk."

"That's so awful nobody knew she was deaf," Lilia practically shouts at me.

"Just awful," Ilana agrees, more softly.

"Anyway, just like everyone else, people with Down syndrome can have all kinds of abilities and gifts, ones that can't be measured in tests, like being creative and artistic or very kind. It makes me so sad that when Judy was little, she never had a chance to go to school or do much of anything."

The girls stare at me, and Ilana scoots in closer, almost crawling into my lap.

"I just wonder why she looks a little funny with no teeth and everything."

"She's looks a little different, partly because of the Down syndrome, but what's terrible is how they pulled out all her teeth at the institution. And then, on top of that, they gave her some kind of experimental drug that makes her move her mouth in a funny way. She can't help it. It makes me sick what they did to her."

Lilia's pulling a tangle out of her long hair. "It makes me sick too."

"I love the way she looks," declares Ilana, pushing some dirt into a crack in the steps. "I love everything about her, and I can't wait for her to come to live with us! We're gonna have so much fun!" I wonder if she's remembering the ketchup wars she and Judy had at that little restaurant in Gallipolis?

With Judy's arrival, our lives will be changed forever, but I live comfortably with my certainty that this decision is right, absolutely right. I sense that she is coming home, and with her homecoming, I too will at last be home.

But before Judy arrives in the fall, I find that I have another journey to make, one that will change the course of my life once again. It is an incredible gift: an offer to travel with a wealthy and generous friend and another close friend of his. The plan is first to bicycle in China and then return from Asia and the Middle East on a cruise. To me, it's irresistible. These faraway places seem like other planets, like stars beckoning to me. Once Judy arrives, I won't be traveling, not for a long time. This is my chance to go out into the larger world before returning to the world that will belong to both of us.

In the living room, as Ilana helps me pack for the trip, I gather papers, dirty socks, and scattered shoes from the floor. I try to imagine our new life together with Judy and all the ways I already know her. She is my twin, my lost self, myself in another form, a shorter me, a kinder me. I've always known this. Picking up Ilana's little-girl sneakers, I think about Judy's small feet, always small. Her feet stayed tiny, while mine kept getting bigger and bigger. I think about that pair of little shoes that was still on the floor under the bed the night after Judy was gone. I left them there for a long time. Then, like Judy, one day they too disappeared.

Sometimes, in my mind, is confusion. Judy is not my sister but my child, the child I followed to protect from gravel and bumblebees. The child who rode on my back, arms wrapped snuggly around my neck, while we raced up the cinder path. The child who followed me when I wasn't following her. I know all this, know it in my bones, but I have no idea who she is now. I don't know what she likes to do, only what she was trained to do, like emptying the dishwasher and setting the table. Who she seemed to be at the institution can't have much to do with her real self, and there was so little I could know of her there.

She must still see things I don't see, and like the feel of things more than I do. It was always that way, the way she stirred the mulberries more carefully and squeezed each one between her fingers. Each little stone, each leaf she held longer, felt more carefully, tasted more deli-

cately. For her, especially, our being together meant our bodies were always touching somewhere—her hand touching my face, leg beside leg—until we were almost and always one. It made no difference then, before we knew she couldn't hear, so why should it be different now?

I run my hand across the scarf I'd dropped on the desk, feel the softness as she might feel it. I stand in the doorway, staring inward, my hand wrapped in the scarf, thinking about Judy and the cloth and the softness that surrounded her.

Suddenly, I am jerked back into the present as Ilana tugs on my arm and pulls the scarf. "Mom, come on!" she says. "We're packing. What you are doing just standing there?"

"Right. Right." I put some folded pants that she hands me into the nearest bag. "Pass me those T-shirts on the table. Better fit those in next." She throws them at me and giggles. Ilana, who is now nine, is passing me more stuff, and fourteen-year-old Lilia, who has made us her special chocolate chip cookies, sits nearby on the couch with Dustin, staring gloomily at the scene.

It's getting dark as the green BayPorter airport shuttle pulls up in front. I hug Ilana and Lilia, hold Dustin's kind, plump self warm against my own body, and drag the new, overstuffed bag, banging its way down the steps.

· · ·

The *Illyria* is a small, well-appointed luxury yacht that has been chartered for a cruise by the American Museum of Natural History in New York. It is waiting for us to board in Singapore, where we meet our fellow travelers. Many are regular supporters of the museum and have been on previous cruises. They soon regale us with their experiences. This is a world of privilege and luxury far beyond anything that I have ever encountered, but the three of us are immediately welcomed and put at ease with an abundance of gracious charm.

After visiting Thailand and Burma, we sail to India. At Maha-balipuram, our bus pulls off the road, and an army of children, small ones and then even smaller ones, become visible one hill over, racing barefoot to meet us, brown skinned, bright eyed, their arms full. They hold out their handmade necklaces and little carvings. One little boy calls me "Mom," and although I know he's had other moms who were his for only an hour, I am filled with happiness to be his mom, if only for this moment. I wrap my arms around him and ask him to tell me his name and his stories. Necessity has made these children fluent in half a dozen or more languages.

We eventually reach Bombay, where we are greeted by the calls of crows and peacocks, the air heavy with a richness of smells, more smells than I knew were possible. In the excitement of discovering these new worlds, I barely notice the announcement that two new guest lecturers will be joining the ship for the second half of the cruise.

The Elephanta Caves, ancient, primal, and full of mystery, lie at the top of an endless flight of steps on an island in Bombay harbor. As I climb slowly, looking all around, I see an old woman sitting on a wall. She is selling betel nut, and I'm curious to try some. I smile and nod at her and then stare, surprised at the size of the leaf-wrapped sandwich she hands me. I am still staring as a tall handsome man draped in cameras comes to walk beside me with long energetic steps.

"Ah, that looks interesting!" he says, with an unmistakable British accent. "It's betel nut," I reply. "I've read about it in *A Passage to India*, and I thought I'd see what it's like. Do you want to try some?" Together, we munch and walk and talk about the caves ahead. He tells me that he is John Cooke and he is the new naturalist and photography lecturer on our cruise.

At dinner that night, I am both surprised and delighted to find that John has been assigned the seat next to me. Years later, I discover that this was, in fact, no accident. Our friendship begins at these dinners,

and we manage to sit together for most of our meals. When night comes, the band is playing and people are dancing. We join them, although between us, we have four left feet, but we barely notice.

After many bus rides to extraordinary antiquities—Petra, the pyramids, and more—we have built a closeness that surprises both of us. By the time we watch the Son et Lumière, side by side, at Luxor, we have fallen in love. John's stories will be forever mixed in my mind with the monks of St. Catherine's Monastery and the pharaohs of Ancient Egypt.

Uncertainty lies ahead. There will come a parting with no reunion on the horizon. John's life is in New York, as a photographer. My life is in California, where I am returning to my nursing jobs and the girls, to Ilana's tenth birthday and Judy's upcoming arrival. John and I imagine our reunion with only intention and dreams to sustain us. But just as Judy and I will be together again, John and I feel certain that we will find our way back to each other. I have come to believe in the power of determination and destiny, and we have both on our side. This much I know.

After an aching farewell in Athens, I fly back to California. Arriving home late at night after a two-month absence, I am thrilled to find Ilana and Lilia waiting up for me, along with Dustin, who wedges in as close as possible. Lilia has beautiful photographs to show me, ones that she has learned to develop in the darkness of our sunless bathroom. I watch as the girls open the only gifts I have been able to bring from India, the jewelry I have been wearing. Everything else was stolen on the train journey through Yugoslavia from Athens. I am left only with memories and the underwear I slept in, arriving home in hastily borrowed clothes.

Not long after returning to Berkeley, I arrange with the local camera club to fly John from New York to give a talk on wildlife photography. He has barely come through the door when Lilia, shoes untied and clothes in the teenage defiance of deliberate disarray, greets him with

"Get out of my aura!" John laughs gently and glances my way, "Now I know I've arrived in Berkeley."

After meeting friends, bringing him with me to meet Sasha and Nadia, John's two-week visit is over and we again say our wrenching good-bye. But barely two days have passed when John calls from New York. Immediately after returning, he had received a phone call from an old friend producing a wildlife documentary for PBS who asks whether John can film for the summer in the Sierra Nevada. The location is just a three-and-a-half-hour drive from Berkeley. Within the week, John has sorted out his commitments in New York and is in the desert, camping under the cottonwoods with his film crew. On most weekends throughout the summer, I drive up to the campsite, bringing a carload of wonderful gourmet dishes, most of them secretly made by friends who are better cooks than I.

As the days of summer grow short, we spend hours talking about creating a shared future. In September, John has a previous commitment to spend four months as a natural history tour guide in Africa. We decide we'll meet in Boston upon his return for a cross-country road trip, bringing his possessions to California.

When John returns from Africa, we buy a friend's large, elderly van and pack it from floor to roof with books and photographic equipment. There is just enough room for the chameleon that John rescued from the departure lounge in Zambia's Lusaka airport. Perched on the rearview mirror, it will journey with us across the continent, circling the lampshades at each motel and feasting on sleepy autumn flies in the windows.

I decide our route should take us through Cincinnati, so that Mom and John can meet. But first, we have an important side trip to make. With more reunion network support, I've discovered that Anna knows that she was adopted. I had struggled for months to write a letter of introduction, but after many false starts, I finally mailed it. Her response

is enthusiastic, so we plan a long-dreamed-of reunion. Lilia is tied up with SAT exams and unable to come, but John and I pick up Ilana at the airport in New York City and head to Buffalo, not stopping until we arrive at our destination, an unassuming apartment building near the middle of town.

I ring Anna's doorbell, while squeezing Ilana's hand. Through the windowed door, I see a figure moving quickly down the stairs, her face in half shadow. As the door begins to open, I push through, reaching out to grab Anna, then letting her go to John and Ilana and their more hesitant, tenuous hugs. I have imagined this moment more times than I can ever count, and now suddenly she is here. She feels light, like a bird that might fly away again. Her bones not solid, her skin soft. I feel a wave of grief wash over me. My baby is no more, my little girl I will never, ever be able pick up and push high in her swing.

"Look at her. You knew she'd be like this," I tell myself. "Of course, she's not a baby. Why would you want her to be a baby? Just stop it. She's beautiful, she's lovely, and she's made the journey through her childhood without you."

I sigh and then smile. There is no baby. That time is lost forever, yet this moment now feels miraculous.

We go up the long, steep flight of steps. I'm just behind Anna—whose adopted name was Esta and, in young adulthood, was changed to Taylor—and I can smell a sweetness surrounding both of us. Is that her? Is that how she smells? Now I'm watching how she moves. Whose steps are those? There's not much of her father in her, I'm thinking, giving myself another tug up with the railing.

"Please come in and sit down," she says to all of us, pointing to the dark-green, tattered sofa. She perches herself on the edge of the only other piece of furniture. This has the definite feel of a college student's temporary, makeshift home.

"Well, so . . . here's your little sister. Isn't that something?" I say to break the awkwardness that I'm pretty sure we're all feeling.

"It's amazing." She turns to face Ilana. "Ilana, when I saw that picture your mom sent, well, I guess she's *our* mom, right? I knew there could be no mistake. I looked just like you at your age. Wait, let me get that picture. I've got it right here." She reaches down to the coffee table and from a stack pulls out a picture of herself at age ten. It's true, she looked exactly like Ilana.

Ilana says, "Whoa, that's pretty scary."

She shows us a few more photos, and I'm already beginning to feel depression seeping around me. Here she is, taking her first steps, climbing on the monkey bars, at the beach, laughing with a friend. I have missed her whole life until today; I can barely stand it. I lean forward, clear my throat, and speak up, my voice a bit too loud. "So, here's what I suggest. John and Ilana can go out for a while, and you and I can have time to talk, just the two of us. How does that sound?"

When we're alone, she smiles shyly. I move forward in my seat. Then she says, "I have some snacks and drinks for us. Just a moment. I'll be right back." She's on her way back from the three feet it took to get to the kitchen. Stepping across the door sill, a beautiful tray of hors d'oeuvres and drinks in hand, she stumbles and everything flies about the room. I see an olive headed under the couch, the cheese squares have landed near the window, and the pretty little tomatoes have scattered themselves everywhere.

"Oh, no," she says, looking utterly deflated, one hand still holding an edge of the tray.

"Never mind, it's nothing to worry about. Let me help"

We're both down on our knees picking up bits and pieces of broken crackers and cheese squares. Inside myself, I'm thinking, "Yep, this has got to be my daughter. This is so exactly what I might do." I'm loving it. Had we been together more than an hour since her birth, we might have laughed together. We weren't there yet.

We reposition ourselves without the little nibbles, and she starts right in. "Joyce, first of all, I just want you to know I have no resent-

ment toward you for giving me up. I only feel grateful that you allowed me to have my life. I realize that you were young and, of course, with your being in medical school and my father in law school . . ."

Stunned, I pause for some time, wondering how best to reply. "Well, that's not quite true, but the important truth is that I didn't want to give you up and I've thought of you every day, every single day." She looks down at her lap and then picks up her drink, takes a sip and says nothing.

I continue, "I wonder what you would like to know about your background. I want to tell you everything I can, that is, everything that you'd like to know."

"Well, there's so much I want to know. About you. About my father. About my family history. I don't even know where to start. What about my ancestry first? That's probably the easiest for starters. I do know that I'm Jewish, but not much else."

I push myself back against the only cushion and try to make myself more comfortable. With my mind scattering, I look through the window searching for some kind of help. I see one lone tree with no leaves.

"I'm not sure what to say, because you're not actually Jewish. I guess your parents who raised you must have been told that, but my background is mostly British Isles—Scottish and Irish, that sort of thing, and your father was Irish with a bit of Spanish. I'm so sorry if this is a shock for you."

I can hear a truck backing up outside and somebody yelling.

"Hmmm, well, I don't know. I haven't really felt being Jewish was all that important to me, so maybe it's doesn't matter so much. It's a surprise though, that's for sure."

We both pick up our drinks, and there's another small pause. "Were you in love with my dad?" she asks softly.

I push my hair out of my eyes with both hands, then pull on the top part.

"Yes, in a really young sort of a way. He was only nineteen and I was twenty, and he was my first love and I was his. He is a very nice person. I hope you'll meet one day; I've been trying to find him and I'm sure I will. He was headed for the Peace Corps, and it all happened so fast. I was emotionally more like a sixteen-year-old, very shy, never had a boyfriend. He was my first love. I guess I already said that. Most of my life experiences were in the pages of books. I just took forever to grow up. Back in those days, if you became pregnant and were not married, you were sent away, and that's what happened with me. I was sent to Miami, where my aunt lived, and because of that, you were born there." I pause as I hear a rubbing sound. It is my foot going back and forth on the table rung.

"So you'd say he was a good person?"

Noises on the stairs. It must be John and Ilana. They fling the door open after a quick little knock.

We've planned dinner at Taylor's favorite restaurant, and she orders a cocktail for both of us, but I have no idea what I'm drinking. As we lean closer and closer, almost whispering to each other, the sounds in the room begin to disappear. Gradually, the room and everyone in it are gone. She tells me about her father's illness, an undiagnosed brain tumor, and how it drove the family apart; how she and her mother lived in a small apartment, her mother working long hours; how her dying grandmother shared her room; later, how she won a scholarship to MIT when she was only sixteen but ended up instead at a state college because her mother could not afford the remaining costs.

I pick up my fork, sigh, and put it down again. All the dreams I had for her: a comfortable, stable life with every opportunity provided. But, of course, I know no one has any guarantees in this lifetime.

We have another drink, and it just happens. I ask her if I can see her fingers. I study them closely. Then I say, "Would you mind letting me see your toes?" She laughs and takes off the shoe closest to me. Yes, all

there, all perfect. I don't need to count them now, but next I take off my shoe, and we put our feet side by side. I'm looking at the same foot, just a younger one, exactly like mine. The second toe is a little longer than the first, a major curve for our little toes. Her toes. She's like me. She's lovely. She's come from me. Nothing can ever take that away.

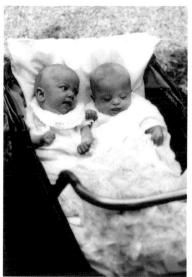

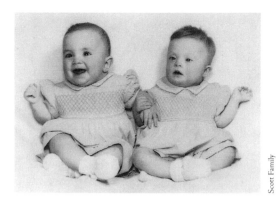

A portrait of the twins, 1943.

Joyce and Judith as infants, 1943.

Scott Family

Scott Family

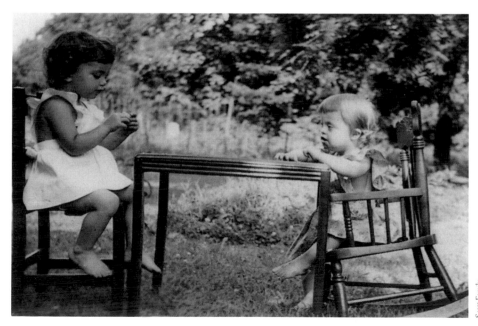

Scott Family

The twins, Joyce and Judith, at age two and a half at their home in Cincinnati, Ohio, in 1945.

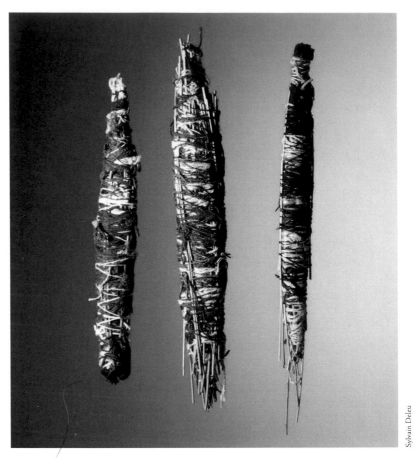

Sylvain Deleu

Untitled (1988). These wrapped bundles are reminiscent of Judith's first sculpture. Elongated forms, often more than two meters in length, are frequent elements in Judith's work.

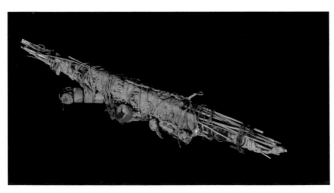

Sylvia Seventy

Untitled (1988). The first sculpture Judith ever created. Many of her later pieces incorporate the same elongated core element. Unlike her subsequent works, this one is daubed with paint.

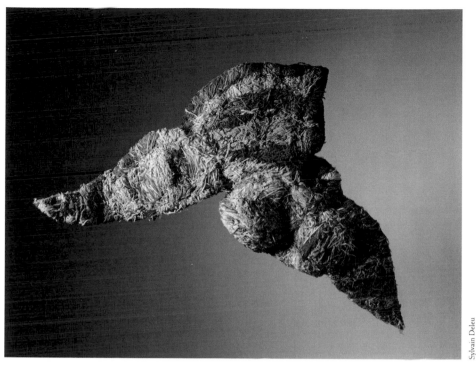

Untitled (1988–89), 137 x 129 x 17 cm. This early work is one of the most massive of Judith's sculptures. The contents of its curiously shaped internal framework remain unknown.

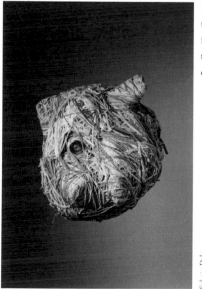

Untitled (1988–89). Components of the inner core of this early piece are allowed to remain visible on the surface. Judith would often wrap the internal structures until totally obscured, sometimes incorporating "borrowed" objects, including keys and, on one occasion, a paycheck.

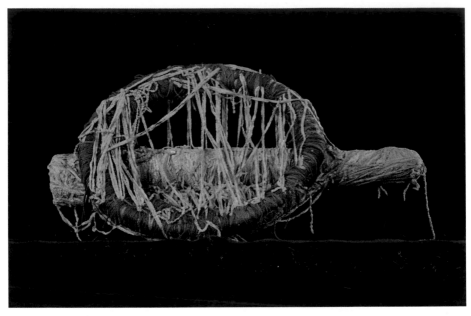

Untitled (1993), 61 x 40 x 10 cm. This large piece is particularly striking in the way it exemplifies Judith's use of powerful contrasts between subdued monochrome and brilliant color.

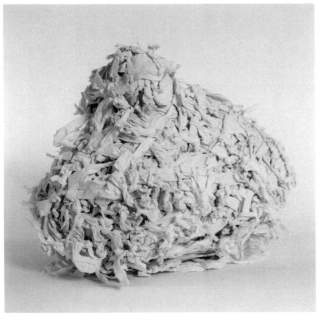

Untitled (1994). This sculpture was made when Judith found herself without her usual store of art supplies during a renovation of the Creative Growth Art Center, in Oakland, CA. She knotted together lengths of dampened paper towels from the restroom to create this monochromatic piece.

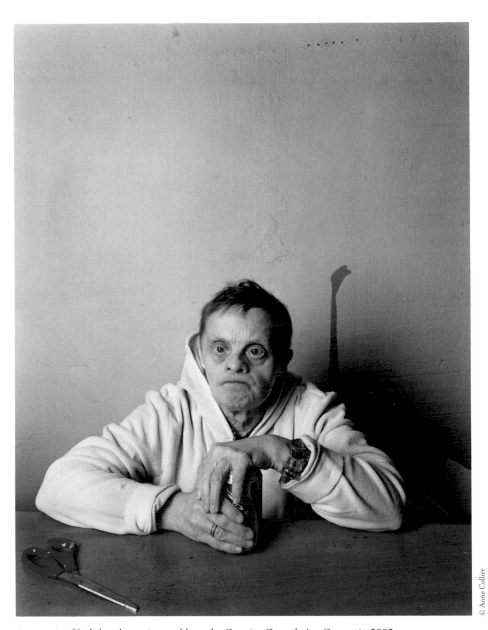

A portrait of Judith at her private table at the Creative Growth Art Center, in 2002.

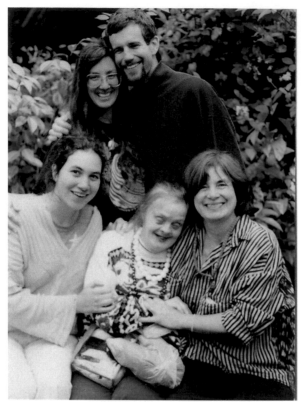

Judith with (from left) Ilana; Taylor and husband, Mark; and Joyce, in 1998.

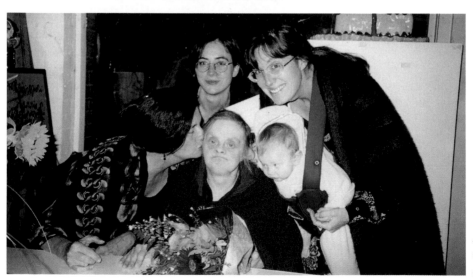

Joyce, Judith, Lilia, and Taylor and son at the first exhibition of Judith's sculptures, at the Creative Growth Art Center, in 1999.

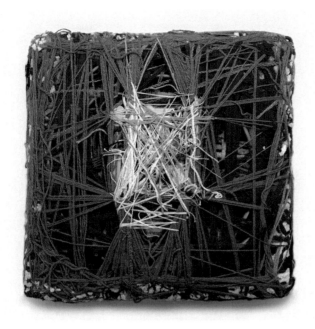

Untitled (2002). The deliberate weaving of the fiber strands around a found wooden frame demonstrates Judith's intentional planning process.

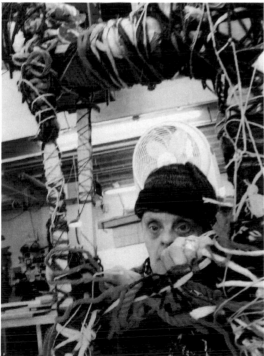

Judith at work on a large sculpture at the Creative Growth Art Center, in 2002.

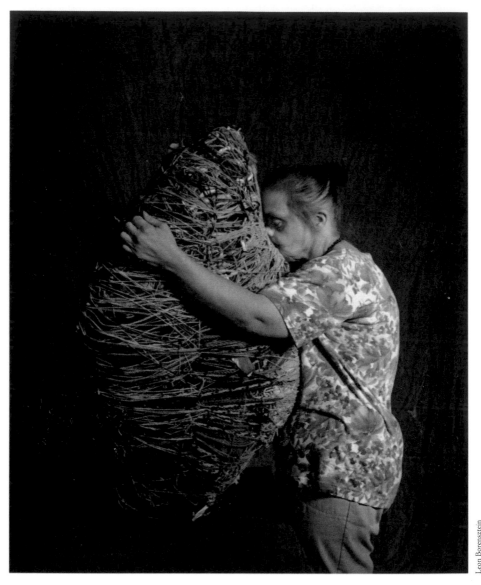

Judith embracing one of her sculptures, which she encountered on display at the Creative Growth Art Center, in 1997.

9

A Big Red Bowling Ball

‌‌‌‌꠹

The traffic across the Bay Bridge and to the San Francisco Airport is terrible. I am anxious. Arriving at the gate, we peer down the walkway. The last straggler from the flight passed us some time ago, and there is still no sign of Judy or of the attendant accompanying her. As we continue to wait silently, a lone figure, small and stooped, appears in the distance. Heavily burdened, this form moves slowly and uncertainly. I stare for a second in disbelief. This one little person, with such an air of desperation, just can't be Judy. It's unthinkable that Judy could be here alone, could have flown unaccompanied all the way from Ohio. Judy, who has not been away from institutional life in over thirty-five years. Besides, I had made arrangements with the institution. The people there had assured me, promised me, that she would be accompanied and cared for on her journey to California, her first-ever flight. But here she is—alone.

Even at this distance, bent with care and her heavy burdens, Judy is unmistakable. I rush toward her. Dark circles surround her eyes, and

her lips are blue and trembling. She seems close to collapse. Seeing me, she lets everything fall and melts into my arms, sobbing as I hold her close. Ilana slips in between us, and she too holds Judy, while John wraps his arms around the bundle that is us.

How long we remain frozen in this emotional embrace none of us remember, but eventually Judy lifts her head from my chest and looks up. The hint of a smile begins to flicker across her wet face, and we start to relax our grip on one another. Moments later, she laughs and makes a string of mysterious sounds, probably some explanation about her earlier concerns, and how she shouldn't have worried.

Then she's ready to go. She leans over to gather up her magazines and her purse, and a bulging leather bag that contains . . . contains . . . what? A heavy red bowling ball! She passes me an empty cup, a pilfered souvenir of her flight, and we, a new, larger, and happier family, head for the baggage claim.

Lilia has picked a bouquet of small yellow daisies for us to bring to welcome Judy, and they are now part of her stash. Snuggled together in the car, we cross the Bay Bridge and follow the freeway toward Berkeley and our new life. Arriving at the house, Judy climbs the peeling red steps and walks in as though she has lived here all her life, as if she'd just left home this morning. Shooing away Dustin's eagerness with a dismissive wave of the hand, Judy glances around, taking everything in, and heads straight for the kitchen. There are some dirty dishes on the counter, and with a quick glance toward me, she finds what she needs, makes some soapy water, and washes them up, in the end, wiping both hands down my blouse in one huge sweeping gesture, clapping them in glee with one giant laugh.

Now it's getting late, so we show Judy her new room, placing her suitcase on the bed. Days before, we moved the recently found, recently painted dresser into her room. We watch as Judy carefully unpacks and places her clothes meticulously drawer by drawer, the underwear rerolled and stacked neatly in rows.

Her bowling ball, like a close relative who has made the journey with her, goes on the chair beside her bed. On the tiny bedside table, we've placed the slightly wilted airport flowers, and on her bed, the two teddy bears the girls have chosen for her, teddy bears destined to stay with her long into the future.

Judy folds her sweater and puts it onto the chair for the next day, puts her shoes just under the bed, places her purse and magazines under her pillow, and then climbs in. She reaches her arms out to me and holds me close, then Lilia and Ilana and John, then blows some extra goodnight kisses our way. Now she snuggles down and disappears, face and all, into the warmth and protection that await under the covers, not to emerge until morning, when in the light of the new day, she already trusts that we will still be there.

With her first night of sleep in her new bed, she seems to know she is home again, although home has moved from a state institution and, years before that, from a small suburb on the edge of Cincinnati. Now more than two thousand miles away, home is where she is with those who love her and know that she matters. Home is where we are together, and she's home at last, both of us together, both of us home.

The next day, just after breakfast, John suggests that the girls and I take Judy to Tilden Park and the Little Farm, where Lilia and Ilana have spent countless childhood hours. I know Judy loves animals, and I imagine she'll love the goats and the donkeys as I do. I am wrong. I was imagining that Judy and I are the same. Judy loves animals, but she does not love *big* animals. When we get near the railings, she hangs onto my arm and pulls me back, even from the chickens and ducks. For Judy, animals must be small and furry, manageable, the kind she can hold and pet, like Mary, our adopted stray cat who already curls up on Judy's bed. Judy soon turns me around, pulls on Lilia and Ilana, and leads the way, marching pointedly back toward the car.

In the afternoon, we walk out along the pier at the Berkeley Marina, where the wind whips at her face, and I wrap her scarf around every-

thing but her small, cold nose. Later, on Saturday, she gets her first taste of garage sales, a weekend passion of mine and soon to be hers. She can pick out any necklace or brightly colored scarf and bring it home. She selects several and keeps looking up at me to make sure I'm not about to change my mind and make her put them all back. To her, it must seem too good to be true. I put some more necklaces around her neck and watch her beam. She pushes my nose in pleasure and quickly tucks the ones she's been clutching into her purse.

· · ·

After two weeks, Judy has met almost all our friends, but she hates going to their houses. She sits on the edge of her chair, watching suspiciously and, after a much begrudged, very short visit, stands up, gathers her magazines close, and heads for the door. True, she can be tempted by a piece of cake or a cookie, but not for long. Actually, she doesn't like me to spend time with other people, no matter where or how. She wants and expects my undivided attention. The problem is that everyone, absolutely everyone, wants to meet her, so we switch to organizing a few small potlucks at home.

When we're in the car, Judy knows that she will sit in front, and everyone else must sit tight together in the back. However, if I pay any attention to them at all, Judy is greatly annoyed. Being deaf and without language means she is left out of every conversation. I think about her experience of living as a stranger among people with hearing and a shared language. I think of all the staff and caregivers who have come into her life and then left. For her, our friends are all strangers to her for now, no matter how thrilled everyone is to meet her. The exception, besides our little family, is my old friend Bette. That Judy and Bette love each other completely has been clear from the start. There's no distance between them.

When Judy and I arrive at Nadia's house after fighting traffic on the

Bay Bridge and across San Francisco, a cold fog has blown in off the ocean and up the block. We hang onto each other as we climb the stairs. Now I'm nervous, adjusting her hat so she looks her best. For the first time, Judy and Sasha, now a five-year-old, will be together. What will it mean? Both are so important to me; I can hardly stand the uncertainty.

As the door opens, a burst of warmth immediately envelops us. Sasha gives a squeal of delight as she sees us and scoots sideways across the floor to be embraced by both Judy and me. Sasha smothers us with kisses and pats on our cheeks with her twisted hand. Nadia, meanwhile, in and out of the kitchen, stirs and shapes her Russian delicacies— stuffed cabbage, piroshki, and borscht.

Over the years, Sasha has become stronger. She no longer needs intensive care around the clock, so my role has gone from being her at-home intensive-care nurse to more of a nurse companion to this incredible child. Sasha soon becomes as bright a feature in Judy's life as she is in mine. Their love for each other is radiant.

When we walk to the nearby zoo, wrapping up well against the wind, Judy helps to push Sasha's stroller, pausing often to move to the front to engage her in animated exchanges, conducted by both of them with exaggerated gestures and sounds that none of us can understand. The female gorilla is a great favorite, and we watch her in her cage as she rummages through her big sack of a purse, taking things out, examining them and putting them back, then taking them out again, like us, I suppose.

In Berkeley, there is a parking lot between our house and the decaying apartment building next door. Surrounding us is a difficult and troubled world, including the occasional sound of gunshots mingling with the sounds of cars with no mufflers. But there's been a change. We are now wrapped in our private paradise. Each day since Judy's arrival, we have felt surrounded and somehow protected. Outside, a border of passion flowers along the fence encloses us in a sea of tropical greenery,

blossoms, and butterflies. On sunny afternoons, I sit with Judy on the tiny porch, watching the butterflies dancing between the blossoms, the sun lighting our faces.

In the kitchen, I soon learn to hide the bananas on top of the fridge. Otherwise, Judy will eat four at one sitting, then swipe another one as she walks by. Some freedoms after institutional life are just too tempting.

Most afternoons, we walk the three blocks to Ilana's school and wait for her. Dustin sits, panting, tongue lolling in anticipation. Judy and I wait by the gate, keeping our tongues in, knowing Ilana is coming soon and we will all walk back together. On other days, Ilana brings a friend home, both of them dragging their backpacks through the front door. Judy rushes from the living room, well in advance so that she can grab her seat and position herself at the narrow kitchen table where they play cards, wedged in between the sink counter and the fridge. With Judy waiting, hands open wide, they gather their cards from the second drawer, slap them down on the table, one at a time. Whose turn now? There are no clear rules as cards are snatched randomly from each other with gestures and bluff. Their laughter floats in a current of happiness that encircles us in our little dark house, now bright with Judy's light.

The girls disappear after a while, but with Judy beside me, help with dinner is a certainty. The two of us have our nightly chopping and tearing jobs. An NBS (nice big salad) is coming up. Bob Dylan's voice plays in the background, drifting in from the living room. John is working quietly in his cramped basement office, writing his book on animal movement.

On my days off, and in the late afternoon, Judy and I develop a few routines: her banana in the car after breakfast, daily rides around town with the girls after school, taking them to their friends or activities and shopping trips. At stores, while my back is turned, Judy will hide the valuables she's been collecting under the items already in the cart. After one trip, I discover half a dozen cans of chopped turkey meat. That's

what I get for talking to the person in line behind us. Wherever we go, not a single magazine is safe from her ever-eager eye and quick, skillful hands.

Shopping at Costco is a favorite adventure for Judy, as it is for Ilana. The possibilities here are almost endless. Together, we push the cart, wandering up and down the aisles, sometimes short on purpose but long on enjoyment. Judy pauses from time to time to catch her breath. Driving back home from our shopping excursion, Judy spots a package of oatmeal cookies on top of a grocery bag in the back. At a stoplight, I hear some crunching, rustling sounds as she begins to edge the cookie bag surreptitiously toward her lap. As she glances sideways, she realizes I've noticed and I can see her quickly rethinking her strategy to now include me. She looks my way with a devilish smile, as if together we are sneaking cookies from our mother's groceries while she's just stepped out of the car for a quick errand. "Ah—ha!" Judy says with glee, including me in her conspiracy. We've made it now; we've pulled this one off. She seizes some cookies out of the package and passes me one, then one to herself, followed by more cookies carefully placed on top of her stack of magazines. We pass the Hilltop exit, Cat Stevens's "Peace Train" blasting on the tape as we sway to the music, heard and unheard, nod our heads side to side, mouths full, crumbs flying, each slapping the dashboard and the top of the car.

10

A New Language

I'm resolute that the rest of Judy's life will be as full and as rich as possible after her years of bleak isolation in the institution, although I'm not clear what such a life might look like. After researching possible programs for adults with disabilities, I visit several depressing ones. In one of the worst, I find people are sitting in little cubicles, separated by screens so they're not distracted by their neighbors while doing mindless sorting jobs. The very thought of Judy—or anyone—being in such a place upsets me.

My close friend Gail tells me about the Creative Growth Art Center in Oakland. She explains that it's a studio that provides opportunities for artists with disabilities to express themselves in whatever medium they choose and includes a gallery next door that exhibits and promotes their work. It is not a place of art therapy, but a place where they are free to create; they are respected for themselves and for their unique talent and vision.

I visit it without much hope. Judy, so far as I know, is not an artist.

I had learned from her records that she had been denied even a chance to participate in a small art activity, and that on one occasion, when she wanted to draw with a colored pencil, it was taken from her and she left the room in tears. One of the few personal reports in her records is a complaint about her behavior in this incident.

On entering the large brick building lined with windows on a small side street in downtown Oakland, I am instantly transported. The director, Irene Ward Brydon, welcomes me. Together, as observers, we stand on the edge of a volcano of creative activity. Everywhere I look, there are artists deeply involved in their work—painting, sculpture, ceramics, tapestry, woodworking. I become an instant convert, a confirmed believer in Creative Growth. I rush home to bring John to see this extraordinary place. He, too, is enchanted.

We are both determined to do whatever we can to ensure that Judy has a chance to spend her days here; I desperately want this for her. I realize I'm holding the brochure with such a tight grip my hand is cramping. But my fears are unfounded. The center makes no prejudgments about her abilities and talents. Irene assures me that Judy can begin almost at once. She will start Monday morning.

Monday morning arrives, earlier than usual, wetter than yesterday or the yesterday before. A pool of water is accumulating where our cracked pavement meets the sidewalk. As I look out the window, I worry at the prospect of persuading Judy across that giant puddle and into the car. We are scheduled to be at Creative Growth by 8:30, early for all of us to be at our appointed places. It will mean dropping the girls off a bit ahead of schedule, and with Lilia's early morning teenage blues, that in itself will be a challenge and a tough start to the day.

Still in bed, with her magazines stacked neatly beside her, Judy appears preoccupied with the one that's on her lap, perhaps as a pretense while she gauges the situation. From her bed, she can see me rushing around the kitchen, and to her, the signs are obvious—unusual rushing, new clothes taken from her drawer and arranged on the chair be-

side her. Something is up. Along with the coffee and John's breakfast preparations, she smells the hint of a doctor's visit or something worse. Whatever it is, she's against it. Now she scoots down under the covers and gives me a furtive sideways glance. A fierce cough brings me hurrying into the room, a worried expression on my face. Lifting her hand weakly to her forehead in a studied, feverish gesture, she closes her eyes and grimaces in obvious pain.

She has made up her mind that today will be just like the preceding ones—hugs with the girls, a leisurely breakfast, and perhaps a visit to the supermarket. Often she and John shop for dinner, a perfect opportunity for smuggling out a pilfered magazine or two from the checkout. Once Ilana is home from school, the pace accelerates. With Ilana and her friends, there are dramatically ridiculous card games and then come our dinner preparations. Judy insists on setting the table by herself, with an originality not sanctioned by Emily Post.

For now, I feel Judy's head as if for a fever and I smile, giving a hearty thumbs-up, then a heartier two-thumbs-up. "You're in great shape. No sign of illness today!" I say. She glowers and scoots further down beneath the covers. In most contests of will, Judy wins hands down, but today is too important and I hold my ground. So far unsuccessful, but still hoping, she rolls her eyes in feigned delirium, looking plaintively at me. Moving close, I shake my head. For Judy, it's time for even further escalation. Sitting up with painful effort, she summons a deep, hacking, tubercular cough. Even so, go she will!

Judy looks at me suspiciously as we park beside Creative Growth, but I'm prepared. I have a new magazine in my hand, and as I open her door, she climbs out cheerfully enough, tucking the magazine in at the bottom of her stack, all of them held carefully and closely against her chest. Irene greets us warmly, and Judy and I follow her into the bright and busy studio. A staff artist helps Judy to a place at a table with others who are painting and drawing, a riot of color flowing across the papers.

Judy takes an immediate dislike to the thin woman sitting next to

her and moves herself and her chair to the far edge of the long table. She takes her magazines and puts them beside herself on an empty chair, pushing it in and drawing it close. A staff member gives her paints with large and small brushes, and after a small demonstration, Judy begins to paint. Meanwhile, she continues to observe all corners of the room with caution, studying the faces and taking everything in. I stay with her for an hour and then leave while she has her lunch: a tuna-fish sandwich, one small yogurt, and a banana.

After an hour, I return and we head home. Judy has painted an almost solid sheet of brown on both sides of the paper in front of her. She's relieved to see me arriving, quickly abandons the paints, puts them on the shelf just in back, and gathers up her purse. She pulls her magazines close again and carries her shopping bag full of playing cards, restaurant flyers, packets of mayonnaise, mustard, and ketchup, along with a few soggy potato chips. We're headed home.

My joy in discovering Creative Growth for Judy is dampened by my knowledge that she will soon need to move to a board-and-care home. When I first reached out to Peggy Hill to ask for her help in becoming Judy's guardian, I knew that Judy would not be able to live with us forever. I work long, irregular hours, and I can't provide the care and constancy that Judy will need in the years to come. Although I knew this in my heart, I had suppressed it, hoping for some miraculous solution. But, finally, with Judy living with us, the painful task of finding a suitable board-and-care home has become an inescapable reality.

Even in her sleep, Judy's in her froggie position, knees out, bottom up, face turned toward me. I stand beside her and cling to this moment, watch her breathe as her covers lightly lift and fall. There's a slight movement around her nose. I sigh. How can I let her know that this cannot be her home forever? How can I do it? I can't tell her because she can't hear, but mainly I can't tell her because I can't stand to tell her. I know that this reunion has given us some time to find our strength together. If only I could tell her that from now on, wherever she is, she'll be

nearby and we'll always be together and always see each other. If I could somehow say all I need to say with the words she would understand, or say it even without the words, then this time of change wouldn't be so sad and so painful. I think of her breathing in my arms with our little girl selves wrapped around each other. I think of her being taken away from her home in the darkness and, now again, to be taken away. How can I do this to her?

I must find a place that's nearby and welcoming, where we can have time with her every day. I want a place with a sense of family, where she can spend her time with people who love and appreciate her. A place that will welcome us as her family. I already know that the state-funded regional center can help with placements, so I turn there for recommendations.

I later realize that despite many dedicated counselors at the center, we are assigned to the exception. Sloppy, unkempt, and overweight, his voice is slow, sleepy, and bored. He clearly has limited interest in Judy or her needs. Telling me not to expect much, without enthusiasm, he suggests a few places nearby.

I begin to visit board-and-care homes in which a small number of people with disabilities live as part of the family. That, at least, is the idea. Many homes are immediately eliminated because Judy is ineligible for those where the people are deaf, because she does not know sign language. At others, she is rejected because of her inability to hear; the homes want only people with developmental disabilities, not deafness. No one seems able or willing to deal with both.

On our regular Sunday phone call, I make the mistake of talking with Mom about my search. I should have realized what was coming.

"I don't know why you would go and take that poor little thing out of a perfectly nice place that she was used to. Now you're in a mess and you don't know where she'll be. You should've left well enough alone. Of course, you don't have time for her. I tried to tell you something like this would happen, but, no, you never listen to me."

I stop moving last night's dishes toward the sink and pause to find the right words and, more importantly, to find my strength and not let myself crumple under what feels like another attack.

"I'm sure it's going to work out fine, Mom. It just takes a bit of searching."

With lightning speed, I change the subject. "How's your friend Shirley? Did she decide to switch doctors after all . . . ?"

Appointments at three follow appointments at eleven. There are few choices, but so far I have visited six places. Each seems worse and more disappointing than the last. Fancy, overdone living rooms in questionable neighborhoods on busy streets, or on quiet streets with gang members lounging at the corner, cyclone fences, pit bulls. Inside, an initial artificial friendliness; small crowded rooms, the "clients" isolated and left by themselves, the caregivers keeping themselves separate, remote, their responsibilities with clients seen as a job and no more.

I check Judy again while she's sleeping, then crawl into my bed full of restlessness and worry, surrounded by doubt all through the night. The doubts turn to a blanket of fog, which by early morning settles around the house, leaving me and everything around us covered in a damp, gray uncertainty. The fog changes its form and the questions take new shapes, but the uncertainty in my thoughts remains: Where will Judy live when she leaves our home? Where is the kindness I'm searching for?

Judy needs me to make these decisions for her, and the responsibility weighs on my bones. In the morning, my doubts grow worse as I see her sitting beside me breaking off the ends of the green beans, just as we did when we were seven and the locusts' high-pitched drone sounded through the screen door. Now, instead, there is a car revving its engine by our narrow kitchen window. Ohio is far away and our childhood is even further. It's not the green beans that are breaking my heart, but

the eyes full of trust and what I find out there in the indifferent world beyond.

Today's appointment is with Mrs. Robinson. Her house is not in a great neighborhood, but who am I to complain about neighborhoods? Besides, it's close by and we can visit Judy any time, provided we call ahead. Mrs. Robinson is welcoming and, in her white nurse's uniform, projects an air of professionalism. She is a large woman, charmingly flamboyant, with her white cap perched on top of a curly red wig, a wig Judy would undoubtedly love to get her hands on. She ushers me into her equally dramatic living room. From there, we go to see the clients, who sit silent in a narrow, almost dark room nearby, dominated by the largest television I've ever seen. The TV fills with the happy expressions of a McDonald's commercial, the flickering light from the screen falling across silent faces that are clearly unconvinced.

Mrs. Robinson has genuine warmth, and hers is clearly the best home that I have yet seen, but it's not what I had hoped for. I call the regional center to ask for more possibilities. Our counselor rouses himself sufficiently to be dismissive: "You don't realize how lucky you are that Mrs. Robinson has a space. You'll never find anywhere better."

So that's it. Maybe we're lucky and I don't realize it. John and I talk it over. "Don't forget," he says, pausing as he adds some tamarind paste to his curry sauce, "Judy is going to be at Creative Growth all day and is likely to appreciate a little quiet time with or without some television in the evening. She doesn't need more activities. She needs to relax, and anyway, she'll be with us much of the time when the Creative Growth part of the day is over."

I bring Judy to Mrs. Robinson's for a visit. Of course, as we begin to park, she senses something is wrong and refuses to get out of the car. The skies are gray; it's not quite dark. In the strange, unfriendly neighborhood, all the houses have bars on their windows. Three young guys are hanging out on the corner. I try to persuade her that getting out of the car might somehow be to her advantage, although I know—and she

knows already—that this is a very big lie. I give her the signs for eating and for getting a nice drink. With tears in her eyes, Judy turns her head away from me, the one person she's counted on to stand by her. Finally, she comes reluctantly and stays glued to my body, refusing to look anywhere but at the ground. Mrs. Robinson's warmth does not reach her.

A few days later, the decision made, I bring Judy and her things to Mrs. Robinson's. In the car, she clings to me and sobs, begging me with every inch of her being not to have to go. I feel sick and want to change my whole life so that she will never have to leave us.

We're both traumatized and heartbroken. I come every afternoon to see Judy and take her for a milkshake or home to play cards. Soon Mrs. Robinson confronts me and tells me I'm interfering with Judy's adjustment. If I don't give her some time and space, she will never be happy where she is. I try to back off. Instead, I come to Creative Growth to see Judy or I pick her up from there. We find new ways to have our moments of happiness together. Still, the sadness softens only slowly.

Following Mrs. Robinson's instructions, I dutifully call to tell her that I will be taking Judy out on Sunday. This she finds acceptable, but she reminds me that I need to be on time. Every Sunday, for our special day together, John, Ilana, sometimes Lilia, and I pick up Judy, and always she is overjoyed and ready and waiting to see us. No one has taught her the names of the days of the week or even how many there are, but Judy knows all about Sundays and is always standing by. In what will become our regular routine, we head for the International House of Pancakes, just after Judy hugs Mrs. Robinson good-bye. It comforts me enormously that a fondness has developed between them.

Judy rushes to the car and swings the door wide, slides her big bottom in, before slamming it shut in eager anticipation. Ilana is at her dad's, so we pick her up on the way. Judy lets out a hoot of joy and bangs on the dashboard, turning it into a drum when we're about two blocks from the big blue IHOP roof on Telegraph. We know we are about to

face choices—six different syrups at least. Judy will have no problems choosing; she'll try a bit of each.

Judy's love of food is a source of some concern, and I make a mental note to start her on an exercise program—well, let's face it, we both need one. My mind wanders and I imagine Judy preparing for the Special Olympics and winning in her category, whichever it might be, perhaps one for deaf Down syndrome artists over forty?

Getting into the sticky vinyl booth with all of Judy's magazines is a trick. After pancakes and waffles with whipped cream and strawberries, we struggle out and head home for a few games of cards.

When we return to Mrs. Robinson's, we ring the bell to be admitted and pass through the steel security gate. We are no longer invited into Mrs. Robinson's private living room. It is seldom used; the massive faux gold-and-diamond chandelier and couch and chairs with plastic covers are too good for those she manages or their families.

In the room beyond, the walls are still lined with the slumped forms of Mrs. Robinson's clients. No one has moved since we left. Mostly women, soft and overweight, they sit in near darkness, docile and impassive, the giant TV now broken and not to be mended for months. Many had been abandoned by their families long ago; all were judged and found wanting, marginalized by society.

Judy goes in reluctantly and sits down at the end of one of the old couches, her chosen place close to the armrest and as far away as possible from her nearest neighbor. The clients barely nod in response to my greeting. I recognize Regina from Creative Growth and tap her on the knee. When her eyes meet mine, she smiles. We know each other.

· · ·

When John and I get married, Taylor comes to California for the ceremony and to meet Lilia and her aunt Judy. Three lovely daughters sit beside us as we take our vows on the spacious decks of a house in

the hills belonging to friends, with the San Francisco Bay spread out magically below us. Taylor looks so much like Lilia that several friends mistake them and are confused. I love it.

I have a passing sorrow that Judy is not here with us to share the celebration. However, I know how much she absolutely hates crowds of people and, even more, hates not having my full attention. She would be miserable. When the party is over, we stop by to bring her a piece of wedding cake; she blesses our marriage with two big kisses and some enthusiastic "Ho, ho, bahs!"

Taylor, increasingly concerned about the military implications of her aerospace engineering program in Buffalo, New York, has switched to environmental engineering and moved to Florida to complete her studies. We talk regularly on the phone. Like me almost twenty years earlier, she's soon drawn to the sense of promise that life holds and carries on the California wind. Of course, I am thrilled at the prospect of her living nearby. Talking things over, John says, "Why don't we offer her the basement apartment; we don't really use it much." Within a few weeks, she's quit her job, loaded her belongings into a huge U-Haul truck, and driven it across the country.

Soon after her arrival, a loving connection develops between Taylor and Judy. Taylor often picks her up while I'm at work and takes her on shopping expeditions and for short walks. The Laundromat is one of their joint projects, where Judy loves to do the folding.

• • •

Arriving at Creative Growth, I am greeted by paintings on the wall, swirls of bright design, and a long mural full of countless, faceless men. There are paper flowers in vases made of exposed wires. Everything radiates its own beauty and an aliveness that seeks no approval, which only celebrates itself.

I am thrilled to be surrounded by the sense of exuberant creativity, a creativity that is apparent in everyone except Judy. Judy shows almost

no interest in her drawings, which seem to be mostly simple repetitive scribbles, often loops and circles, seemingly random.

I begin to bring Ilana and Lilia to visit. Each falls in love with Creative Growth in almost the same way I have, but still I'm not so sure about Judy. I often find her sitting separate from everyone else, still filling page after page with paint without even looking at what she is doing. Instead, she continues to scan the room, keeping an eye on everybody and everything. Meanwhile, all around her I see other artists creating wonderful shapes and images. I worry about her. For Judy, the best part of the day seems to be lunch and a chance to get a Diet Pepsi.

I watch her coloring a piece of paper, a solid, unrelenting green. She turns the sheet and does the same again in another, similar tone, the paint sometimes so thick that the paper becomes textured. It can stand alone. As time goes on, she begins to create with a more powerful use of color. Never mind, I tell myself, she hasn't really been here all that long. She needs time to get used to things after all those barren institutional years. Judy needs to run her life on her own timetable. At this point, I continue to feel ecstatic seeing her in a sympathetic and supportive environment with access to creative materials. I have no sense of expectations, only gratitude.

As I visit Judy at Creative Growth, I slowly get to know some of the artists who work near her, never ceasing to be amazed at their unassuming creative talents. Regina, who lives at Mrs. Robinson's, continues painting as we talk softly together. I notice how the surface of her page seems to fill with fallen rose petals. I wonder what they might mean to her. She sits silently for a while, her dark, worn hands resting in stillness on her thighs, thighs heavy with cheap pasta dinners and too many breakfast rolls. Her eyes gaze out at the cars passing along Twenty-Fourth Street; perhaps she's thinking of the white bus that will soon pick her up and carry her home to her room with the bright red pillows and pink bedcover.

I ask her about the roses. Her room, she whispers, makes her think

of roses. She tells me how when she was little, the old man next door had a big garden and let her pick roses for her mother. Her mother was always surprised, always happy. That was before she started hearing voices and calling Regina the devil. Those roses had been the happy times.

Ever since her mother left—and that was a long time ago—ever since she came to this house, she hears only words from Mrs. Robinson, only words about sitting down and cleaning up. Regina tells me that she can remember soft words; she can almost hear a song her grandmother used to sing at bedtime. It was about babies and an apple tree.

Back to work, she picks up her paintbrush and makes seven apples, all green, all in a row. They are coming out of the head of an old woman with dark eyes. Far away, at the edge of her painting, Regina draws more roses, with petals falling onto sleeping babies, babies both dark and light. I give Regina's shoulder a squeeze and then move on, noticing others and their energy expressed in shapes, colors, and contented smiles.

The staff has let me know that Judy does not seem to be engaged in her work. They explain they have offered her the opportunity to work in many different media—paint, clay, wood, and more—but none appear to hold any appeal. They can find nothing to interest her. I sense that they may soon ask Judy to leave, something I cannot bear to contemplate.

But one day, across the studio, Judy observes a visiting fiber artist, Sylvia Seventy, as she teaches a class. Sylvia encourages Judy to join in, but Judy prefers to sit alone at the end of the table and watch. Soon she does become involved, but only on her own terms. Later, art historian John MacGregor would write, "No one could have predicted the nature or the intensity of her response to the new materials. Clearly incapable of conforming to expectations, of following instructions or imitating what the other students were doing, she simply invented something totally new."

After almost two unengaged, fallow years, Judy suddenly begins weaving discarded objects of all sorts into creations that would later be universally acclaimed for their exquisite beauty and complexity. Tom di Maria, the new director of Creative Growth, observed that Judy's art would become her language to address the world. Just as infants take a year or two to master the elements of language, so Judy's experiments in art as her new language required a similar interval to find its voice.

Judy often begins by carefully selecting threads, yarns, and strings for their subtle tones and textures, which she weaves layer upon layer in endlessly changing patterns over a core created from whatever objects she can find or scavenge, but transformed always into a unique and improbable structure.

The first piece of Judy's work I see is a twinlike form tied with tender care. I immediately understand that she knows us as twins, together, two bodies joined as one. And I weep.

From that point on, Judy's situation at Creative Growth shifts dramatically. The staff soon gives her the freedom to scour storerooms in search of yarns and other materials and leaves her mostly undisturbed to forage throughout the studio for objects that she might incorporate into her sculptures. Only "borrowed" keys, wallets, and, once, my ex-husband Richard's paycheck will be surreptitiously reclaimed by staff if spotted. She wraps and buries the rest, including the night custodian's broom, a broken chair, and an old shopping cart left by the front door, never to be seen again.

On this morning, as on most others, Judy is noticeably stooped and moves with caution as she walks carefully to the small white bus that takes her and her friends to Creative Growth. Judy, as she ages, seems older than her years. However, stoop or no stoop, when she arrives, she slips deftly past the crowd waiting to sign in at the entrance and begin their day of artistic expression. She admits no delay and feels an immense pull toward her emerging piece, which seems to beckon her. As she moves to her chosen place toward the back of the huge studio,

now bright with morning light, a box of tissues on the table catches her ever-scanning eye and disappears with a swift sweep into her capacious black bag. Had someone's sunglasses, address book, or lunch box been visible, they too would have suffered the same fate. Sometime before lunch, the tissues find a place in her evolving creation. Often the objects that become hidden deep within her work seem to reflect her life experience, perhaps recapturing in some way the losses she experienced at the institution. I look at Judy and wonder how she can translate those lost years of institutional living so vividly into the living heart of her work. Judy is "stealing" back and transforming what was taken from her when she was seven. The thirteenth-century Sufi poet Rumi once wrote, "What was lost in the looking comes back completely changed." This seems like a perfect evocation of Judy's sculptures.

Judy takes down and examines her current sculpture, which she had placed carefully on the shelf behind her yesterday. She gives it a loving pat. She pulls out her large box of yarns from its hiding place under the bench—ones she had deliberately selected days before—this time colors of muted earth tones. Laying her scissors on the table, she pulls out the chair next to her and places her packed lunch, her black bag, and her magazines on it. Looking around quickly to see who might be watching, she swiftly pushes the chair and its precious contents out of sight beneath the worktable, then pulls it a bit closer to her. Years of institutional life have left their mark, and she is ever vigilant and guarded about her possessions.

Now it is time to start work. While other artists are still waiting in line to check in, some patient, some restless, Judy is already focused on her latest creation. Turning the piece around, she selects an area and begins weaving an orange thread through, around, and in and out of strands already in position. She works without stopping throughout the morning, pausing only to glance occasionally around the studio, ignoring all but a few staff members who come by to greet her and observe her latest creation. When Tom di Maria stops by, they greet each other

with high fives, and Judy nods knowingly in the direction of the soda machine, the signal for him to buy her the regulation Diet Pepsi that convention now demands.

Her current piece, like others before it, may take several months of intense work before Judy considers it complete. Only she can decide when it is finished. Although various staff artists may be astonished by what they see in the different stages of creation, they recognize that there is no persuading her to stop. Out of respect for her creative process, they never try. Judy continues to cover and recover a piece a dozen times or more before she is satisfied. Countless masterpieces, thus glimpsed but momentarily, have vanished forever, consigned to oblivion by Judy's resolute, unwavering personal vision. For her, they are but one step in her creative process.

Only when she and she alone is satisfied does Judy, with a dramatically expressive sweep of the hands, signal to staff artist Stan Peterson that he can take it upstairs to join the growing collection of her work in storage.

At lunchtime, she puts her things away. She quickly consumes her banana and sandwich, and resumes work until three.

Judy's workdays are routine and filled with relentless work and dedication until, following a major earthquake that rattled the Bay Area in 1989, the building undergoes extensive retrofitting and turns into a construction site. Once the project starts, all the artists must be evacuated each day. For three months, the staff takes them on daily walks to Lake Merritt, where they draw, have lunch, and perhaps throw a Frisbee, before returning in time for their buses home. Each day at the construction site, backhoes excavate the concrete studio floor. Welders are building cross-braces for all the corners and reinforcing the brick walls with rebar. All the workers wear ear protection and goggles. There is constant noise, confusion, and flying sparks.

Toward the back of the studio, a ramshackle blue tarpaulin covers a few desks and file cabinets. Under this shelter, Judy, alone and unperturbed at her table, maintains the ritual of her daily art process. Being deaf, she is insulated and isolated from the chaos of her immediate environment. However, she eventually exhausts her supply boxes, with no more materials available. Stan Peterson later wrote, "Being a true forager, she then went scavenging. After washing her hands at the sink, she discovered that the paper towel dispensers would keep unrolling yardages if she kept turning the crank. Taking armloads of this material back to her darkened cave, she would start knotting and assembling the bolts of rough paper into a lump-like form. Each day it grew, gained more presence."

The workday is over when the small white buses start to line up outside to take the artists home. Judy once more slides her box of yarns under her table and places the growing sculpture on the shelf. Giving it a farewell pat, she picks up her bag and heads for the door. Another short bus ride through the streets of Oakland, and she is at Mrs. Robinson's once more, back to her room to change out of her work clothes, which she neatly folds and places carefully in their appointed place, each drawer, as always, meticulously arranged. Judy understands order and routine. In fact, she absolutely insists on it. Getting Judy to alter her routines can be close to impossible, like persuading a powerful river to change its course.

A Room of Her Own

Our house on Roosevelt Street has served us well, in spite of its idiosyncrasies, but we feel the need for more space. When, in 1989, a realtor friend tells us of a large brown-shingle house he has for sale near the UC Berkeley campus, we act quickly.

We have not been settled for a week before an old friend, and now new neighbor, mentions that she knows of a board-and-care home less than two blocks away. I am thrilled by the possibility that there might be a place for Judy so close by, and I call to find out more, arranging to visit the following day.

The front door opens even before I reach the top step, and there is Connie in sweatpants and T-shirt, full of exuberant warmth and welcome. Connie, her face a study in kindness, is from the Philippines and manages Windsor House with her relatives. Once inside, I glance around and see on the left, opening from the hallway, a large, bright living room with sunlight streaming in. The television is off and a few residents, absorbed in their own worlds, are busy coloring, playing cards,

listening with headsets, or working on jigsaw puzzles. The silent row of half-asleep clients at Mrs. Robinson's seems a world away.

I comment that the living room seems almost empty, and Connie explains that each morning, most of her clients board a regional center bus and spend the day at an activity program, several of them going to Creative Growth. Typically, only two or three elderly women with Alzheimer's disease remain at home.

As we begin our tour, Connie mentions that she does have one vacancy. It seems I have arrived at the right moment. I meet Lily, the house cook. Her very little girl, Aurelle, has Down syndrome and is playing happily in the middle of the kitchen table. I can immediately picture this child on Judy's lap and imagine the joy that Judy will experience in having a little girl to love. Next, we head upstairs, where Connie shows me the bedrooms and bathrooms. Connie mentions that family visitors are always welcome at any time, day or night, without appointments. "Just come on in. You can be with Judy whenever you want, wherever she is," she says. I can hardly believe it. The contrast with the limited access at Judy's present accommodation is striking.

Connie apologizes, saying that the room Judy could have is small and in the middle of a long hallway. She adds that, at the end of the corridor, a large bright room with two windows looking out over neighboring trees and gardens will soon be available, and I visualize it for Judy. I can see it painted in bright colors, with some plants, lots of cushions, and full of family photographs. In the meantime, this small room is more than fine. What I feel is a loving, compassionate energy swirling everywhere, and that is all that matters.

Within days, Judy happily joins the extended family at Windsor House, and I can tell that she instantly feels this place will be her home. She somehow knows what to do without knowing the words that go with any expectations, without knowing any rules. Reaching her room, she goes straight to the chest of drawers where she carefully unpacks her clothes and folds her underwear on the top left side. Pillows and

stuffed animals go on the bed, magazines and purse under her pillow, a few additional things tucked away in the closet, and there! She's settled in with no fuss or hesitation. She does not allow me to help, only to watch, as she smiles at me and then to herself, making little clucking mother-hen noises as she makes her nest.

The next morning, I join her in her bedroom before breakfast, bringing her a new scarf from the collection I keep by the door, always ready to deliver, often accompanied by a banana. Judy never likes to share her banana, and now she watches me cautiously as she methodically breaks off bite after bite, smushing them with her gums before swallowing.

Next, she dresses with care, putting on two tops and a sweater, even though it is not actually cold. Then a scarf over her head and over that a hat, also covered by another scarf, which she wraps around and tucks in with a flourish. She runs her hand along the scarf, feeling its softness surrounding her head. She is becoming her own artwork, a living, breathing sculpture. Looking one last time in the mirror with a smile of pleasure, she is prepared for her day.

By the end of the week, Judy seems completely at home and has subtly begun a takeover, an apparent silent plan to manage the entire house with its eleven other clients and several staff. As she walks down the long upstairs hallway, she systematically flushes every toilet and puts down each lid in its place. In the evening, just as carefully, she turns off all the hallway lights, letting everyone know that it's time for them to be in bed. She peeks in Ruth's room where she's sitting in her lounge chair and shakes a warning finger, reaching around to turn off her light.

In the morning, Judy soon knows that Paul, also an artist at Creative Growth, will be waiting downstairs. Judy has been drawn to Paul ever since she started at Creative Growth. She has little time for anyone except for Paul, and to find him living with her in the same house must feel like winning the lottery.

Every day when I arrive, I find Paul, with his shy smile, sitting quietly in his headphones and blue baseball cap emblazoned with the letters,

P-A-U-L. As Judy heads toward the breakfast table, she pauses briefly to plant a kiss on his cheek and wrap her arm around his shoulders. Bobby, the maternal and bossy wannabe mother to everyone, is big and slow, and almost flows from her overstuffed chair. She wants to make sure that Judy has tied her shoes. Of course, Judy's tied her shoes. She loves to tie them, many times over. It's one of her minor pastimes, but Bobby tries to boss her anyway. Judy waves a hand dismissively in her general direction. She's having none of it. For a moment, the image of our mother flashes through my mind. Judy has inherited Mom's fierce independent spirit, but the deep sweetness and compassion belongs only to my sister, my twin. Judy sets her breakfast tray on the table, with her magazines on the seat beside her. After a quick attack on her own food, she returns to the kitchen to carry trays for Jenny and Mary, who, lost in a world of forgetfulness, never leave their chairs. She helps feed them—a bite for you, a bite for me. Breakfast over, Judy collects her magazines and her lunch—her sandwich and banana—sits back on the couch next to Paul, shoulders touching, one leg crossed conveniently for easy access to her shoelaces, and waits, ready for the bus to take her and her Creative Growth companions to the studio.

On this morning, Judy obviously wants to control my time, and she clearly indicates that I should leave. Since she can have no control over my arrival, she takes charge of my departure, but I'm still here. She points unhesitatingly toward the door and waves me a deliberate good-bye twice. There's no way around it; I have been dismissed.

In the evening, back home at Windsor House, we sit together on Judy's bed. She's leaning against a lion-head pillow with her purse beside her. Thoughtfully, she passes me four of her eight magazines. She pulls me close, kissing both cheeks, an eye-to-eye closeness that makes her seem cross-eyed. Four of her eight magazines! What have I done to deserve such an extraordinary act of generosity? Here in my hands I have a 1984 copy of *National Geographic*, *Good Housekeeping*, and *Art News* from three years ago. Back and forth, we pass the *National*

Geographic, with its pictures of mountain climbers and gorillas, kissing the cute guys and the very cute gorillas. Suddenly, she's up and putting on her nightgown. She climbs into bed with her four prized magazines and purse tucked safely under her pillow, pulls up the covers, waves me a sweet good-bye, and then blows me a brief kiss. Clearly it's time to leave.

As she reaches to turn out the light, I look again at those dark circles under her eyes and the paleness that borders on blue. I wave back with my own small, sad good-bye and softly close the door she'll never hear. The hallway is in darkness. No doubt Judy turned off all the lights in the long hallway as she approached her room.

The enormous freedom at Windsor House makes it easy for all of us to visit Judy and also to take her on outings. In a scene that is often repeated, I bring Judy with me to go grocery shopping. While my back is turned as I scan the shelves, Judy surreptitiously slips into her bag whatever may appeal to her. Fortunately, it's almost always magazines. Then, while her back is turned, I replace the ones she has selected with *Real Estate Today* and *Car World* from the free racks just inside the store door. This time, I am lucky, and she doesn't seem to notice the exchange.

One day, when I arrive at Windsor House, Connie and Judy are doing yoga stretches, both on the floor with legs touching, pulling each other forward and back. It is a particularly good morning because Connie has given Judy a Band-Aid, a fashion accessory rather than a medical necessity, and placed it on the finger of Judy's choice. She shows me proudly. The finger now carefully wrapped, Judy holds it up for Connie to kiss, and both of them laugh.

Although I know Connie is planning to marry, I'm devastated when, after two happy years, I arrive one morning at Windsor House upon returning from a visit to John's family in England and find her gone. Instead, I meet Lucy and Joe, part of the same large, extended family, recently arrived from the Philippines. I can hardly imagine how Judy

must feel now losing Connie, who she's come to love so much. How many caregivers moved on and away from her in her thirty-five years at the institution? She's had so many enormous emotional losses in her life, yet her capacity to love remains. Within a few weeks, Judy, while initially reserved and cautious, embraces Lucy and Joe with a new love, one that will continue to grow.

12

The Opening

"Let it go well tonight, please let it go well." I repeat the words over and over, as if I am back in Ohio, eyes scrunched shut, praying for Judy to come home. "Please. Make it turn out all right." Inside, I feel like an eight-year-old child yearning for her lost sister, her best friend, her twin.

At the traffic light, I make a quick turn on yellow off Telegraph Avenue, hoping to gain a minute or two of precious time. Instead I encounter a homeless woman with her shopping cart and loosely roped dog crossing slowly in front of me. I pause, taking long, deep breaths, doing my best to remember my meditation training. "Breathing in, I relax my body. Breathing out, I smile." But tonight these words hold no power. Instead I squeeze the steering wheel hard, then move the gearshift aimlessly while I wait. My poor worried mind is repeating its urgent plea that Judy be in good spirits for tonight, this most important of nights. It's an old feeling, this sense of desperation, the familiar anxiety that I must be ever vigilant about Judy, that something bad might

happen if I am not, that all will be lost in a moment's inattention when things might change and never be right again.

I find a parking place right in front of Windsor House and accept this stroke of luck as a good omen. Reaching into the back, I gather up Judy's long blue dress, her cream-colored shawl, the little makeup bag I had borrowed, plus a couple of magazines for bribery. Pushing the car door shut with my hip, with arms full I hurry up the three concrete steps and knock.

Lucy answers the door, rolling her eyes in mock despair. "She's upstairs and already in her pajamas, ready for bed," Lucy warns, nodding for me to go ahead. I want Lucy to come with me, for I know Judy now loves and respects her and, most importantly, pays attention to her, but I realize that tonight I'll be on my own trying to persuade Judy to break her routine. With each step, I try to compose my face in the hope that she won't notice my anxiety, my sense of urgency.

Although she is unable to hear me, I knock as always and open Judy's door slowly. She has never liked surprises. She has experienced too many bad ones. It is evening now, her time to relax in bed with her magazines and TV. She sees me with my arms full, sees the worry behind my mask, and knows that something is up. She frowns. "Why you? Why me? Why now?" Since childhood, she has recognized my feelings better than I do myself.

Lucy is right. Judy already has on her blue-flowered pajamas, with her pink slippers placed neatly next to the bed. On her head is only a single scarf, a clear indication that she has settled herself in for an early evening and for her downtime. Judy has no idea that this is to be *her* night. Maybe I should have come earlier. In preparation for the challenge ahead, I give her my best smile. She gives me her best you-can-just-forget-it stare.

I get the evening clothes out of their plastic bag and show Judy the blue dress, hold it up to myself, swishing about to demonstrate how lovely it will look. Then I hold it up to her. She pushes my hand and

the dress away and screws up her face in distaste. She makes a point of peering around me to see the TV. I turn and switch it off. She gets up, walks around me, turns it back on, and returns to bed. I remind myself that getting annoyed is not going to help.

I sit down next to her, point to the two of us, and pretend to be steering the car with my arm around her. She shakes her head; her lips are grim, disappearing into the space where her teeth once were. I stand in front of her making gestures of eating what must clearly be delicious food, given the obvious pleasure I am experiencing. Then I point to the closed door where we need to go. She shakes her head some more, looking away with a theatrical toss of her head.

It's not working. Okay. I do some more fast thinking. Giving up is not an option. Tonight is a celebration, a double celebration. It will be the first public showing of Judy's sculptures and the launching of *Metamorphosis: The Fiber Art of Judith Scott*, a stunning new book about her work, by John MacGregor. This night is Judy's night. There is no way I can allow her to miss it.

I get out the makeup kit and a mirror and begin to apply my lipstick. I smile into the mirror and then, holding Judy's chin, put some red on her barely visible lips. She looks in the mirror and smiles. Next a little rouge, first on my cheeks, then on hers, then some shared glances into the mirror, and we smile out loud. Things seem to be going along pretty well now. The knot in my stomach is starting to soften. I do a little dance around the floor, indicating the good times ahead. She smiles some more. We do a high five. Now we're on a roll. I reach out my hands to hers and pull her up, and we dance about, bumping our hips sideways. While she's still standing, I give another quick flash of the dress, then reach to the buttons of her pajama top and begin to help her to pull her arm through. She agrees with the idea and goes on to remove her pajamas, tops and bottoms. I pull the dress over her head and we're halfway there. A little slip to step into, no problem. The stockings and shoes she is not thrilled about, but she cooperates. I hand

her the shawl and help her wrap it around herself, and there we are. I am so pleased. I am smiling. I am relieved. I notice she is not smiling much anymore.

She is not looking pleased, but maybe I'm just anxious. Maybe she's okay. Maybe she's fine. I put the makeup back in the bag and gather up our things. It's time to go. She has her large black bag with her magazines and other valuables as she heads toward the bathroom. Of course. Last stop before we head out the door. I wait, pacing back and forth in her room and out onto the landing, peering impatiently over the banisters and down into the hall from time to time.

Paul, short, solid, and steady, is sitting in his usual chair in the living room, patient as always, motionless, except for an inner smile that at times flits across his face. Next to him are our closest childhood friend, Kathy, and her husband, Jim, who flew in from Cincinnati earlier in the afternoon. Paul looks different tonight, for he too is dressed for the occasion and has on his best pants and shirt. Kathy has helped him with his beautiful green tie bearing ducks in flight. On this special night, Paul will accompany Judy.

Paul keeps his thoughts about tonight to himself. In fact, he has always kept his thoughts to himself. For his first five years at Windsor House, no one knew that Paul could speak. He had never spoken a single word, maintaining his own self-imposed silence, until one evening when he asked quietly, almost in a whisper, "Could I please have some more mashed potatoes?" He was given potatoes, lots of them.

Judy clearly sees more in Paul than his quiet manner might suggest. Coming or going, she never misses a chance to plant a big kiss on his cheek. Their friendship was cemented on Judy's first ride with him on the bus from Windsor House several years ago. Climbing aboard, she pulled herself up the steps and sat next to Paul, choosing to wedge her ample bottom into the seat beside him, although a sea of empty seats surrounded them.

Finally, across the hall, the bathroom door opens and Judy appears. Clad again in her pajamas and bathrobe, which she must have hidden in her bag, and wearing her bright pink slippers, she glides into her room. Turning on the TV as she passes by, she sits down gently but resolutely on the bed next to me. She smiles graciously and gives me a little comforting pat. *Jeopardy!* has just begun.

They're waiting downstairs, and they're waiting at Creative Growth. They're all waiting. Surely they won't start without her. Judy is smiling to herself while she pulls out her magazines and leans back comfortably in her bed. I am desperate. I fly through the hall and down the stairs to find Lucy pouring juice in the living room. "Lucy, Lucy," I cry, "she's back in her pajamas!" The panic in my voice is barely suppressed. Lucy, ever calm and patient, lays down her tray and moves gracefully up the stairs with me panting beside her.

I don't know what she does or how she does it, but it works. Judy understands that Lucy means business. She knows very well that I am just her sister, her other self. Lucy points to the rolled-up dress already put away in a drawer, pulls it out, and starts again. Judy ignores me, but cooperates with Lucy without hesitation. Most likely this is about being twins and who calls the shots, but never mind; we are now back on track, only somewhat later than we had hoped.

Judy balks at taking off her slippers. She takes the black pumps from Lucy's hands and puts them away in her closet with a decisive close of the door. There's elegance, and there's comfort. She recognizes the importance of both and has made decisions about her own priorities long ago.

Now Judy lets me help with her head scarves. Between us, we make a combination of two designs with bright colors mixed, interwoven, and wrapped more simply than her art but somehow related. As interest in Judy and her art grows, so will the size of her sculptures and, even more, the flamboyant exuberance of her scarves and headdresses.

Judy, Paul, Kathy, Jim, and I all squeeze together in my Subaru hatchback. Judy settles comfortably in the front seat next to me. The others are stuffed in the back. I pass Judy her banana, a ritual we have developed over the years, a small thank-you for tolerating all the inconveniences I bring about. She peels it with careful deliberation and then plunges in, three bites and it's gone. She passes the empty banana peel back to Kathy and chuckles, one of our little jokes, one that now includes Kathy.

I am conscious of directing all my conversations first to Judy, who wants always to participate and wants not to be excluded. Judy watches our mouths move and nods in agreement with an occasional exclamation, an "Aha" of surprise, mixed with expressions of scorn, of pleasure, of concern. Judy's babbled conversation may be short on words but not on feeling, and the intention in her utterances is always absolute.

Uncertain of Judy's interjections, Kathy and Jim respond directly to me from the back seat. A black cloud gathers over Judy's face, and she folds her arms over her chest and glares straight ahead. "Kathy, Kathy," I interrupt. "Judy first, she wants to be part of all we say."

"Oh, sorry, sorry. Of course, sorry, Judy," Kathy says, tapping Judy's shoulder to gain her lost attention. Now all our conversations continue through the "Aha" loop, and Judy decides she does like that they're with us, her enthusiastic "Aha" and "Ho, ho, bah" comments growing ever more animated as we drive through the early evening traffic.

At one point, Kathy, somewhat confused but doing her best, turns to Judy and asks her, "How long does it take to get to Creative Growth?" Judy replies with a dramatic "Aha!" and a slap on the ceiling. I translate for Judy. "Oh, fifteen minutes at the most," I say in Judy's direction, as I rush to make the light. Judy pats my leg in agreement.

Paul remains silent. He sits hunkered down in his corner of the back seat, staring out the window with his slight smile. There's a certain Mad Hatter's Tea Party atmosphere inside the car.

Navigating the streets of Oakland, Judy, from her shotgun position,

points out spots of interest and various places that she recognizes. She sees the Burger King on Telegraph Avenue and soon realizes we are headed for Creative Growth. Her spirits clearly lift. As we near the studio, she is careful to point out each turn, wanting to be sure we make no mistakes.

For the past twelve years, Judy has been coming daily to Creative Growth, where the staff has given her free rein to express her innate creative genius. But few people have seen her creations beyond these walls. The discovery of her work and the extraordinary story of her life remain untold. At this triumphant gallery opening, the larger world will discover Judy's extraordinary sculptures.

Finding parking at the studio is even more difficult than usual. I ask Jim to take care of the car so Kathy and I can go in with Judy and Paul. Judy is pleased not to find herself at the doctor's office and particularly happy to be at Creative Growth. So after gathering up her black bag, her stack of magazines, and reclaiming her banana peel from Kathy, she goes in happily.

Tom di Maria spots us as we enter and is ready with a welcoming set of high fives for Judy and Paul. Judy looks at him expectantly, and dutifully he hurries off to get her a Diet Pepsi, their daily ritual that he must repeat despite having already done so just this morning. Many of the staff are here and head toward Judy and Paul, to congratulate Judy and to let them both know how great they look. Paul beams in his modest way. Judy's face crinkles with pleasure, particularly at having her turbans appreciated. I beam, too. We are all beaming. I am not the one who is being appreciated tonight, and yet I feel as though I too am the one.

Deep inside, Judy and I inhabit a world where there is no difference between us, a place where we are one being, where no one else goes. As in our beginning, it is a place where her movements and mine are related, so tightly bound are we. In our shared womb, who could have named the one who moved, not Judy, not me, not even our mother

who knew us only as one. The distinction between us remains fluid and undefined.

Beyond us in the studio, helpers—all of them Creative Growth artists—set out plastic cups and bottles of wine, crackers, and cheese on a large trestle table draped in white. Judy is immediately interested in the crackers and cheese, moving swiftly to get some for herself and Paul. Paul, doing a bit of anxious rocking in a nearby chair, accepts the snacks. The back of the workshop is partially closed off with curtains, and I imagine Paul and Judy must feel strange being here and yet not have access to their work, their art.

Before long, Tom draws me aside, eager to describe the scene at Creative Growth earlier in the day. "We wanted Judy to have a preview before this evening's opening," he says. "Naturally we were curious to see how she would react to meeting her pieces again. Most of them have been in storage for several years since she finished them. I felt pretty sure she'd recognize them, but not everyone agreed.

"The gallery itself was without light, with only the sculptures lit," he continues. "It's a pity we couldn't keep it that way for tonight, as each piece seemed to float alone in space supported on light beams, but it would have been too risky with so many people. The staff was all standing together in the shadows at this end. When Judy opened the door at the far side, we could see her pause for a moment, hesitating slightly at first.

"Once her eyes had adjusted to the light, however, she came straight in. We could just see the broad smile on her face as she clearly recognized her sculptures. She went to each one in turn and greeted it, a hug here, a kiss there, sometimes a gentle caress. Some seemed only to receive token recognition, just a simple wave of the hand. It brought to my mind a mother meeting her long lost children.

"But then, when she had finished, she came over to us. She was very expressive, clearly thanking us—that's one sign she knows—and her expression said even more. We had no doubt at all that she understood

that we had brought all her 'children' together and that she wanted to acknowledge this. I don't believe there was a dry eye anywhere." I breathe this in and thank Tom for sharing it, once I've found my voice.

Now Creative Growth is bright and festive. A line has gathered in the street, all admirers of outsider art. Wearing coats and sweaters against the cool night air, they are patiently chatting together as they wait for the doors to open. They are a potpourri of Bay Area art collectors, professors, aging hippies, Piedmont matrons, Goth girls, and young ponytail types. Inside, Creative Growth's board of directors, together with some distinguished patrons of the arts, have already been admitted by the gallery doorman. Everyone wants to meet Judy. Most are middle-aged professionals, all elegantly dressed. Radiating confidence and enthusiasm, they seem pleased with the event as it unfolds. Perfumes mingle and bright scarves catch Judy's eye.

In greeting these eager strangers, Judy's responses vary from ignoring some with what borders on disdain to embracing others with eyes full of tears. I wonder, does the person she embraces remind her of someone she has loved or does she sense something within that person that engenders a deeply felt connection? I cannot say. She cannot say. Many reach out their hand to hers, others make gestures of goodwill and admiration; the man in the brown turtleneck silently pantomimes applause, his partner signals with pleasure, a strong thumbs-up.

I too am warmly greeted. Nina, an artist on staff, admires the borrowed Thai silk jacket I am wearing. She squeezes my hand and smiles. Strangers come up to introduce themselves and say how excited and thrilled they are about this evening and, more particularly, about Judy's work. Several journalists and photographers are full of questions for me: "What was it like growing up with a twin with Down syndrome?" "Are you identical?" "Has she always been deaf?" "Did you realize she was an artist before you enrolled her at Creative Growth?"

I look over at Judy, this small, self-possessed figure sitting amid all the confusion of people surrounding her, wildly plumed as always,

lacking the language of those around her, yet supremely centered in her solid, certain self. Judy knows her worth. She has never allowed herself to feel discounted by the world or by anyone. Despite decades of institutionalization, her light was miraculously not extinguished and now shines with brilliance. It dazzles us. She cannot name the recognition she receives in this moment. Living in a world without names, without sound, this night of recognition is like . . . like what to her? It must wrap around her like the embrace of a warm Midwestern night, these admiring smiles, these loving eyes. Judy has known hard eyes and soft eyes and understands the difference.

Moving through the crowd, I am delighted to see John MacGregor, who is here to celebrate not only the vernissage, or private viewing, of Judy's first show, but also the publication of his beautiful book, *Metamorphosis*. His careful attention to our story had earlier brought me to tears. Here was someone who was interested in knowing the unfolding of our lives, who cared about Judy and what she had suffered, someone who recognized and celebrated her genius. In some ways, I felt that, with him, we were heard for the first time. As long as Judy was overlooked, I was overlooked. As long as Judy was a secret, I was a secret.

At Creative Growth is a wall lined with photographs of the artists. Prominent are pictures honoring two who have recently died. One was a young woman artist with Down syndrome who had a sudden heart attack and was gone. Seeing it, my anxiety about Judy's heart condition is reactivated and then quickly again suppressed.

Already here and waiting to greet us is the family. Judy's family. Our family. My daughters, Judy's nieces, glow with pride. We have traveled a remarkable and complex journey since the first days when all of us lived in a crowded one-bedroom flat—Judy, my two youngest girls, and I, together with John. Now, here tonight, there is the addition of Forest, my baby grandson, Taylor's little boy. He's the one Judy loves most to pat. They have all surrounded her and seem almost unable to break away from her to look at the exhibition.

Our friends, too, are here, all dressed up and happy and proud to be celebrating Judy and her art. I have long since moved those friends who do not celebrate Judy to an outer, more distant circle, and they are not here. As in childhood, Judy and I come as a package; you don't get one without the other.

As I watch guests enter the exhibition gallery, I see reflected in their eyes the same shock and stunned surprise that I experience in the presence of these pieces. I recognize their sense of awe as they move into the room, their sense of the unspoken coming to life, being given form. Emotions, experiences in their pure form, undiluted by words or the repetition of stories told and retold. Instead, they find the concentration of a life distilled into these mysterious forms with their dense, rich colors. Feelings too deep for words and stories never before spoken or heard are here expressed, and we cannot help but gasp. Here, deeply moving but unfathomable, we detect the experience of betrayal, the sense of loss and longing; here, the feeling of closeness, of oneness, of love. Feelings covered, hidden, compressed into a small tight space and protected; here, feelings exposed and exploded, a riot of joyous color.

These oranges and reds, perhaps our rich Ohio summer sun, the greens our trees and grasses, the soft bumps reminiscent of the rabbits we loved. Here, in one piece, she seems to be trying to forget something. I can feel its presence hidden under dozens of layers of covering.

Two pieces remain my favorites, the first of her sculptures I ever saw. They are figures that look like Native American dolls, like twins facing each other. I had cried then, understanding them to be symbols of the two us together again. Here are another two shapes wrapped so gently together, so tenderly entwined and joined, that they may be the two of us in our oneness and our two-ness. In another piece, I see someone caught in a straitjacket and thrown onto her back, not dead, but alive and waiting to burst free of her confinement. Here I see Judy

as a butterfly, now free, now large, stretching her wings. Within me, there is a softening. Closed doors begin to open. Like Judy's sculptures, treasures that have been hidden for decades are now reclaimed. The little girls locked away when company came, hidden from the world outside, our mother's shame, are from a past long ago. That was before. From behind these closed doors, Judy and Joyce begin to emerge, to have a voice, to be free.

What I hold as words in my memory, she holds in her sense memory and speaks through her touch and the movement of her hands. The stories I tell in words, she tells in color and texture, in shapes and touch. As she weaves her memories into these forms, I more clearly than ever know that I will continue to write and weave her story, our story, with my words.

As John MacGregor signs copies of his book about Judy's work, he and a local art critic discuss one of the pieces nearby. They move off together down the gallery to examine the piece in question. Judy wastes not a moment. Seizing the initiative, she steps quickly forward, slides into John's empty chair, and immediately takes over the signing, to the delight of the growing crowd of admirers who throng around her for her signature.

John MacGregor, gracious as always, accepts his eviction with a rueful smile. Within moments, more people gather around the table, everyone now eager for a copy of the book autographed by none other than the artist herself. No simple inscription, no delicate signature for Judy. Often the signing is only complete when no more space remains to be filled on the title page. Judy does nothing by halves.

I watch her from a distance in her flowing blue dress and pink slippers. Judy pauses for more juice, crackers, and cheese, brought to her by one of her admirers. The gallery has been filled with people, wall to wall, for a couple of hours, and Judy is getting tired. I see her small shoulders begin to sag. The circles around her eyes are darker now; she appears paler, more fragile. The long line of people still waits hopefully

for her signature in their book. Although she has no words for "I want to go home," her decision is clear. She turns away from the line, picks up her magazines and some new additions she has added to her stack. I see that she's found a copy of *Moosewood Cookbook* somewhere. She turns her back on the next hopeful person in line and pulls up her black bag, gives me a quick, knowing glance, and heads for the door.

The crowd parts to make way for this small, iron-willed figure. I hurry after her, promising the rest of the family that I will soon return. Kathy rounds up Paul, who is also happy to head home. I ease Judy's slipping turban up from her forehead. I kiss both her cheeks as I open the car door for her. My smile of pleasure includes us both, and I feel certain that whatever her understanding and interpretation of this evening, she has appreciated all the attention and the food.

Some admirers follow her to the car, still hoping for her signature, for their own personally signed copy of the book. With Judy and Paul inside and the car door closed, people thrust books through the open window in desperation. Judy, regal to the end, obliges with a final, theatrical flourish before signaling to me that it is time to drive off.

Now riding home, we are quiet, the streets less crowded, the darkness enveloping us. I pat Judy's leg now and then. She gives me the softness in her eyes and then leans back, resting at last. I ask Paul if he's doing okay. He nods. Through the warm silence, I can feel the space full of contentment and quiet happiness.

Back home at Windsor House, in her own brightly colored room, Judy puts her things away carefully as always, regardless of how tired she might be. Again, she slips on her blue-flowered pajamas, puts her magazines under her pillow, along with the newly acquired *Moosewood Cookbook*. I motion for her to scoot over a little so we can lie down together, just for a bit. She turns off the lamp, and only a light from the neighbor's porch softens the room's darkness. My arm around her shoulder, she reaches up her hand in the near dark to pat my cheek.

Lying side by side, I think back to the dreamtime of our distant

childhood and the twin journeys along which the fates have carried us—the sad, tangled paths we'd traveled alone before finding each other again. I begin to realize that my childhood prayers, so earnestly beseeched have indeed been answered. Judy and I are living in a nebulous galaxy of miracles extending far beyond anything I might ever have dreamed of or could possibly imagine.

13

A Fleeting Smile

A few months later, I head back to the Midwest, to Intuit: The Center for Intuitive and Outsider Art in Chicago, which is having a special exhibition featuring Judy's sculptures. At the exhibition, I am surrounded by visitors, anxiously wanting to learn everything they can about Judy, her life, and her art. The presence of my nephew Glenn and his wife, Jennifer, who've driven all the way from Cincinnati, heartens me. Their effort in coming to Chicago affirms to me that our family has begun to acknowledge Judy's talents.

From Chicago, I go on to Cincinnati to visit Mom, who is nearing her ninetieth birthday. Macular degeneration has dimmed her vision, and she has now moved into a retirement community. A number of her bridge-playing friends already live here, and their daily bridge games have provided strong compensation for the move.

Mom's new apartment is smaller than her condo but still beautifully furnished with her antiques and, as always, meticulously maintained with pride. When together, we mostly sit on her oak bed with the

giant matching bureau and mirror. At other times, we squeeze into the kitchen on the little ice-cream-parlor chairs that have been part of our family forever.

We make graham crackers with peanut butter before bed, exactly like the three o'clock lunches she made for us in Judy's and my childhood. In the afternoon, we spend a bit of time in the living room with the blinds raised to let in the light. I sit close to her on the pink satin couch with Aunt Helen's beautiful, hand-painted hurricane lamp beside. I put my hand over hers, her hand now pale with blue veins and bruises, probably much the way mine will be in thirty years.

We play Scrabble on the lazy Susan atop the raised wings of the coffee table. As always, she beats me. I look at her pearls and think how she dresses so beautifully every morning, but now, with her failing eyesight, she can no longer see the occasional spots and splashes from meal time. Her Gucci purse is elegant but beginning to fray. She has no idea and I'm not about to tell her. Pride is all she has left. The figure who years ago had sat frozen, helpless, and unmoving by the kitchen stove is transformed by a dignity and strength that have fortified her, but also given her a rigidity and severity that can be difficult.

In the afternoon, I stop by to see my brother Jimmy at his uptown VW repair shop and garage on Beechmont. It's bursting with used, unused, maybe someday-to-be-used car parts. I am shocked to see a sculpture of Judy's on his desk at the back, rising above all the papers and projects and notes to himself. I recognize it as the one I had given to Mom two years earlier. Jimmy follows my questioning stare to the dusty but still-colorful piece.

"Guess I need to talk to you about that." He pulls off his cap, scoots the cat out of the chair, and sits down. "You sit over there. Just move those catalogs to the table. Go ahead, put them on top of that pile of stuff."

I look again at Judy's piece before turning to him, noticing a black smear of grease on his face.

"So, how did Judy's sculpture end up here, for heaven's sake?" Anticipating a reply I don't want to hear, I'm already slumping deeper in the chair.

"Well . . . I was helping Mom move and found it in the trash. Decided I'd keep it. I guess she doesn't know how to appreciate Judy's art at this point."

"She just threw it away?"

"Ahhh, well . . . ," he begins hesitantly, "you know how she is. She's getting old now and . . . and doesn't have a lot of room for new ideas, especially about art."

I play with the edges of the papers nearest me. "That's true. But, still, this is about Judy," I begin. Unable to continue, I reach down to stroke the cat.

· · ·

When Mom met John years before in 1986, she had liked him. More importantly, unlike most of my life choices, she approved of him. Since John and I married, I've detected a gradual thaw in my relationship with her, fueled by the softening of my own feelings toward her, as I let go of the blame and resentment I'd harbored for all those years since Judy had been taken away. Sharing my life with Judy, who resented no one, who wasted not one second dwelling on a painful past, was beginning to affect me. And it seemed to me that the meditation on forgiveness that I had quietly been practicing these past several years had begun at last to soften my own heart. Our talks on the phone are now more intimate and more real. Today, Mom wants to talk about Uncle Clarence:

"It was horrible for me when Toady was born. I was already ten and Gramma never again had time for anybody but him. I felt like I lost her then. He was so sickly and she was always worried about him, fussing over him, wrapping him in an extra blanket, staying up late watching over him. And funny looking! He looked so much like a little toad. I

guess that's horrible, isn't it, calling him Toady like that, but that is what he looked like.

"Then when I started high school and wanted to be popular and have the boys like me, here was this strange-looking little brother of mine always hanging around. I remember when Harold Norton came over, there was Toady picking his nose and acting peculiar. It was horrible. I felt so embarrassed."

I'm thinking how sad this is, not just for him, but also for her, and even more sad now since she still can't stand him, to this day. What did it mean to Mom to have this happen a second time? Judy's disability must have conjured up that scared ten-year-old who lost her mother to the care of her strange, needy brother. Maybe each time she saw Judy, all the old feelings flooded through her mind, making her incapable of empathy. Maybe on the outside, she is a distant adult, but inside, the unvoiced sadness of a little girl still lives and grieves. I feel sad for her.

Anxious that Mom understand how well Judy is doing, I try to persuade her to visit us in California. "Don't worry about a thing. We'll pay all the expenses," I say. Finally, she agrees. It will be her first visit. I'm especially eager for her to see Creative Growth and Judy's happiness, to observe firsthand the creativity that she expresses. I'm hoping that now and at last, Mom will be able to recognize Judy's creative self, acknowledge her, see her beauty, and begin to celebrate her.

When Mom arrives, she almost immediately announces that she is tired and not ready to see Judy. She says she needs to wait a few days. I recognize the same resistance, a disguise for her sadness and her fear, that so often prevented her from driving me to visit Judy in the past. We walk at the Marina, eat on the wharf in Sausalito, take the ferry across the Bay, and ride the San Francisco cable cars. Gradually, it becomes clear that Mom is not ever going to visit Judy at her board-and-care home, but that she will, at some point, visit her at Creative Growth.

Days later, we're at last on our way to see Judy. We stop at a light,

and I see Mom fiddling with the bits and pieces in her purse. Pulling out an extra scarf, she asks, "Do you think Judy might like this?"

"Mom, she'll love it. She'll be thrilled."

She nods and closes her purse, the scarf folded carefully on top. She pats her hair a little as we are parking and smooths her skirt while getting out of the car. As we head into the gallery, I watch her become old in front of my eyes, a bit more bent, a bit more unsteady. I hold her arm. She would never admit to any doubt, any fear, but I can silently hold her arm. That much she will allow me to do.

Tom di Maria comes to meet her, and a few of the staff introduce themselves. Judy is in her usual corner, the entire table hers. Her giant sculpture is in front of her, making her seem smaller than ever. Mom greets no one warmly, but does shake a few extended hands. On seeing Judy, she moves back a bit to find a chair, one not too near. She watches her for just a little while, but will go no closer. Judy notices someone looking at her and turns away. The connection they've had seems more buried than the inner heart of one of Judy's sculptures.

We stay only a short time before Mom motions with her head toward the door. I give Judy the gift scarf and tie it carefully around her head. I catch a smile crossing Judy's face, but can only imagine the one on Mom's, a fleeting smile in this fleeting moment. I wonder if Judy knows, for even a few seconds, that Mom is someone familiar. Have time and distance erased all conscious memory of her? What does our mother feel as she stares at her daughter who sits working on her art with such focused intensity? Now she turns and heads toward the door, with no backward glance. We drive to Lake Merritt and a more intimate interaction with the ducks. Mom and Judy never meet again.

Two days after Mom returns home, a dog runs into my bicycle, sending me headfirst and helmetless over the handlebars. When I regain consciousness hours later in Highland Hospital, all recollection of her visit has been obliterated. My memories exist only as tiny spots of light

in an otherwise dark room. All that remains of Mom's visit are the notes entered in my journal while she was with us. Later, John tells me what happened, how an ambulance came for me, how the back of my head felt like enclosed pudding, and how, like a small child, when I awoke, I asked plaintively, "Where's my mom?" In intensive care, I drift in and out of the darkness. I am asked what month it is and make so many wrong guesses that I am left alone and allowed to drift off again.

The next few days at home are blurred. A giant bandage swathes most of my head. Within my skull, there is a terrible pain. As soon as I can, I walk slowly over to be with Judy and sit on her bed beside her. She sees my head layered and wrapped in bandages and takes off two of her scarves to wrap around my ugly white ones. Then, she gives me one of her magazines, a comfort food that doesn't need to be eaten and will never spoil.

Sudden noises or movements startle me. Light gives me a migraine, and any confusion multiplies and ricochets within my head. My memory is bad. John stands firmly by me, but feels helpless. Thankfully, Lilia is away at college, but it's terribly hard for Ilana to be around my hypersensitivities. I feel someone has taken my brain, twisted it, and clamped it tight with a clothespin. The only place of comfort and peace for me is with Judy. Being together in her room is like sitting together when we were little girls. We sit on her bed, our shoulders touch, our hands touch as we gently put cards in each other's laps. After a dozen variations of our basic game of taking cards randomly from each other's piles and replacing them with others, we tuck all the cards in Judy's purse, which will go under her pillow, and we start in on our magazines. Eventually, as always, Judy lets me know, with a small good-bye wave and a nod toward the door, that it's time for me to leave.

14

Heartbreak

As darkness settles, I angle the lamp so the light spreads over both of us. Judy smiles with her eyes, gives a significant nod, picks up her cards, and begins. She likes the feel of cards between her fingers, likes the feel of the slap she cannot hear as she builds her stacks, piling card upon card across the table. Judy's inner imp bursts with demonic laughter as she suddenly sweeps the cards to her side of the table in a lavish gesture. We have rules, but they are rules neither of us understand. Whatever the rules, they change moment to moment as our game progresses. Besides, regardless of the rules, both of us like to break them. I watch Judy return again and again to her stacks, covering card with card, carefully covering, covering, covering. We take turns, or else I slip my cards in whenever I can. There is a barely known beginning and no recognizable end to our game.

Although John and I originally bought the rambling brown-shingle house south of campus on Benvenue with the idea of creating a home that we could share with a community of international students, it

hasn't turned out as we expected. In our imaginations, there would be stimulating dinners and endless, wide-ranging discussions on art, politics, poetry, and history. What we overlooked was that most of the students would be coming to learn English, not yet actually speaking it. Our conversations are instead limited to little more than "How are you?" and "Today, it be look rain." Moreover, their interests rarely overlap ours. Making new friends their own age is more to their liking than strained efforts at dinner conversations with their elders. Yet the house is friendly and lively, reverberating with the youthful energy of our young guests. This evening, our young Japanese girls are a bit shy around Judy. Always polite, they bow to her and smile, holding up their hands to cover their smiles in shyness. Judy nods, equally gracious, and returns to her cards.

Following my bicycle accident the previous spring, I long for a quiet retreat where we can occasionally escape the whirlpool of communal confusion as so many people's lives swirl around, in and out of ours. In time, we discover the perfect spot in the Sierra Nevada, a mountain hideaway near the old gold-mining community of Dutch Flat. Set in a grove of oak trees is a cabin on eight secluded acres adjoining the Tahoe National Forest. Our only neighbors are the squirrels, birds, and a few bears.

When we bring Judy there for the first time, I worry that she might not like it. I want her to be happy here, for I'm already imagining Dutch Flat as the place where Judy, John, and I will live together when all of us are old and retired. Side by side, as we drive along, we're both fiddling with our sun visors. Judy watches me and follows my lead—to the side, to the front—hers just like mine, regardless of where the sun might be. But she soon begins to sense my anxiety. The anxiety has become infectious, and now the two of us are full of worries. Judy looks half-heartedly through her magazines and glances over at me—then at the magazine—then at me—then the magazine again.

The two-and-a-half-hour drive up Interstate 80 feels much longer. I

reach under my seat to see if I've hidden an extra magazine, something to hold Judy's interest, something to please her. There's no pleasure there. She's grinding her toothless gums, over and over at a great rate, something that gets on my nerves, although I know she can't help it, those damned drugs they gave her. I'm afraid she may be worried that I am planning some new and highly unwelcome move for her. I can only do my best with pats to her leg, a little neck rub, nods of my head . . . and a thumbs-up every now and then. I circle my heart with my hand to indicate happiness, and she does the same, giving me a dubious look all the while.

Off the freeway and along the bumpy dirt road, we drive through the woods and finally down our steep, winding driveway. Once we arrive at the house, I feel the hesitation in the soft, subtle resistance in her body. I wrap my arm around her as we go up the path and then slowly climb the steps to the deck. Her arms are full and her breathing heavy. John rushes down from upstairs to help us. Opening the door, he gathers up our bags, everything except Judy's magazines, from which she is never willingly parted.

On just those few steps outside, Judy seems to be struggling and short of breath, but she recovers once inside the door. She heads immediately to the only really comfortable chair in the house, an almost-new recliner, plops down in it for a minute, leans back, then rearranges her magazines, and lets out a huge sigh of relief.

Judy soon comes over to the kitchen counter to help me unpack the groceries, but on opening the fridge, she spots a container of yogurt. Staring briefly, she pulls it out and salutes me with it before stacking it on top of her magazine pile for safekeeping.

Now she's ready for action. We sit on stools, facing each other across the counter. Judy, leaning on her left arm, pulls out a head of broccoli and passes it to me. I've been given my assignment. She herself attacks the romaine lettuce. Chop, chop, chop. Piece by piece into the bowl it goes, just like the dandelions and mulberries long ago. We sit,

Judy's legs barely touching the bar, my usual sixties music playing in the background.

The weekend is everything I'd hoped it could be—time together, peace, quiet, no interruptions. We sit side by side in front of the blazing log fire while Judy contentedly looks through her magazines and I read and write. I bring her cooled-down tea. Through the large picture window, we watch the flying squirrels coming to eat the peanut butter and half oranges we've nailed on the closest trees. Upstairs, Bach filters down from where John is busy at his desk. By late Sunday afternoon, none of us are ready to leave and head back to Berkeley.

Soon after we return, I arrive early at Windsor House to take Judy to the doctor. She has a cold and I'd like her to have a checkup. I can see at once that it won't be easy. As I come through the door, Judy is on her way to the living room. She looks at me suspiciously, sensing where we might be going, and decides that she's having none of it. After giving her an only-half-accepted hug, I point to the door, pretend to be driving, and take her arm. But her feet are planted firmly, fiercely firmly. She somehow manages to double her weight, to become immovable and solid amid all that softness.

Paul enters the room at this moment with his portable CD player and his headphones. He whispers to me. For a man of few words, he's very clear: "Can I have some more batteries?" I've learned to keep extras in my car for just these moments, and I hurry out into the brisk morning air to find them. As I open the door, Judy does her own hurrying to the couch and deposits herself, cementlike, in her corner.

Once Paul and I have put in the new batteries, I shift his headset sideways and speak into his ear, lifting his baseball cap slightly. "Paul, I need your help to get Judy to the doctor's for her checkup. Can you go with us?" He nods. Displaying a pretense of certainty of which I'm quite uncertain, I tuck one arm in Paul's, offer Judy a new scarf, motion toward the door, and make the sign for drinks. Taken all together, particularly with Paul's presence, it works. Judy shifts her position on

the couch, gathers up her magazines, checks carefully all around herself, picks up her bag, and rises queenlike.

The doctor gives Judy a cursory examination, his stethoscope barely touching her skin, and I can't help but wonder where both his mind and heart are. I'm not sure he cares. It worries me that he doesn't seem to remember her from one visit to the next. Who on earth could forget Judy? He hands me a prescription for decongestant for her runny nose, and we head back out the door, Judy a bit heavier with the extra magazines she's managed to slip into her bag while in the waiting room.

. . .

En route for another weekend in Dutch Flat, Judy is tying her shoes again . . . and again, maybe a dozen times. Her one leg is folded comfortably over the other, higher and with more apparent ease than any yogi. She shakes her head in rhythm to music that only she can hear. After a while, she pats her mouth and looks at me expectantly. I nod. McDonald's will be appearing just as soon as we reach Davis, and she knows it.

We park and look for a good place to sit, choosing a vacant table near the window, far away from the noisy group of kids about to engage in a food fight. I place our order for cheeseburgers and shakes, while Judy pays with a ten-dollar bill. She puts her hand out to get the change, which she puts quickly into her own purse; then she laughs and passes it to me with a private chuckle. She carries our tray, piling it high with packets of ketchup and some mayonnaise we won't be using, then carefully places her tray on the table and slides in.

As we're eating, she looks over at two quiet little girls sitting across from us and waves to them. They give their mother a worried look, so I smile at them and say, "She likes you. Don't you love her purple hat?" They nod and smile silently, but their mother pointedly looks away.

Back in the car, riding along, we begin our celebration. She bangs her hands on the roof of the car, slaps the dashboard, and shouts, "Ho,

ho, bah!" I do the same. For Judy, the fact that I am forgetful after my head injury, get lost easily, and can no longer spell does nothing to undermine the joy we experience in each other's company.

There's a full moon straight in front of us, and I believe we're both entranced by it—the moon, and the pinks and purples of the blue-gray sky. Judy points through the window at the moon, and we both nod. She gives a quiet, contented burp and goes back to retying her shoes.

This weekend, the journey to Dutch Flat has a purpose. For over two years, Betsy Bayha, an independent filmmaker, soon to be working with George Lucas, has been following Judy both at Creative Growth and at Windsor House, building an intimately detailed story of her life. Now Betsy is bringing her crew up into the Sierras to film Judy at home in Dutch Flat. It will prove to be the first of several films made about Judy, as her fame grows and she is embraced by the international art world. There are hours of filming while we cook together, play cards, look at magazines, collect pinecones: Judy is being Judy in all her eccentricities—funny, loving, stubborn, then full of willingness to engage.

In the afternoon, Judy and I walk down the drive together, being filmed as we walk, unconsciously in step with each other. All is well until we turn around and start walking back up the slope to the house. For Judy, it suddenly becomes an utterly impossible task. She seems terrified, grasping hold of me and gasping, not able to get enough air. This is not simply her usual shortness of breath, which I've noticed for years. Something is seriously wrong. I'm fearful that it may be related to her heart and that the heart defect she's had since birth has gotten worse. I have always known that we both had heart defects and assumed they were the same and that, being twins, hers, like mine, was relatively insignificant. Now I realize I must get her back to Berkeley and to a specialist as soon as possible.

As the filmmakers begin to pack, I throw her medications and last night's pajamas, which she'd tucked under her pillow, into her overnight bag. Judy scurries in to rescue some hidden magazines. I take a

muffin for the road, kiss John good-bye, and we leave. Betsy and the film crew are still packing as we wave our farewells and bump down the dirt drive and onto the highway.

I call my ex-husband, Richard, a senior physician at Children's Hospital, as soon as I am back in Berkeley, and he is able to get an immediate appointment with Dr. Saba, a cardiologist, who agrees to see Judy the next day. After his examination, Dr. Saba takes me aside and tells me that Judy has a gaping hole in her heart that reduces the amount of blood getting to her lungs. This serious condition means that she is in heart failure. Overcome, I can't stand to have Judy out of my sight. Next week, she will have tests at Alta Bates Hospital, in the congenital heart clinic. How I wished I had known to bring her there years ago.

We wait. I force myself to be optimistic; I can't stand to think of the alternative. I plan to see Judy every day from Wednesday to Friday, to spend evenings with her, and then bring her to Dutch Flat for the weekend. Dr. Saba has started her on a special medication, and she seems a bit better; the circles under her eyes are not so dark. She is happy and full of hugs, but that's Judy. She clearly remains unable to do anything without great effort. Even our few stairs are difficult for her.

At the congenital heart clinic, we again meet with Dr. Saba, who explains that the hole in Judy's heart is called a PDA, a connection between the aorta and pulmonary artery that should have closed at birth. Not uncommon in babies with Down syndrome, it can now be treated early on, but the operation was unknown when Judy was born. As a leading authority on this operation, he explains that the surgery is normally performed on infants with very small hearts. It's much more uncertain with adults, especially considering Judy's age, and closing the hole completely so that all the blood passes through the lungs is almost impossible.

The outlook seems even more bleak when I discuss the surgery and the risks with Lucy at Windsor House. She has a medical background and knows Judy well and loves her. She feels that rather than take a

chance with the surgery, we should let Judy live out the number of days that God has already allotted her. I had wanted Lucy's support and encouragement, but I can't accept her perspective. I already believe that if Judy can have a chance for a longer and healthier life, I want us to take that chance.

Although, at Creative Growth, Judy continues to be totally absorbed in her work, her declining energy has been noticed. Her passion is undiminished, but everything is clearly becoming difficult for her. When she works, her head now droops. She takes short breaks and leans her head on her hand and closes her eyes.

We're going back and forth between Benvenue and Windsor House when the phone rings, and Dr. Saba is on the line. "I have really good news," he says. "The Food and Drug Administration has just approved a new device, a coil that may be able to completely block the hole in Judy's heart. I would like to schedule an operation as soon as possible." Within the week, two doctors fly out from the East Coast, one of them the inventor of the new device, joining Dr. Saba for Judy's heart surgery.

I realize the operation will be risky at her age, and for days, I'm unable to sleep. There are no guarantees. The doctors have told me they don't expect her to live much longer without surgery. I don't see that there is really any choice. I wish she could tell me what she wants; I wish I knew. People with Down syndrome age more quickly than others. Maybe this surgery will be an overwhelming strain on her whole system. She's already lived close to fifty years past her predicted life span. Is it right to tempt fate this way? Maybe Lucy's right. But how can I live without her? And how can I ever live with myself if something goes wrong?

· · ·

On the day of the operation, each step of the way is excruciating: getting Judy out the door and into the car, and then through the sliding doors and down the corridor into the hospital. In the changing room,

she refuses to take off her clothes and put on a gown. I take her arm as gently as I can and she pulls it away, sits on the little bench, arms folded and tight. I hold up the gown and wave it in the air, as if it's a very pretty scarf. She's not going for it. I put my arm through—see, no problem—but no. "It's a very nice gown," I say, my face right up close to hers with my mouth big, exaggerating the words she does not understand, all in the hope she'll somehow begin to agree. Another refusal. Then I remember what works when she needs a mammogram. When I take off my clothes, put the gown on, and then sling my breast on that big cold plate, then and only then is she happy to do the same. So I grab another gown and do the same—clothes off, gown on—and voila! She cooperates. Twins always, this time it's the two of us in our hospital gowns.

Next, Judy refuses to get onto the gurney that's parked outside. Instead, she sits resolutely on the floor in utter rebellion. I wonder what recollections she may have of the surgeries in the institution—all her teeth being pulled, those ineffective ear operations.

While I'm wondering what to do next, our nurse returns. She pulls some stickers from her pocket and sits down on the floor next to Judy. She and Judy begin a game of sharing the stickers back and forth. One on Judy's cheek, one on the nurse's arm, Judy's knee, the nurse's nose. Pretty soon, all of us are laughing, and Judy's happy to climb onto the gurney with more stickers tucked in her hand.

Once there, the nurse gives her a sedative, and even with her incredible powers of resistance, she yields and drifts off. The stickers fall lightly from her hand. I watch her face now, so at peace. As she's lying on the table, I reach out and stroke that little bit of hair she has, and then she's gone, rolled down the hall to the operating room.

With John away in England, Richard, who also loves Judy, comes with me to the hospital. Although tensions remained between us, we are both utterly committed to the girls and Judy. Waiting in the tiny alcove at the end of the hall, I pace like a caged animal, my anxiety

building as time passes. I'm beyond solace. I hear footsteps approaching and hold my breath. It's a nurse, who kindly asks if we'd like to observe the operation.

Through a large window, we can see Judy's sheeted form surrounded by doctors, lights, and machines. We also see a television screen mounted high on the wall near us and realize it's displaying the surgery in every detail. I can even see the wires moving through her arteries. I watch and I pray. I pray as I prayed when I was a little girl. "Let Judy come home to us. Please, please, let Judy live."

When it's over, Judy is wheeled out after what seems to me a long, endless operation. I can now be with her in the recovery room. I start to stack up all the stuff I've brought with me, some magazines to give Judy, some papers, notes related to our memoir, that I've been too nervous to look at. As I walk down the corridor, I hear her screams of terror, her desperate wailing. I drop papers and magazines as I run to reach her. She is thrashing wildly, howling and flinging herself from side to side; her arms and legs are tied with restraints to the railings.

She is alone, terrified, and panic stricken. It's absolutely horrible. She is beyond any comfort, and none of the medications have calmed her. She is out of her mind with fear, and I am out of my mind seeing her suffer. I put my hands on her face to calm her and try to get her eyes to look into mine, but she pulls away, moans, wails, and thrashes some more. Her eyes have the crazed look of a wild animal held down, knowing it's about to be slaughtered.

Eventually, one of the East Coast doctors approaches me with his clipboard. "I'm sorry to have to tell you this, Ms. Scott, but I'm afraid your sister appears to have had a heart attack." I look at my poor Judy wailing, and I too want to wail and thrash and fling myself into the walls like Judy, but without her ties and constraints. I barely look at him. I hate him. I hate his glasses, his thin face, and his balding head. I excuse myself and rush to call Dr. Saba, who returns to the recovery room at once. He examines Judy, carefully checking her, her records,

and electrocardiograms. He reassures me that no, it is not a heart attack. It is simply the heart's efforts to reroute its circulation correctly after almost sixty years.

Judy's wailing and thrashing continue, and in desperation, I telephone Lucy at Windsor House, asking her to please come and help me find a way to comfort Judy. Now there are two of us beside her, but Judy continues to scream and flail, so we both feel completely helpless. Through Dr. Saba, I ask that Judy be allowed to leave the hospital as soon as possible and not stay overnight unless her situation is life threatening. I'm now afraid she'll die from the stress and terror she is experiencing. Eventually, at nine o'clock, the doctors allow her to go home.

Judy is wheeled out into the cold night air, and with careful deliberation, she climbs slowly into the car. She gives me a weak but grateful attempt at a smile. At Windsor House, Lucy and I help her slowly climb the stairs to her bed. I stay with her, sleeping on the floor beside her bed. The next morning, I bring up her mashed food from the kitchen, and she lets me feed her like a baby bird, looking up at me with soft blue eyes. She loves the scrambled eggs and soggy toast. Later in the morning, I go to Café Strada for my latte and bring her a muffin. Again, we play baby bird.

I call Mom as soon as I get back to the house to change my clothes. "Mom, it's me, everything's okay. She's doing well."

"What? Who? Ilana? Was she sick?"

"No, Mom. Judy. Remember? She had heart surgery yesterday."

"Oh, that's right. Well, that's good. That reminds me; I wanted to tell you that Dr. Benton said I'm going to need to change my blood pressure medication again. I can hardly believe it."

"Oh, really? That's too bad. Well, listen, I better get back to Judy. We'll talk on Sunday, okay?"

Putting down the phone, I slowly and deliberately pick up some magazines to bring to Judy at Windsor House. I feel weighed down by sadness. Mom needs to forget about Judy and I need her to remember.

This is the way it always seems to have been, or at least it's all I can re-member. Both of us are far from Mom's thoughts; Judy has been almost erased. I have spent a lifetime trying to please her, hoping she would let us both into her heart.

I breathe into my tight shoulders and imagine myself with Judy, the two of us alone together, as it had always been. Two days and two nights later, Judy's smile slowly returns, and she reaches toward me for one long, sweet embrace. We can hold each other again. I climb in bed beside her.

In time, Lucy and I persuade her to come downstairs to eat with the others, and she soon settles back into her familiar Windsor House routines—managing the lights and toilets, enjoying her meals, helping to feed others (and enjoying their meals with them), looking at her magazines while sitting close to Paul, retiring to her room early, TV on in the background with no sound needed. The little white bus comes and goes. Judy waves good-bye from the living room, even waves good-bye to Paul, but shows no interest in leaving, no interest in moving from her position on the couch. She seems to have completely let go of her life at Creative Growth.

She likes that Paul sits next to her whenever he's home, and she's begun again to carry trays in and out at mealtimes. She regularly tends to Jenny who, lost in her chair, lost in her dementia, can no longer feed herself. She keeps storybooks beside her for Aurelle's late-morning return from nursery school. Aurelle climbs into her lap, and they look through dozens of picture books. Aurelle helps turn the pages until she slips down to find her mom in the kitchen. After two weeks of this domesticity, and several conversations with Dr. Saba, I decide it's time that Judy goes back to Creative Growth and the life she's loved.

Unfortunately, my decision is not Judy's. Instead, she makes her intentions known by not getting dressed at all. She now lives her Wind-sor House life in her bathrobe and slippers. My gestures suggesting an outing—steering the car, signs for eating, drinking—all fall on already

deaf ears. Even the picture I bring of the International House of Pancakes has no effect.

In the end, I ask Lucy's husband, Joe, to do a fireman's carry with me to bring Judy to the car so I can drive her to Creative Growth. Forced into our old Subaru, she's slumps down in her seat and glowers until she sees the red-brick building and the little white buses. Then she claps wildly, happily joins me in entering, gives me a thumbs-up, and hurries back to the unfinished sculpture that has been waiting for her behind her worktable. She waves to me enthusiastically and is back again at her sculpture, her life.

15

Fish in a Bottle

~

From inside my purse, I can hear the muffled sounds of my cell phone. I burrow down through the accumulated layers of lists and notes on which I've preserved and fossilized my thoughts, thoughts now settled like sediment on an ancient lake bed. Since my bike accident, I compensate for my imperfect memory by writing lists—and lists of lists. Everything must be planned, revisited, and reviewed. Seizing the phone on its final ring, I press it upside down to my ear. It's Tom di Maria.

Tom tells me that another film crew is coming to shoot at Creative Growth. This time, he says, they are distinguished, award-winning filmmakers from Spain. I'm silently thinking that it would be interesting to meet them, but at the same time, I'd feel uncomfortable, inadequate. Distinguished? They're probably elegant European intellectuals, remote and condescending. I know the type. Besides, I have no time, what with Judy and the girls, with work and my writers' group.

But within the week, Tom calls again. He says that the filmmakers, after hours of filming at Creative Growth and then Windsor House,

have fallen completely in love with Judy. They feel they have begun to capture her essence on film, the whimsical way she pokes fun at all our pretenses, how she dresses herself so outrageously and celebrates every moment. Now they would like to film her at home with her family. Tom asks me if the group might come up to Dutch Flat over the weekend.

Thrilled for Judy, I immediately give my consent. But as soon as I put the phone down, a torrent of worries begin to swirl through my head. Will the house be big enough? After all, it's really only a cabin in the woods. What will we feed them? I immediately pull some paper from my purse and start making new lists.

When I arrive at Windsor House to collect Judy on Friday evening, she must realize that something especially interesting is about to happen, because not only is she all packed and ready to leave, but she is dressed even more dramatically and more extravagantly than ever. She wears her intensely purple hat, but this time with feathers and two extra scarves circled, recircled, and entwined. I look at her and think of an aging queen, reigning alone but imperiously in her silent palace. After a quick kiss to Paul and a hug for Lucy, we're off.

During the entire two-and-a-half-hour drive up the freeway to Dutch Flat, I pat Judy's knee and squeeze her shoulder in reassurance, when, in fact, Judy is not worried about a thing. I'm the one who's worried. Once we have arrived and Judy has carefully unpacked and is tucked in bed with her magazines, John does his best to reassure me over a glass of wine.

The Spanish film crew arrives at the house just as the early morning sun starts to filter through the trees. The four of them flow into the house as my worries flow out. They are young, warm, and enthusiastic and clearly love Judy and being here in the woods with us. John, with his filming background, watches them with professional curiosity as they set up their equipment.

From the comfort of her recliner, her throne, Judy watches in surprise as they enter and then rises to greet them. Thrilled to see them again, she exchanges lavish hugs. Only Gemma speaks English, but all speak a language Judy understands, a language of love. For Judy, whether they are speaking English, Spanish, or Catalan is all the same. Her language, expressed through her art and lavish gestures, needs no words. It's a language the filmmakers know well, and soon the house is overflowing with an irrepressible and contagious joy.

They film Judy helping with cooking, playing cards, adding scarves, while intermittently filming and interviewing me as well. After hours of this intense work, Gemma explains over another cup of coffee that the original script for the film had focused on four separate arts programs for people with disabilities—to be filmed in four different countries—with Creative Growth being but one.

"Over the past week" she says, "we've decided that Judy is such a powerful personality that we're going to abandon the original plan for the film and focus exclusively on Judy and Creative Growth, if that's all right with you?" Nodding in silent assent, I gaze into my cup, unable to suppress a smile. I want to wrap my arms around Gemma, but instead I push the plate of warm banana bread in her direction.

The filming finished, in the evening we have a birthday party. It's not actually Judy's birthday, but no one loves a birthday party more than she does. And no one deserves it more. After a lifetime of not being noticed, today we are all here to notice and to celebrate her. Judy directs us while we sing and wave our arms. Then she blows out the candles on her cake. We light them again—she blows them out again—and again, several more times. Each time, she is beside herself with delight. She's the conductor, directing us in singing "Happy Birthday" these many times, while she claps with glee. Finally, after a wild pillow fight, we all collapse onto the bed with her, laughing ecstatically.

· · ·

Taylor, pregnant with her second child, has moved with her family into the Sierra foothills, only an hour away from Dutch Flat by winding mountain roads. Her pregnancy is difficult, and doctors instruct her to remain in bed for the last four months. I spend at least one night each week with her, cooking, keeping her company, and looking after Forest, who is now four, while Taylor's husband, Mark, is away at work.

When labor begins in earnest, only four weeks early, I rush to meet Taylor and Mark at the Auburn Hospital. Once again, I feel blessed and honored to share in this birth. It's an extraordinary scene, even by New Age California standards. In the corner, a friend is playing his Australian aboriginal didgeridoo, filling the room with a deep, unearthly droning.

We massage Taylor through her contractions until she gets out of bed and begins to dance. At last, after all these months, she can move and she chooses to dance. The didgeridoo plays on as she weaves her laboring circles. Mark and I encircle her in the dance, moving with her. All of us can feel this new life emerging, coming to join us. We begin sobbing in our circle—a circle of sobs and holding and feeling blessed. After that, nothing is ever the same for me and my once lost daughter. The walls between us, a silent legacy from our painful history with so many years of separation and loss, have fallen away. Little boy Sky arrives, and we welcome him into our family.

As I drive back to Dutch Flat, I find myself thinking about Judy's and my birth, and about Mom—and all the difficulties she faced. Judy had weighed well over a pound more than I and had gone home from the hospital with Mom while I remained for another two weeks in an incubator. With no knowledge of Down syndrome or the muscular weakness that babies with Downs have, she had tried unsuccessfully and without any support to nurse her. By the time I got home, her milk was gone, and she was faced with me, a baby she'd barely met. It started to make sense that she might have found bonding with me at that point difficult.

I call her and tell her about Sky's birth and explore these thoughts of mine. She's pleased to hear about the birth and the baby. Then I go on, "Mom, I was thinking how hard that must have been for you to leave me in the hospital and have me gone for more than two weeks and then suddenly appear when you were quite used to Judy and didn't even know me."

She said, "You know, you're right. I haven't thought about that for such a long time, but you were just an extra baby that showed up at our door. All I knew was that I was about to have twice as much work. Judy and I already had our routine, and I remember wondering if you were even our baby. I just didn't know you. You were a cute little thing though. I'll say that about you. Anyway, thank heavens I had Gramma and Daddy to help, but honestly I don't know how we managed. I remember Daddy gave you a bottle at night, and I gave one to Judy, and that's about all I can remember. I felt so tired, so drained."

• • •

Lake Geneva sparkles in the bright spring sunshine as John and I arrive in Lausanne, Switzerland, with our friend Maureen, a doctor from England. Home to the world's foremost collection of outsider art, Lausanne's Collection de l'Art Brut is staging a major exhibition of Judy's work. Traveling together on the train from Paris, we discuss Judy's creativity and her place in the art world.

Leaning in close, I start explaining to Maureen once again about outsider art. "It's importance," I repeat, my voice getting louder than I intend, "lies in its essential purity; artistic expression untainted by a desire for recognition, success, or financial gain, no wish to prove anything or please anyone, not one's mother or true love—no one—none of these motives." I go on, "It's art produced by those on the fringes of society in response to an all-consuming creative drive that cannot be suppressed, art created to impress no one, to prove nothing. It's pure creative expression."

Maureen nods in agreement, as she does each time I have told her. Slipping off my shoes, I stretch my feet across to her seat and we continue the conversation. Is creativity a natural human state that is schooled out of us at an early age? Maureen and I think yes. John briefly puts down his computer magazine to question our reasons and voice his mild, uncertain dissent: "Surely, if creativity is an innate blessing, it can only be temporarily denied rather than obliterated." We quickly silence his doubts as the train pulls into the Lausanne station.

The museum director, Lucienne Peiry, greets us warmly as we enter. Although Judy's work was unknown when Lucienne first wrote her authoritative monograph on outsider art, she has since become an ardent admirer, acquiring a number of Judy's pieces for the museum's permanent collection.

The galleries are closed in preparation for this evening's opening ceremonies, but nevertheless Lucienne invites us in for a private viewing. Much of the building is in darkness, and our footsteps echo eerily as we deliberately make our way from room to room. John and Maureen wander on ahead, continuing their conversation, pointing, exclaiming, and nudging each other for attention, while I linger behind. I have been drawn to two figures enveloped and united by gossamer threads, almost twinlike. I want to be alone with this stillness, the quiet and the magic of these pieces, which speak to me through their beauty and through their silence. I recognize several of Judy's sculptures on loan from Creative Growth, but some of those from the museum's permanent collection I don't remember ever having seen before. Many hang suspended on invisible threads, subtly illuminated by concealed spotlights, allowing visitors to walk through and around, examining each piece from every angle.

The scale and quality of the exhibition is magnificent, and it is breathtaking to see these exquisite shapes and colors vying with one another for attention in such a setting. Even tall John appears small in relation to some of Judy's pieces. Lost in the silent beauty of the exhibi-

tion and overcome by the magnitude of this tribute to Judy's vision, we do not notice time passing until the doors are suddenly thrown wide and the opening ceremonies of the official vernissage begin.

With the press and television crews, and the public in attendance, the museum is soon packed. Tom di Maria is here representing Creative Growth. John MacGregor is one of the featured speakers, addressing the crowd in fluent French, and Betsy Bayha has come with a film crew to record the event for *Outsider*, her ongoing film about Judy as an outsider artist. It seems as though everyone of importance in the art brut world has come to this opening.

Curious, we stand quietly in the shadows, watching with growing fascination the visitors' pleasure, amazement, and admiration, as many of them encounter Judy's art for the first time. We are particularly thrilled at the expressions of wonder and surprise on the faces of children as they wander through this surreal jungle of exuberant colors and shapes. We strain to overhear the hushed, but intense comments expressed in more than a half-dozen languages. No one, it seems, remains unmoved.

As the crowds begin to thin at evening's end, the applause is still silently echoing inside my head. After this event, no one could fail to appreciate that Judy has become a major figure in the art world—well, I can't be sure about our mother. In a way, I long for Judy herself to be here, and yet, just as much, I'm happy she's been spared. She would have hated the journey, the crowds, and the interruption to her creativity. The excitement and confusion would have meant nothing to her but misery. That people are drawn to her work is of no interest to her.

The following morning, I telephone Mom in Cincinnati from a booth just outside the train station. I can't wait to tell her all about this latest major exhibition and Judy's growing recognition. "That's nice, very nice," she says. "I just hope you've had good weather there; it's really getting cold here. I've already pulled out my camel-hair coat. Can you believe it?"

My heart sinks, and I think, "That's it. I give up. I'm never sharing any of this with her again, ever," knowing all the time that I will go on trying again and again.

. . .

Back in the Bay Area some months later, Tom di Maria and I arrange to have lunch together. First, as always, when I arrive at Creative Growth, I head for an embrace with Judy. Then Tom appears with his usual offering of Diet Pepsi. Accepting the expected gift, Judy nods and waves us off. She has work to do and we're on our way.

We choose the Vietnamese restaurant on the next corner, the one with the fish swimming their final hours in the tank in the window as we enter. We have barely sat down when Tom leans forward excitedly, unable to contain himself any longer. With a big smile, he begins, "Joyce, I have to tell you what happened last Friday in New York. I was giving a lecture up in Harlem on the talents of artists with disabilities, and I can't wait to tell you what a little boy said. It was quite unbelievable, absolutely wonderful in fact." Taking a quick sip of water, he recounts how he was talking with a group of children in a large school auditorium.

"I was telling them about Judy and her incredible sculptures. I had with me a few pieces to show them, together with some of those large photographs of her that Leon Borensztein took for John MacGregor's book. Then I told them something of her institutionalization and those thirty-five years before she reached Creative Growth, and how, given this chance, she's become such a dramatic artist and creatively driven person."

He paused, took another drink and smiled broadly. "Then I asked the audience what they thought. One little kid, close to me on the right, reached his hand up urgently, and I pointed to him.

"'Fish in a bottle!' he shouted out, loud and clear.

"I didn't know what to say—had no idea what he was talking

about—so I asked him, 'I'm not sure what you mean. Can you tell me more?'

" 'Well,' he said, 'she was a fish trapped in a bottle, and now she's swimming free.' " Tom hesitated a moment. "When he said that, I got tears in my eyes. I could hardly speak. But that's it, the perfect metaphor for Judy's life, isn't it? Isn't it? Now she's swimming free."

I nod silently, for now I too have tears in mine.

Tom orders another iced coffee, and I continue sipping my still nearly full glass, pushing the cubes around with little stirs as we discuss what's been happening lately in the world of Judy's sculptures. He finally takes a bite of his now-cold noodles, then starts with an overview of the growing interest in Judy's art around the world. He tells me that she has one-woman shows coming up in both Japan and France in the next two months, then a show in New York, and another next spring in Baltimore at the American Visionary Art Museum. "We're getting several calls a week from newspapers and magazines everywhere," Tom says, adding almost as an afterthought, "I know you've been involved with *Reader's Digest* and the article they're writing, but now the *New York Times* is doing a big spread on her as well. Oh, and terribly exciting, Peter Jennings and ABC television want to have her as person-of-the-week next month. Isn't it incredible? Our Judy."

I study his face, just a quick glance, then I look down. I take my chopsticks off the plate and make them into a triangle, put them back beside my plate, then turn them around, wondering if this could really be happening.

How wonderful that Judy doesn't even notice or care—she cares so much more about finding a new magazine than being a famous person in the world. How lovely that when she decides to reach out her hand to welcome a person who has come to see her, it could be the writer for the *New York Times* or the cleaning person in the back room—or even Peter Jennings himself. What she's reaching toward is the heart of that person, nothing more, nothing less. That's all that matters to her.

16

A Soundless Symphony

At Windsor House, Judy is sitting up in her bed in the near darkness. The covers are neatly placed over her knees and folded on her lap, where she holds an open magazine, an orderly stack of others beside her against the wall. Slowly and carefully, she turns the pages. It is quiet. It is always quiet in Judy's world, but now nothing moves, not her resident friends, not the TV screen, only her fingers and these pages. She seems to love the colors, even in this dimness. She strokes the pages that have her favorite pictures, touching, caressing the shapes that interest her. I imagine her remembering these tonight in her dreams and in her tomorrow, in the new form she is bringing to life in her sculpture, with the colors that are with her in this moment and with the colors that remain from a childhood long ago.

She looks up and sees me watching her. She smiles, reaching out her arms for one last closeness. However short our visit, to me it feels like refueling at my own personal gas station. That enveloping embrace fills

me in a way that nothing else can. Who we are now, who we were at five, or who we were at thirty seem both separate and the same. We are connected by a thread of longing and by memories so deeply held that they have taken years to rise to the surface. Other memories stay at our solid cores, dark ones, bright ones, hidden treasures like those buried within her sculptures, too deep for words, too solid ever to rise. I leave her bedside and we wave goodnight with each one of our fingers, and I close the door again without a sound.

In the morning, Judy lets me take her to Creative Growth, although generally she prefers her little white bus and her seat beside Paul. We walk in through the gallery, and she takes a few minutes to admire the exhibits in the hallway. Judy pauses at a painting she particularly likes, this one by Regina, and it seems to me that she keeps a special place in her heart for her, ever since the days when they sat on the couch together in the semidarkness at Mrs. Robinson's.

In the studio, I sit to one side, doing my best to separate myself while I watch her work. What will she do next? The piece is already enormous; it seems impossible to add more—and yet she does. What looks like a discarded piece of metal is pushed through the center, and then the wrapping begins again.

This piece has grown into an immovable giant, in contrast to some others that have remained as small as elegant ballroom handbags. The colors are varied—subtle combinations of muted tones in one piece, a riotous rainbow mix in the next—but always placed and blended resolutely and without hesitation. Judy chooses her next color and knows without question where it belongs, begins threading it through to its perfection. Like Michelangelo, she seems to let the piece speak to her, telling her what to add, where to add—but never where to take away. Her hands move deftly, without pause. She works with an absolute certainty, powered by a deep internal vision.

I'm often reminded of how staff artist Stan Peterson described two

recent scenes that underlined for me Judy's total dedication and absorption in her creative process. In his description, he wrote:

> Judy is at her table, a tangled mass of colorful wrapped yarns and fabrics in front of her. She extends her right hand with the large needle and yarn to the full range of motion. Her left hand pushes lightly down on the knotted asymmetric geometry of stitchery growing in front of her. She pulls the sewing line taut and then loops it back under the holding web. The mass is getting bigger and being sutured together.
>
> Meanwhile a visiting film crew is laying parallel tracks on the studio floor, making a runway for their video camera. The BBC is at Creative Growth shooting a program about Judy and her remarkable fiber sculpture.
>
> The sound technicians set up a huge tripod and position a long boom over Judy's head. She is oblivious to the big fuzzy black microphone dangling near her. Judy keeps on with her stretch and stitch. Sometimes she looks up at the new commotion, all dressed in black, gives a brief smile, and makes soft clucking sounds. Deaf and very secretive, she could be sitting on a golden egg.
>
> Now the camera starts to roll from the front windows down the tracks to Judy's worktable at the rear of the studio. A long smooth pan and zoom, this is a first in cinematic technique at Creative Growth, where normally it's handheld videos or large tripods set up right next to her.
>
> The zoom gets closer, yet remains at a respectful distance. The other working artists, more than eighty in number, are mostly engaged with their own artistic processes in drawing, painting, ceramics, or wood, but some are viewing the event as a daytime television show. Judy never moves.

The film crew has been there all morning, and she has gotten up just once to use the bathroom. Her world has been intruded upon in much the same way as wild animals have safari buses passing through their habitat, and like them, Judy totally ignores the pointing camera lenses.

Then the next morning, the studio manager pulls the fire alarm for a practice. Everyone is to evacuate the building. It is being timed and all staff and students are to exit through the front doors and proceed to the street corner. But where's Judy?

Two staff members rush back to retrieve her from her work-table. She is winding yellow and red yarn around the black mass of some giant sculpture, which is now heavier than she can move. The teachers gesture, "get up" and "go out the door," and they yell, "fire, fire" as loudly as possible. Attempts are made to sign to her with fingers rising in imaginary smoke. Judy looks up, gives a little smile, pats her sculpture, and makes more quiet clucking sounds while she continues working. Hopefully, if the fire were real, she would move—but perhaps not.

What might she have placed at the center of this huge piece she's creating? The greatest mystery to me is the secret talisman, which she so often conceals at the core, the very heart of her work. It may be a flower, a stone, or a colored bead, sometimes a folded piece of paper, carefully marked. I cannot help but wonder, "Who is this person living among us? What has she come to tell us?"

Reactions to Judy's sculptures can be emotional and profound. Benedetto Croce is one who has been touched by their magic. Deaf since birth, Benedetto is a museum director in Rome and an artist who shares the world of silence with Judy. As he watches a film of her at work, her hands lovingly caressing the threads as she weaves them to realize her inner vision, his eyes fill with tears. Seeing more than just the

creation of a beautiful work of art, he signs, "She is creating a soundless symphony, her hands plucking the threads she weaves like the strings of a silent harp."

· · ·

At Windsor House, thanks to Lucy's patience, my impatience, and the persistence of both of us, Judy is dressed, except for her shoes, which she refuses to put on. It has not been easy. It's already evening, which Judy knows means dinnertime and definitely not time to get dressed and go out.

We are to bring her to the opening of an unusual exhibition of her sculptures, and we're already behind schedule. For the first time, Judy will see her own work outside Creative Growth, at another venue, and I'm both excited and anxious that she enjoy the experience. My hope is that she'll love seeing others enjoy her work, but I know she's just as likely not to care.

I have strategized with our mutual friend Bette, who is at the foot of the stairs, ready to dazzle Judy with such enthusiasm and excitement that she'll allow herself to be lured into the car. But as we descend, Judy spots her, realizes a trap has been set, and does not wait for anyone. She decides to skip the dazzling and makes a sudden sharp turn into the living area, where dinner has started.

And we wait. Only when she has finished eating and not a scrap remains, does Judy reluctantly allow herself to be led down the porch stairs and toward the car. But this time, just before she gets in, she makes another sharp right turn and walks away, down the street and along the sidewalk, clutching her magazines, headed who knows where. I quickly start the car and head down the block to get ahead of her. Turning into a driveway, I manage to cut her off, opening the car door at the right moment. We've cornered her. Grudgingly, she accepts defeat and climbs in, with Bette right behind.

On the drive to pick up Ilana, Judy begins pointedly coughing, and

by the time we are headed across the Bay Bridge into San Francisco, she is feigning a near-death attack of some sort, all done with great conviction. She pretends to throw up, glancing occasionally at me to gauge the effect. She is still caught up in her drama when we reach our destination.

We find a parking place behind the Exploratorium, a world-famous hands-on museum of science, art, and perception. Tonight is the opening of a new show entitled *What Did We Learn?*, featuring Judy's work. Her presence is important, and the press is waiting. Now, Ilana and Bette have gone inside, but the two of us sit in the parking lot, Judy resolutely refusing to get out of the car. The usual bribery won't work, not even when Tom appears with fabulous gifts for her, a wig and ribbons from a couple in New Mexico who are great admirers of her work. Finally, Tom goes back into the exhibition, leaving me with Judy in the car.

As I wait, I become increasingly annoyed and miserable. I look at the solid, stubborn self beside me and give her my darkest glare. "How come," I ask myself, "when she is not able to understand the situation, she is the person with absolute control?" I offer her a new magazine, but without effect. I fume. Then I do what I have never done before. I suddenly grab her entire stack of magazines, march round to her side of the car, and fling open the door, signaling emphatically for her to get out—now! With a regal gesture, head held high, she rises from her seat, steps out slowly, and takes her magazines from me. Leaving the car, she walks toward the building as though it was part of her plan all along. Judy, who is now completely composed and cooperative, even in good spirits, strides imperiously into the museum. I follow behind. Inside, she is instantly captivated by the exhibits, looking carefully at each one, and only a bit later decides to enter the galleries containing her sculptures.

In the first of the three rooms, examples of her work are on display, which she quickly greets with obvious delight. She puts her face close

to examine them, then steps back, waving to them her hellos and good-byes, blowing a few kisses. She remains oblivious to all the throngs around her also examining them. There is no information in the room about the pieces or who has made them.

In the second room, visitors are invited to write down their reactions and interpretations of the pieces they have just seen, with some specific questions such as, "How would you identify this art?" "Who do you think this artist might be?"

Some suspect the pieces might be tribal art from distant parts of the world; others imagine them to be relics from Ancient Egypt. Still others are certain they are Native American totem figures. The range of suggestions is remarkable, but no one guesses correctly. Only in the last room, where a large screen shows Judy at work, is it revealed that this is the work of an artist who is both deaf and has Down syndrome.

Judy is fascinated to see her own work, but not so interested in seeing herself on the screen, preferring to find somewhere to sit down and rest. She finds an unoccupied museum guard's chair and unties and reties her shoes several times, then pats her mouth, and looks at me expectantly. Time to eat something.

We move to the entry hall, where there is a table of refreshments. We sit together on some metal folding chairs at the side, and I bring her some cheese slices and cherry tomatoes. She barely eats them; obviously, she's feeling tired. We vaguely watch the constant stream of visitors, but there's no sign of Ilana or Bette. I look all over for them. Judy reties her shoes again and then suddenly decides she's completely fed up with the situation and wants to go home. She announces that the evening is over with a window-shattering scream that she alone cannot hear. Fortunately, I've long ago become impervious to stares. Standing up, I instinctively press my finger to my lips—not that she cares—and help her on with her coat as she gathers up her magazines. I ask one of the museum guards to find Bette and Ilana and tell them to join us outside as quickly as possible. I take Judy out to the car, and there we

wait . . . and we wait . . . and we wait. Judy gives me one of her pointed, accusatory scowls and does some more shoe-tying to pass the time. Exasperated, I finally feel forced to go back inside and look for them, locking Judy briefly in the car. While I am inside searching, Tom comes out to find Judy leaning hard on the horn. I am mortified to have left her alone. Finally, Ilana and Bette join us; I scowl at them. While Ilana, Bette, and Judy spend the whole ride home squeezed together in the back, laughing and giggling, I fume and mumble to myself as I drive.

Later that night, I am sitting with Judy on her bed and she is look-ing at a magazine back to front. Periodically, she looks over at the TV, but mostly she pushes her hand into my face and has me hum into it. For bed, she is wearing a brown hat with a gaudy flower, along with her beads and her nice pink bathrobe. Her plants are looking well, and her curtains are tied with a knot in the center. She wears a pretty red scarf under her hat, and now she is rearranging it. Behind her is the extra lion pillow that I gave her last month. I start to say something about what an intense evening it has been, but Judy flips her hand at me dismissively in a gesture that clearly means "you have no idea what you're talking about." She may have a point.

· · ·

As Judy's fame has grown and our reunited life has extended to al-most twenty years, I become increasingly aware of the changes time has wrought in our lives and our characters. Judy has dramatically in-fluenced all of us, none more so than the girls, our mother, and myself.

Almost imperceptibly, I've become conscious of a softening in my relationship with Mom. Since Judy and I found our way back to each other, I have no longer felt dominated by our mother. I've begun to let go of our past and free my mind of resentment and judgment, forgive her, and accept her for who she is. I have slowly come to sympathize with the terrible burden of loss that she has been carrying for so many years. Not only the loss, but her sense of shame and embarrassment,

the assumption of guilt she has felt, first for Judy's disabilities and then for sending her away. In those days, there were no options, just as there were none when family and cultural pressures forced me to give up Anna for adoption. In the 1940s, as James Trent, co-editor of *Mental Retardation in America*, wrote, "To have a defective in the family was to be associated with vice, immorality, failure, bad blood and stupidity. To place that defective in a public facility was to be associated with the lower classes." It's little wonder that Mom, for whom others' opinions were terribly important, would feel mortified.

Mom and I now talk almost daily on the phone, growing ever closer. At least twice a year, we also spend several days together, mostly alone in her apartment, side by side. Here, without the old barriers, we have time for sharing deep remembrances and even deeper confidences. She's sitting in the soft red armchair, and I'm close beside her on her end of the couch. We have our feet up and our cups of tea warming our hands. We're talking about Judy—Judy, whom we rarely spoke of for all these many years.

Mom says, "I don't know, it's hard for me to even admit this. I don't think you ever knew, but after you started school, I just didn't know what to do with her. She'd wander around the house looking for you like a lost soul, poor little thing. I just didn't know what to do. I hate to even say this but sometimes, probably a lot of times, I'd just lock her in your room until you got home. It was all a nightmare. To this day, I feel just terrible about it."

"Mom, it's just so sad that you didn't have any support, no one to help you. It's so sad for Judy, but so sad for you too."

"I know it. I know it." She sighs deeply and pulls the red pillow beside her closer. "Then when they tested her and said she could never go to school and would never be able to learn anything . . . nothing . . . and Reverend Baron and Dr. Cronin, too, telling us the only thing we could do was put her in that place in Columbus. Letting her go like that, I don't know . . ."

She stares into her cup like some other past might float to the top and allow her to have a different, less painful set of memories.

I put my hand on her knee. "It must have been a terrible decision to make, but remember, you did keep her, you tried to keep her, and most parents back then put their babies into an institution right away. And you didn't do that. You tried."

I see her blink back tears. "We did. We tried. The whole thing just about killed your father."

I'm thinking to myself, "No, actually, I'm pretty sure it did kill him."

There's a pause and a silence.

She pushes herself slowly up from the chair and says, "I want some hot tea, not this lukewarm stuff. How about you? Let's get back to that Scrabble game."

Occasionally, I mention that Judy has become a famous artist, but I don't think Mom believes me. The story she was told and has clung to about Judy being profoundly retarded makes it impossible for her to shift her perception. I give her a copy of John MacGregor's book, but I doubt whether she has read a line of it. She remains unaware that MacGregor likens Judy's work to that of Sir Henry Moore, that others detect hints of Picasso.

Mostly when I mention Judy's art, she just says, "That's nice," and changes the subject. But gradually I've begun to sense a shift in her attitude. Now and then when we talk, she will actually ask about Judy—something she's never done in the past. The thaw has begun.

One day I mention to Mom that *Reader's Digest* has commissioned an article about Judy. This, I know, will mean something to her and to her friends. It proves to be a sympathetic article, emphasizing the painful and impossible position in which Mom had found herself all those years ago. As soon as the magazine appears, I order a large-print copy and bring it with me to Cincinnati so I can deliver it to Mom in person. My hope is that Mom can feel that if *Reader's Digest* writes with understanding of her impossible situation and millions of people

read the magazine, the world will realize she did her best and she can be relieved of the guilt and shame she has carried for so long.

Mom is thrilled with the article. Judy's recognition and the sympathy expressed for Mom's position allow her to feel both proud of Judy and understood. The shame, the guilt, and the almost secret daughter have been transformed into a public celebration. The burden she has silently borne for sixty years can finally be laid to rest. With this sense of acceptance comes healing.

On my next visit when I enter her apartment, I am stunned to see, prominently displayed on her dresser, a large photograph of me and Judy together, one which Lilia had taken and mailed. Never in our whole lives has there ever been a picture of us to be seen anywhere in my mother's house.

Mom now carries the *Reader's Digest* article with her wherever she goes—to the dining area, the hairdresser, the bank, and, of course, to her bridge clubs. It sits on top of her walker, in plain sight, when she is riding on the elevator. Should someone neglect to ask about the article, she does not neglect to tell them. By the time I return again months later, there is no one in the two-hundred-and-eighty person retirement community who does not know all about Judy—and even a bit about me.

17

All in Black

I tell this as it happened, and as I tell it, my thoughts do not come one by one, as sentences must. They come in a sea of fragments, washed up randomly from everywhere: from inside my head, from Judy, and from some unknown place deep within.

I had been to the airport, dropping John off for his flight to France, and decided to stop by Creative Growth. Here I watch Judy wrapping and tying her latest sculpture, with the same attention and care as always. However, this piece is different, very different. There is absolutely no color in it, only black. I am puzzled. Her work, every other piece, has always been alive, radiant with color. Some of us hear with sound, but it seems to me that Judy hears with color and hears in color, yet this piece has none.

When I arrive at Windsor House for our weekend, Judy flings herself into my arms and then turns around and reaches for her magazines stacked beside her on the couch. She hands them to me with a pat to my cheek and what seems a farewell pat to her magazines. She's giving

me her magazines? All of her magazines? I don't know what to think. Well, maybe she just wants me to carry them for her, but it's never happened before. I kiss both her cheeks and sign thank-you. She signs thank-you back to me. I never know what she means by that either. Is it her boundless gratitude for our love, the same boundless gratitude that I feel, or is it just that she repeats the sign I make? But, either way, it feels to me another expression of our lifelong love.

I turn toward the stairs to suggest we pack for her weekend in Dutch Flat—our usual pattern. Instead, pointing to the hallway, she motions me toward the door. I follow. On the buffet near the front door is her colorful overnight bag from Bali, ready to go. This is unusual. Did she know we were going this weekend? How did she know? How is it that this time she is completely ready for the journey?

Paul is in the other room, just on the other side of the wall, and we walk around the corner to wave. Judy, bag in hand, comes close and plants a big kiss on both his lined cheeks. He's a lucky man. There's a lot of love in those kisses, I'm thinking.

I hand her the magazines as she gets in her front seat of our old, beat-up Subaru. Judy pushes them into my arms again. She seems determined not to keep them, despite my protestations. I put her precious pile of old issues of *National Geographic* and *Good Housekeeping* on the back seat. Maybe she'll want them later.

Driving up, I realize we've left too late, and the traffic is terrible. We help pass the time pointing at things out the window and nodding with a "Ho, ho, bah!" thrown in now and then. The sky is changing color, and we point out the fading radiance of oranges and reds and deep purple. Then comes the moon, so often our companion. After more pointing and satisfied nodding, Judy ties and reties her shoes while she leans back into the evening with a satisfied smile. Maybe this activity of lacing her shoes is an echo of her artistic work, a longing for a piece that lies silently tucked well away on her shelf at Creative Growth, although I can't be sure.

By the time we get to Auburn, I'm starving, and knowing Judy, I think she must be starving, too. We find a little Mexican restaurant in the Old Town and settle into our booth. I decide to get flautas for Judy, soft ones.

Judy doesn't seem to be eating with her usual enthusiasm, but who could blame her. Her flautas are too plain, even for her. She drinks down a big lemon-flavored juice.

Just as I'm paying for the meal, Judy rushes past me to the bathroom. Startled by her hurry, I push the door in after her to make sure she's okay. She mostly ignores me except for a nod, gets up, washes her hands carefully, but then holds her stomach. We head out toward the car while she clings to my arm and climbs in. The atmosphere in the car has changed. Judy's not her usual smiling, enthusiastic self, but she's not complaining either, just clearly uncomfortable. I turn my head to watch her closely, observe her discomfort with unease. When I get on the freeway, I wonder if I should go straight to the hospital, just to be sure she's okay, but I think about how absolutely terrified Judy is of hospitals and what it would be like for her to be in the emergency room with a stomachache. We'd most likely wait there for hours and then get something resembling Pepto-Bismol.

When we drive through Dutch Flat and up the long dirt road, we park in front of the house. I go round to open her door and she grabs my arm and hurries up the steps to the front door with me, going directly to her bed in the back room. Now I'm concerned. Her stomach must really hurt. I pull up the covers, check her forehead for fever, and bring her a hot-water bottle, hoping she will be more comfortable. Judy's nightgown, full of pink and red flowers, is under her pillow, and I show it to her, although I'm pretty sure she doesn't feel like changing her clothes. She doesn't. I lie down with her and stroke her hair, her face. Then I try giving her a bit of tea, which she refuses with another shake of the head, so I rearrange her covers and climb in again with her. Judy seems to be concentrating on her breathing, except she is looking

at me with great intensity. She has reciprocated none of my attempts at smiles and thumbs-up of reassurance. It seems to me she's breathing too fast, which makes me more anxious. I call the hospital to see if I should bring her in; they say they can't give advice over the telephone. I call a home advice nurse at the closest Kaiser Permanente hospital, but I'm turned away. Judy is not a member. I call Richard, who is reassuring. Back I go, bringing her a big teddy bear, which she hurls against the wall. It seems that what's important to her now has nothing to do with teddy bears. I climb back in bed and lie down beside her, as she leans in close, our faces almost touching. She looks at me with great seriousness, but with no fear, no moaning, no sign of distress, or even discomfort, except for breathing more quickly. She must be okay. I know so well that when she's in pain or sick, she tends to be miserable, to moan and put her hand on her forehead and carry on with an excess of drama. I hold her and talk to her, telling her stories about when we were little, and we look in each other's eyes for a long, long time. I stroke her hair and hold her in my arms. We are almost back in our childhood bedroom beneath the shelter of the ancient blue spruce that protected us always. Judy looks into my eyes.

Quite suddenly, she stops breathing. I can't believe it. I double- and triple-check. I lift her head in my hands and plead with her. I beg her. I start mouth-to-mouth breathing . . . breathing for her. Quite suddenly, in my arms and with great peace and equanimity, she has died.

I do not feel great peace. Instead, I am beside myself, horrified, desperate. I try CPR. I call 911. They tell me to move her to the floor and continue the CPR. I plead again with her not to die. I beg God not to take her.

The medics arrive and send me out of the room. I stare in through the window from the deck and watch them working on Judy. I feel the stars cold in the night sky and feel very, very cold. I watch them and pace back and forth, back and forth in the window. Too quickly,

it seems they're giving up. I rush back in and say, "Can't you try just a little longer? A bit longer, that's all. Please." But they continue putting their oxygen, their stethoscopes, all those bits and pieces in their bags and leave the room.

There she is on the floor where they left her, where I lie down beside her. I want to hold her more. I do not want to let her go. I feel her eyes still fixed on mine, and I know what she is telling me. I know it deep in my heart and in my bones. I must carry on with her message to the world that a human being's worth and gift to the world has nothing to do with any outer appearance, but with the mysterious gifts that lie hidden inside them, just as within her sculptures. Her message that there is beauty in what others, in their ignorance, might discard. With my heart, I make her my promise.

All the while, she continues to look at me with her deep, thoughtful eyes, continues looking deep into my soul, telling me what matters now. Even in death, I still see the same intensity in her gaze and I *feel* her message. A message and a purpose that will stay with me as I live out my life.

Now Judy's stomach has grown large as if she's pregnant, as if she's giving birth. My heart floods with so many layers of sorrow. I study her face and then feel confused. I stare, and stare some more. Hers is no longer the face of someone with Down syndrome. It is the face of a wise woman, a healer.

Most of my life, it had been a source of wonder to me: Who was she really? How was it she had a center so solid that was strong and loving through almost a lifetime of neglect and suffering? How could that be? I had wondered many times before if she was not actually a kind of healer, a bodhisattva, coming to earth as a teacher, taking a vow of silence, willing to take on enormous suffering in order to be with us in a place of love and wisdom, and now, here she is, her mask removed, a healer, a wise woman.

My close friend Anna Marie stays with me through the night. When she looks closely at Judy, when Judy had been gone from her body only a short while, she says, "My God, she doesn't have Down syndrome anymore. She looks like a Native American medicine woman." It was true.

Judy's Legacy

Today, Judy is no longer recognized primarily as a leading outsider artist. She has successfully crossed the nebulous divide that has separated art brut from the formal art world. Judy is now recognized as a brilliant and original contemporary artist. As her works have been acquired by museums around the world—including the Museum of Modern Art and the American Folk Art Museum in New York, the American Visionary Art Museum in Baltimore, Collection de l'Art Brut in Lausanne, the Irish Museum of Modern Art in Dublin, and the Museum of Modern Art in San Francisco—she has paved the way for other artists to transcend the original conceptual limits placed on their art. In terms of her artistic reputation, her disabilities are now consigned to mere biographical footnotes.

Rebecca Hoffberger, director of the American Visionary Art Museum, wrote, "Collected by art cognoscenti the world over, hailed in Europe as 'one of the most important artists of the twentieth century,' and toasted at champagne art openings on three continents, this

improbable artist, who was born with Down syndrome, could neither hear nor speak, read nor write. Yet this fiercely loving personality, unwillingly separated from her adoring twin sister and institutionalized for thirty-five years, went on to achieve a level of heralded praise few who create art will ever know."

In Europe and Asia, as well as in the United States, art lovers have gathered in growing numbers to marvel at Judy's creations and experience firsthand the raw magic they exert on the soul. In New York, gallery director Matthew Higgs called Judy's sculptures "one of the most important bodies of work—'insider' or 'outsider'—produced anywhere, and under any circumstances, in the past twenty years." In London, in 2011, the Museum of Everything staged the largest exhibition of Judy's sculptures ever assembled in one place. Informed by a popular BBC television program, crowds numbering in the thousands flocked to admire and revel in Judy's mysterious vision. Speaking about Judy's art, the museum's director, James Brett, enthused, "Hers is the best story in the world."

From October 2014 through March 2015, the Brooklyn Museum's exhibition *Bound and Unbound* featured the first comprehensive collection of Judy's work in the United States. Rave reviews appeared in the *New York Times*, *New Yorker*, *Wall Street Journal*, *Financial Times*, and *Time Out*, and in many newspapers through the Associated Press. Critics were enamored by the spirits found in Judy's sculptures, likening them to Native American medicine bundles.

"There is . . . something exquisitely magical about Judith Scott's pieces," wrote Hoffberger. "Much like the mojo bags and shamanic medicine sacks, whose secret contents are often wrapped in string and yarn to form bundles for broadcasting protection and healing energies, Scott's works contain the unseen and the barely seen, like a peek into an earthbound crow's nest feathered by shiny bits and colorful string collected from his travels."

But it is not just in the art world that Judy's star shines brightly.

In social media, from blog posts and tweets to Facebook comments, people from all walks of life and all over the world stand testament to her broader impact. Teachers find her an inspiration, both for their own work and for that of their students. And Judith has become a source of encouragement for those unexpectedly called to face the challenges of disability.

More touching than any extravagant praise from museum directors and other luminaries of the art world are poignant communications from the parents of children with disabilities, who write to express their gratitude for the hope, encouragement, and inspiration that Judy's story has brought them.

When Judith arrived at Creative Growth in 1987, she came with almost a lifetime of painful and isolating experience, unexpressed and unshared. It was through the creation of her sculptures that she was empowered to discover a language through which she could express the unspoken and find a voice to communicate with the outside world. Creative Growth gave her this opportunity and the universal language of art gave her this voice.

When I picture a heaven for Judy, it looks very much like Creative Growth. I can see Judy there, creating her sculptures, maybe not with old shopping carts, broken scissors, or brooms, which may not be available, but with the leftovers and discards of heaven, whatever those might be. She wraps with her usual intensity and looks around, maybe now at the clouds and angels, but she has no time for them. She is working. Her fingers do not bleed as she weaves through a strand of blue, and she smiles. In my mind, I am there beside her.

Acknowledgments

To the staff and artists at Creative Growth Art Center for providing the sustaining and creative environment in which Judy could discover her art and her voice, particularly, directors Tom di Maria and Irene Ward Brydon, staff artist Stan Peterson, gallery manager Catherine Nguyen, and Judith's best friend and fellow artist, Paul Costa.

To John MacGregor for his early recognition of Judy's genius and for creating the beautiful and insightful book *Metamorphosis: The Fiber Art of Judith Scott.*

To Stephen and Ondrea Levine, who, through their meditation retreats, opened my heart and mind to the possibility of becoming Judy's guardian and, in so doing, enriched and expanded both our lives immeasurably.

To Beacon Press for believing in this story and making the publication of *Entwined* a reality, and particularly to my editor, Joanna Green, who remained committed to the project throughout the editorial process.

To Stacey Glick, my ever supportive agent, who never faltered in her commitment to finding the right publisher for *Entwined* and who, with warmth and enthusiasm, continues still to provide advice and encouragement.

To photographers Leon Borensztein, Sylvain Deleu, Eric Butler, Anne Collier, Johann Feilacher, Erin Brookey, Benjamin Blackwell, and Sylvia Seventy for the generous use of their beautiful images.

To my two gifted editor friends, Gail Shafarman and Elizabeth Stark, who have guided and inspired me through these many years of the book's gestation.

To those who have been part of the evolution of *Entwined* from its early drafts onward, sharing their time, insights, and ideas: Elizabeth Green, Nanou Matteson, Jeany Wolf, Ruth Hanham, Carol Cujec, Jen Mar, Elizabeth Sojeck, and Ilsa Brink, our valued web designer.

To the members of my two writers' groups, now lifetime friends, who have suffered with me through years of rewrites, rereads, and my own recurring doubts. I thank you: Marilynn Rowland, Wendy Bartlett, Doris Fine, Karen Greene, Dean Curtis, Winifred Reilly, Victoria Werhen, Pat Kunstenaar, Jan Sells, and Laura Prickett.

To the museum and gallery directors and curators who recognized and embraced Judy's art and presented it to the world, particularly Rebecca Hoffberger, Lucienne Peiry, James Brett, Catherine Morris, Matthew Higgs, Johann Feilacher, and Frank Maresca.

To the filmmakers who have brought Judy's story so vividly to audiences around the world, especially Betsy Bayha, Gemma Cubero and Alicia Productions, Scott Ogden, and Miranda Sawyer and the BBC.

To Dr. Ziad Saba, who, through Judy's heart surgery, gave her extra years to express her creative fervor and love of life.

To my very dear friends, who have loved Judy and supported me through these many writing years, most particularly Bette Flushman, Herb Slater, Wendy Bartlett, Marilynn Rowland, Pam Weatherford, Anna Marie Stenberg, Peggy Hill, Anne and Ray Poirier, Michael

Whelan, Emily Fragos, Kathi Dillinger, Jill Christie, Lily Wu, and Brinda Callahan.

To our first family and the people of our past who loved Judy and me, who gave us our childhood, our lives, and our dreams.

To my own family, whose patience and belief in the story have never faltered: my daughters Taylor, Lilia, and Ilana, and my life partner, John Cooke, who has lived with this book through all its incarnations and without whom it could never have been written.

Finally, to those who have given help and support but remain unmentioned because of my faltering memory, I offer my apologies and sincere thanks.

I owe to all my deepest thanks and offer my grateful heart.

• • •

The author will be donating a portion of the proceeds of this book to the Creative Growth Art Center in Oakland, California (creativegrowth.org), and the Down Syndrome Connection of the Bay Area (dsconnection.org).